HOUSTON
THEN & NOW

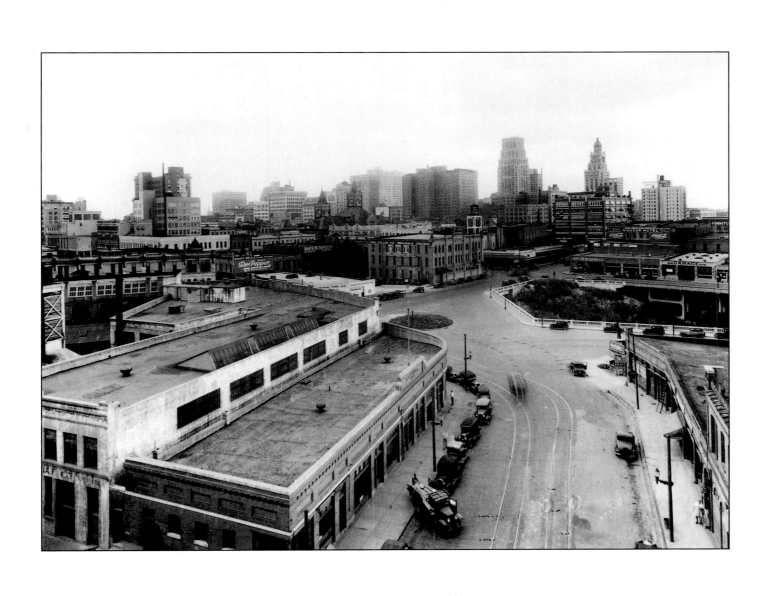

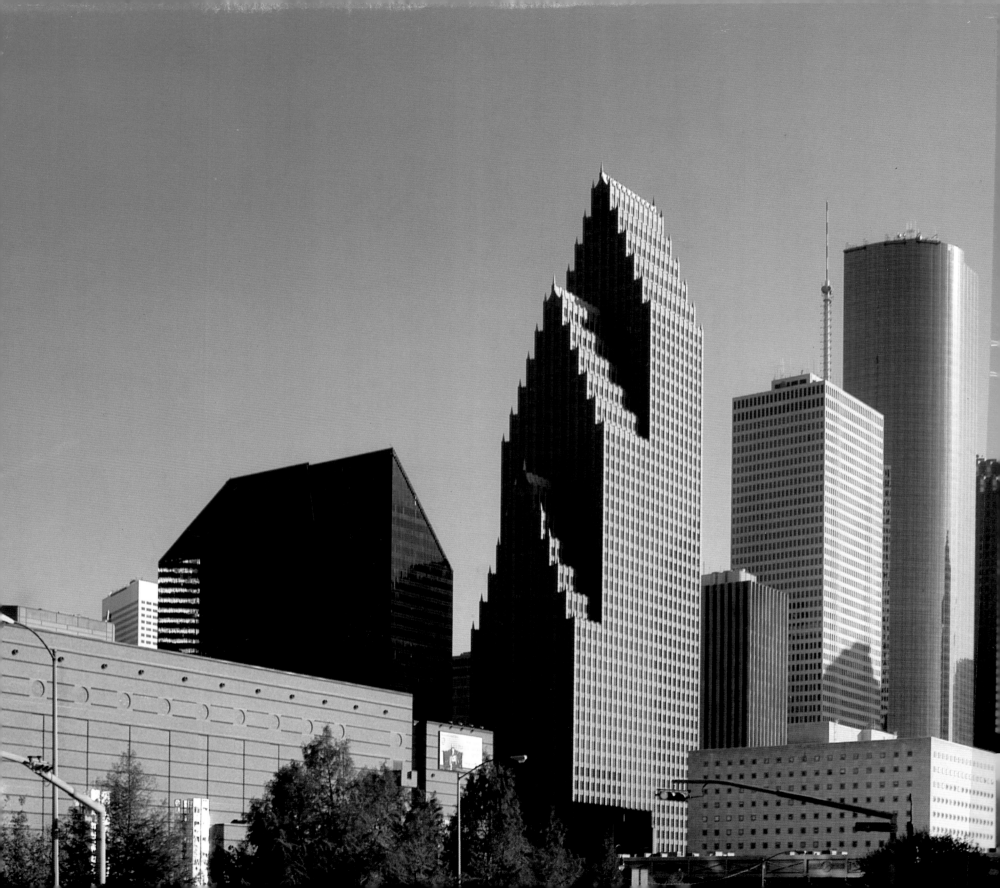

HOUSTON
THEN & NOW

WILLIAM DYLAN POWELL

THUNDER BAY
P·R·E·S·S

San Diego, California

Thunder Bay Press
An imprint of the Advantage Publishers Group
5880 Oberlin Drive, San Diego, CA 92121-4794
www.thunderbaybooks.com

Produced by PRC Publishing Limited
The Chrysalis Building
Bramley Road, London W10 6SP, U.K.

An imprint of **Chrysalis** Books Group plc

© 2003 PRC Publishing Limited

All notations of errors or omissions should be addressed to Thunder Bay Press,
Editorial Department, at the above address. All other correspondence (author
inquiries, permissions) concerning the content of this book should be addressed
to PRC Publishing Limited, The Chrysalis Building, Bramley Road, London
W10 6SP, U.K.

ISBN 1-59223-137-3

Library of Congress Cataloging-in-Publication Data.
Houston then & now / William Dylan Powell.
p. cm.
ISBN 1-59223-137-3
1. Houston (Tex.)--Pictorial works. 2. Houston (Tex.)--History--Pictorial
works. I. Title: Houston then and now. II. Title.

F394.H843P69 2003
917.64'1411'00222--dc21 2003054198

Printed in Hong Kong

1 2 3 4 5 07 06 05 04 03

ACKNOWLEDGMENTS:

Many thanks to the staff of the Houston Metropolitan Research Center's Texas
Room: Will Howard, Doug Weiskopf, Nina Oliver, Ellen Hanlon, and Ron Lee for
their priceless research assistance. Thanks to Joel Draut, the research center's photo
archivist. And a very special thanks to the authors whose works were both a valuable
resource and a pleasure to read: Betty Trapp Chapman, Marguerite Johnson, Marie
Phelps McAshan, Sister M. Agatha, Jim Hutton, Dorothy Knox Houghton, Barrie
Scardino, Sadie Gwin Blackburn, Katherine Howe, as well as the many contributors
to both the National Park Service's National Registry of Historical Places and the
Texas State Historical Association's New Handbook of Texas. Many thanks to my
wife, Stephanie, for help on the home front.

PHOTO CREDITS:

The publisher wishes to thank the following for kindly supplying the photographs
that appear in this book:

Then Photography:
All photographs appear courtesy of Houston Metropolitan Research Center, Houston
Public Library, Texas. Thanks to Joel Draut for his help.

Now Photography:
All photographs were taken by Simon Clay (© PRC Publishing).

For cover photo credits please see back flap of jacket.

All enquiries regarding images should be addressed to Chrysalis Images.

Pages 1 and 2 show: The Houston skyline, then (photo: © Houston Metropolitan
Research Center, Houston Public Library, Texas), and now (photo: Simon Clay/
© PRC Publishing); see pages 88 and 89 for further details.

INTRODUCTION

It was time to make a decision. On April 21, 1836, General Sam Houston and his newly formed army of the Republic of Texas squinted across the Texas prairie at the men sent to gun them down: the Mexican army. The Texans were outnumbered, undertrained, and desperate to avenge what they felt was unfair treatment by the Mexican government. As the day warmed and the mosquitoes swarmed, their rage came to a head. The Mexican soldiers, having failed to post a lookout during their afternoon siesta, were awakened by the panicked screams of their leaders and the smell of gunpowder. The Battle of San Jacinto lasted only eighteen minutes, creating a new nation: the Republic of Texas.

Houston was officially established on August 30, 1836, just twenty miles from the San Jacinto battleground. Its founders were Augustus C. and John K. Allen, brothers from New York who had befriended General Houston before the Texas Revolution. The Allens were imaginative and ambitious land speculators. They supported the Texas Revolution with gold rather than lead, contributing money and supplies to the badly underfunded army of the Republic of Texas. When the war concluded, they purchased over 6,500 acres of land near the Buffalo Bayou for less than $1.50 per acre, naming the new town site after their old friend and new official leader, Sam Houston. Envisioning a lucrative trading post on Buffalo Bayou, they immediately began promoting the town to anyone who would listen.

By 1837, the Allens had successfully lobbied for Houston, at the time consisting of just a handful of tents, to become the temporary capital of the Republic of Texas. As in other parts of the new republic, land grants were offered to settlers meeting certain qualifications. People trickled in as crude frame houses sprouted, birthing a rough and somewhat rowdy village not atypical of frontier Texas. It was not an easy place to live or do business. The bayou they banked on for generating trade was constricted and difficult to navigate. Even the most basic amenities and infrastructure were scarce commodities. But in a town started by and for entrepreneurs, people continued to see more hope than hassle in the future of Houston.

Houston's role as the republic's capital lasted only two short years. It was crushed by Sam Houston's political opponents and the possibility of Texas acquiring New Mexico, which necessitated having a capital farther to the west. But its commercial momentum continued, and the adrenaline associated with establishing a new nation pulsed through the United States and Europe. Immigrants poured in from around the world.

Cotton would make Houston an important city during the Civil War. Insulated by its geography and trade, little of the Texas soil was seen by Northern forces. Despite its failed affair with the Confederacy, the latter half of the nineteenth century brought a modest amount of prosperity. In 1853 Houston's first railroad, the Buffalo Bayou, Brazos, and Colorado, was built. First National Bank was chartered in 1866. Telephones, public schools, and even an automobile or two all made their way to the Bayou City. In the 1880s, New York and Houston were the first American cities to build power plants. Efforts were also started to make the bayou more accommodating to trade.

In January of 1901, in the nearby town of Beaumont, a group of wildcatters ushered in a new age of Houston history: oil. Spindletop, the name of the knoll where the oil was found, marked the beginning of an economic windfall that would make the California Gold Rush pale in comparison. Enterprising engineers and businessmen rushed to the region by the thousands. Merchants prospered and many financial alliances were formed. Though their enterprises began outside of the city limits, these new oil barons would center their operations in Houston.

Despite the Great Depression, the period between 1901 and World War II was a perfect storm of enterprise and economic prosperity for Houston. Accompanying the discovery of oil, engineers finally brought the Houston Ship Channel to a depth of twenty-five feet. In 1915, the first deep-water vessel—the *Satilla*—landed at its wharf. This one-time tent city now had both unlimited access to a valuable international commodity and an efficient means of delivering it. Over the next two decades, oil refineries sprouted up everywhere along the ship channel. The oil went out, and the opportunities came in.

In Houston, culture started to boom. Social clubs of every variety proliferated and Texas's first fine arts museum was born. Theaters, music halls, and drama societies of every size and variety drew heavy patronage. Universities were born and began to set a high standard. A symphony orchestra was established. Mansions built in the High Victorian architecture style flooded the streets as the names of its pioneering families ceased to be associated with their former lives in New York, Massachusetts, and Germany. These families became the fabric of what had just become the most populous city in Texas.

It is true—success really does breed success. The decades following World War I brought a growing skyline, luxurious suburbs, and dramatic improvements in the city's infrastructure. The Texas Medical Center was founded in 1943. Five years later, Houston saw the construction of Texas's first freeway. The arts continued to develop. National recognition for Houston's progress was shown in 1962 when NASA moved its Manned Spacecraft Center to the city.

Houston today is part Manhattan, part Republic of Texas, and part United Nations. Life in Houston brings the world to one's doorstep. One is as likely to come across a Hindu temple, a Haitian poetry recital, or a horse race. There's almost no ethnic food that can't be found, no type art that can't be enjoyed, and no enterprise without potential.

Despite its urbanization, the institutions and incidents defining Houston since its days of Mexican rule have left many footprints across its 620 square miles and following them is a fascinating journey. From Sam Houston's fateful battle to today's ongoing fight for continual progress and prosperity, the city of Houston has—then and now—proved itself an unbeatable champion.

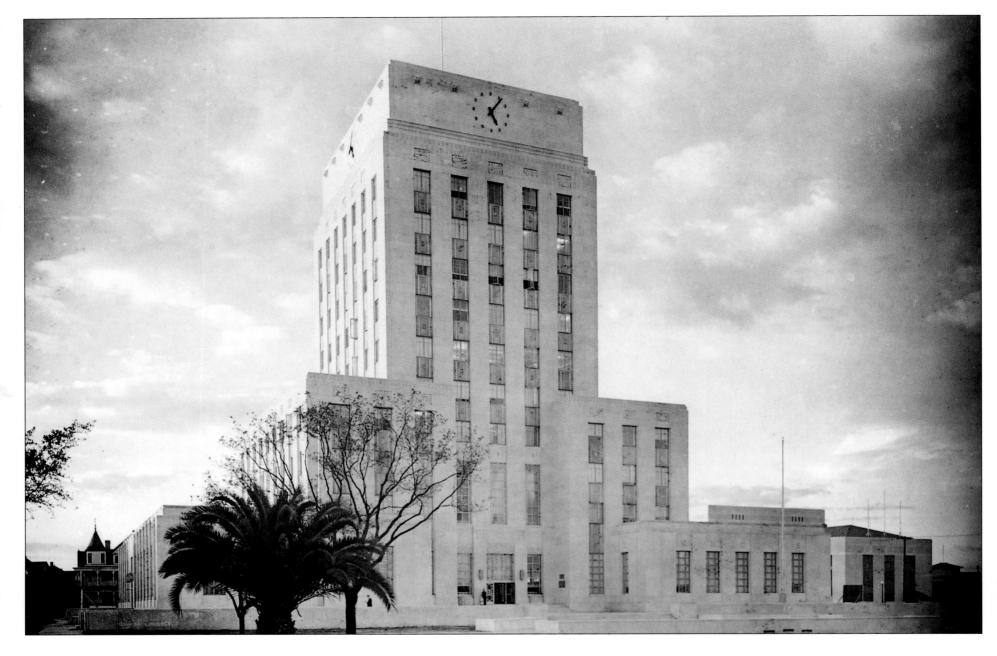

At its completion in 1939, Houston's City Hall was a significant downtown landmark. Its Cordova limestone facades and clocks on all four sides are guarded by miniature Texas wildcats. The building's entrance opens to Hermann Square, a small park bequeathed by George Hermann. Legend says Hermann purchased this patch of land downtown so his laborers could sleep off their payday rowdiness. It was cheaper than paying their bail.

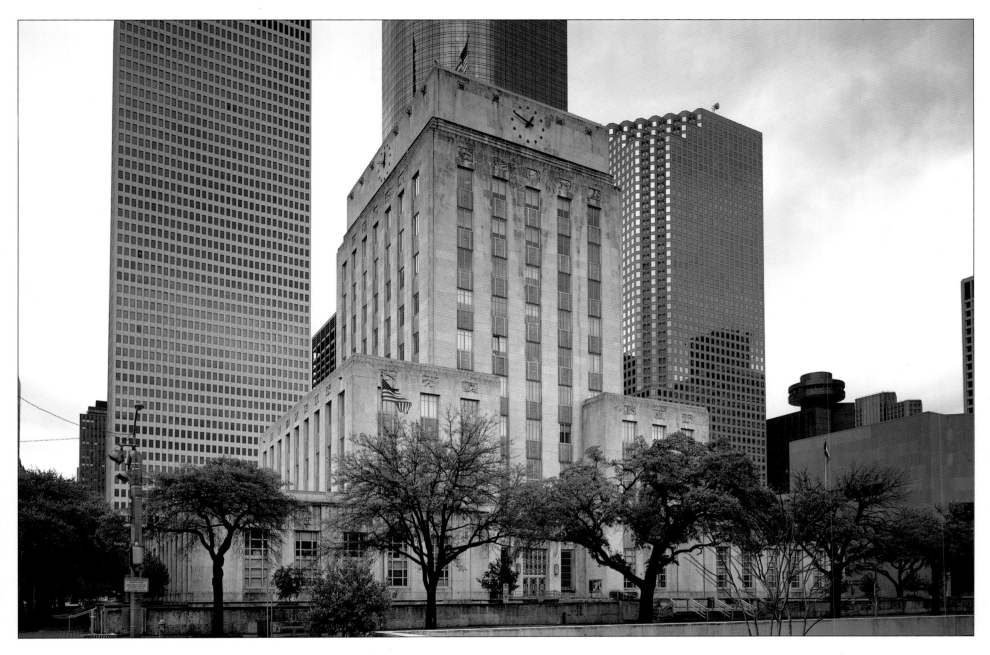

This small building is still the official city hall, though its role has become less administrative than ceremonial. Barely noticeable downtown, only the building's west side is free of an overpowering pillar of steel and glass. Although the police are supposedly still lenient to those sleeping in Hermann Square, one's chances of snoozing during the festivals, speeches, concerts, rallies, and other vibrant events held there daily are pretty slim.

Andrew Carnegie built over 2,800 libraries, including this Italian Renaissance structure completed in 1904 at Main and McKinney. Chartered by the Houston Lyceum and Carnegie Library Association, its roots rest in the Houston Lyceum, a members-only group that had migrated around town in one form or another since the 1830s. Its directive was not only book propagation, but also the hosting of weekly debates and lectures.

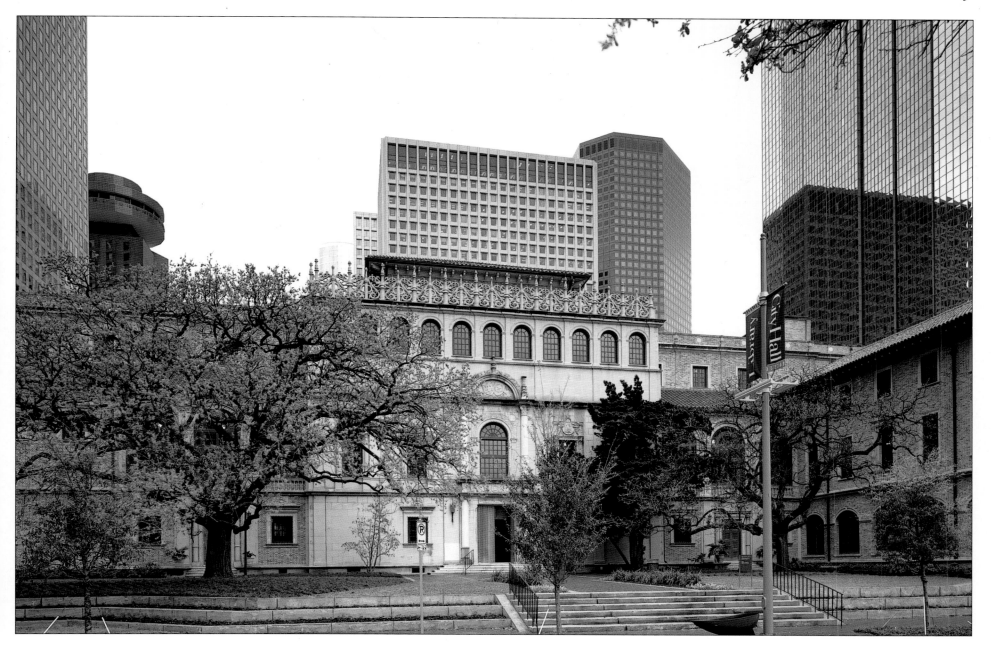

Led by head librarian Julia Ideson, the Carnegie Library soon outgrew its original
structure and the new, Spanish Renaissance–style Houston Public Library was
erected three blocks west in 1926. After her death, the building was named the
Julia Ideson Building. The city soon outgrew this building, too. It now houses the
Houston Metropolitan Research Center—a historical research facility preserving
regional collections, archives, and manuscripts.

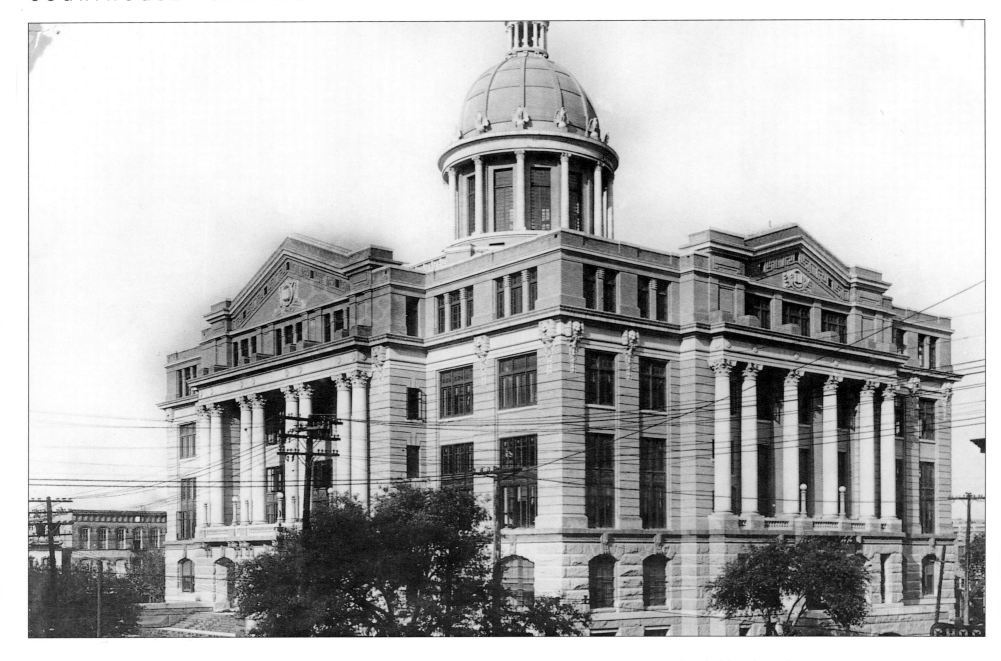

When court sessions were first held in Courthouse Square in 1837, it was known as the Eleventh District Court of the Republic of Texas. The first session was held right under the trees, probably much to the defendant's anxiety. The Harris County Civil Courts Building, which occupies the site today, is the fifth courthouse to lay down the law in this downtown locale. It was dedicated on the seventy-fifth anniversary of Texas's independence.

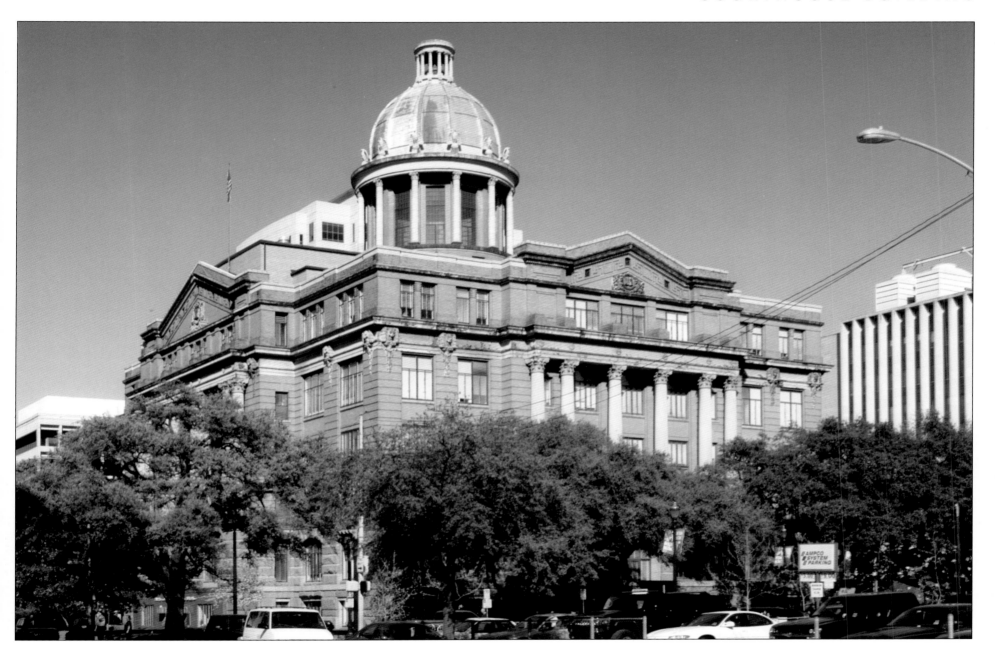

The building avoided demolition in 1938 by only a handful of votes. Why isn't a seventy-story office building in its place today? Maybe its neoclassical charm has won the heart of too many Houstonians. A more likely reason is the stipulation assigned by the Allen brothers that Courthouse Square's ownership will revert to their legal heirs should the land be used for anything but a courthouse.

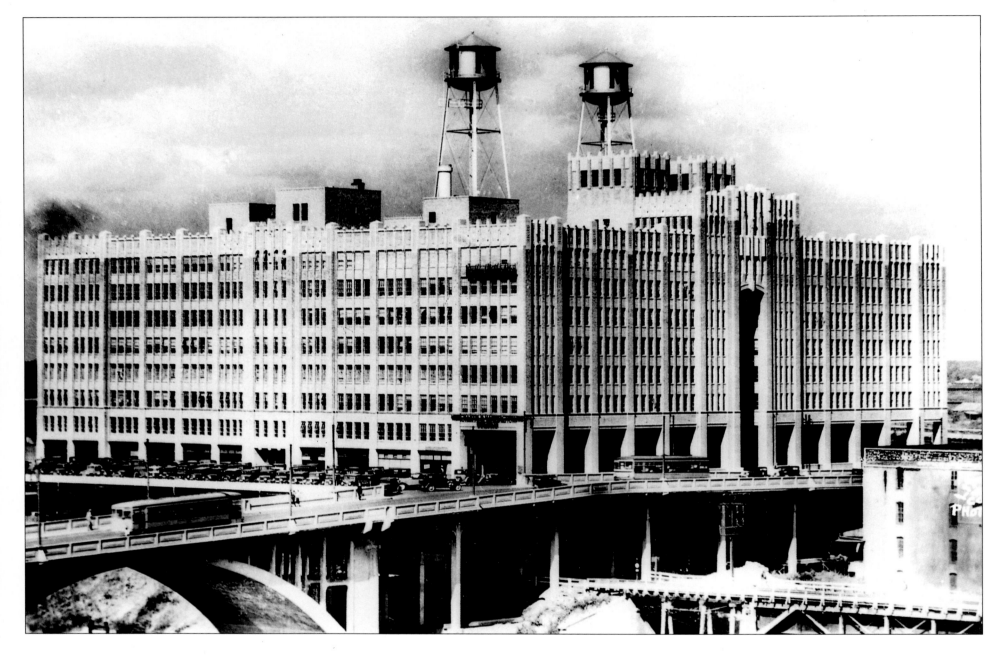

In its prime location at One Main Plaza, the Merchants and Manufacturers Building was modeled after the Merchandise Mart in Chicago—a hybrid office complex, warehouse, and exchange. But it was doomed almost before its 1930 opening. The project's primary financier died in 1929—the same year a flood would mar the facility. After eventual bankruptcy, it became government property. In the 1950s, an oilman bought and renovated it.

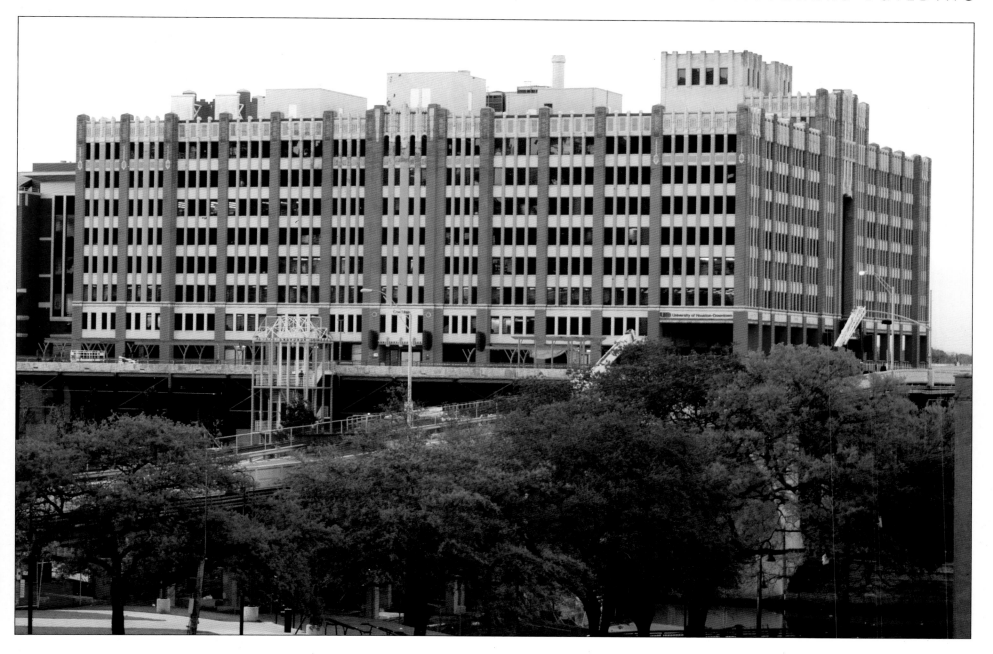

Knowledge is the building's biggest commodity today. In 1969, this modern might-have-been got a new lease on life when it was purchased by South Texas Junior College. When the University of Houston absorbed the college in 1974, it assumed ownership of the building, which is now the campus of the University of Houston–Downtown (UHD). Over 10,000 people attend UHD pursuing a variety of graduate and undergraduate degrees.

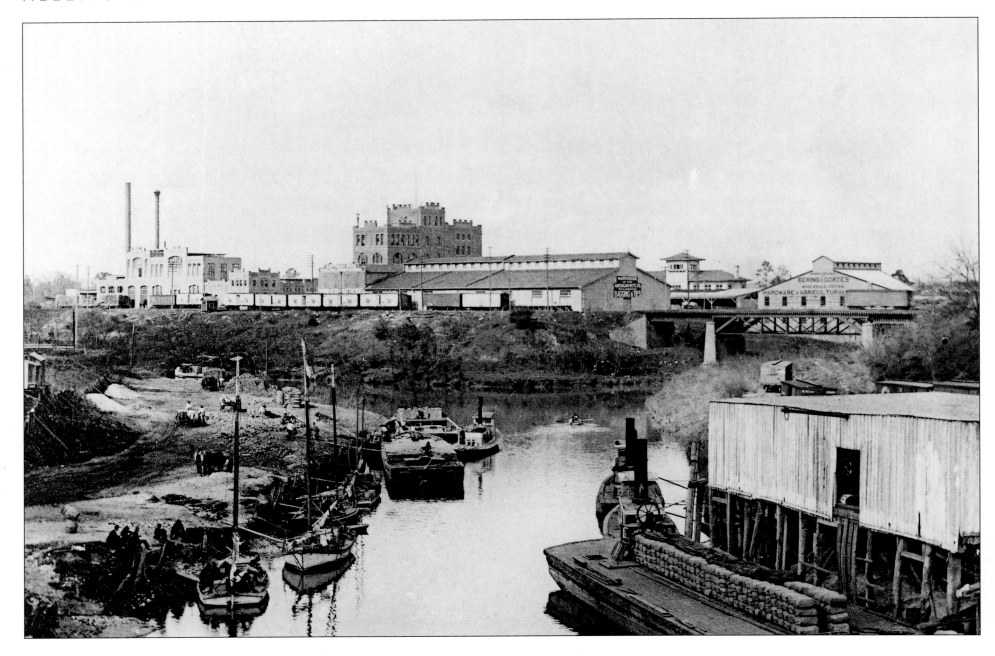

In the heart of town at Buffalo Bayou's south bank, Allen's Landing was the birthplace of Houston's water commerce. Perched on the confluence of the Buffalo and White Oak Bayous, it received its first ship, the *Laura M.* from Galveston, in 1837. Though the ship accidentally bypassed the soggy tent collection that was Houston at the time, Allen's Landing would buzz with freight and business for decades to come.

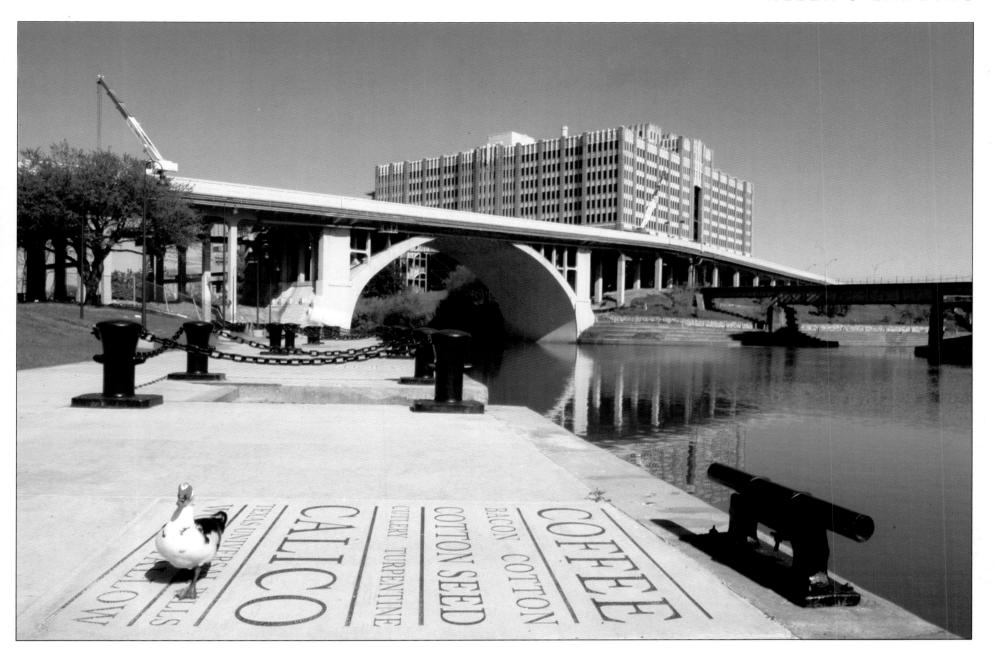

Today there are more hikers and kayaks than horses and cotton at Allen's Landing. Over time, Houston's shipping industry migrated east to the new Houston Ship Channel. But a replica of the old Port Promenade can be found at what is now Allen's Landing Park, along with a historical marker, lawns, public art, and other amenities. A magnet for weekend festivals and urban hiking, the existing park will soon undergo expansion.

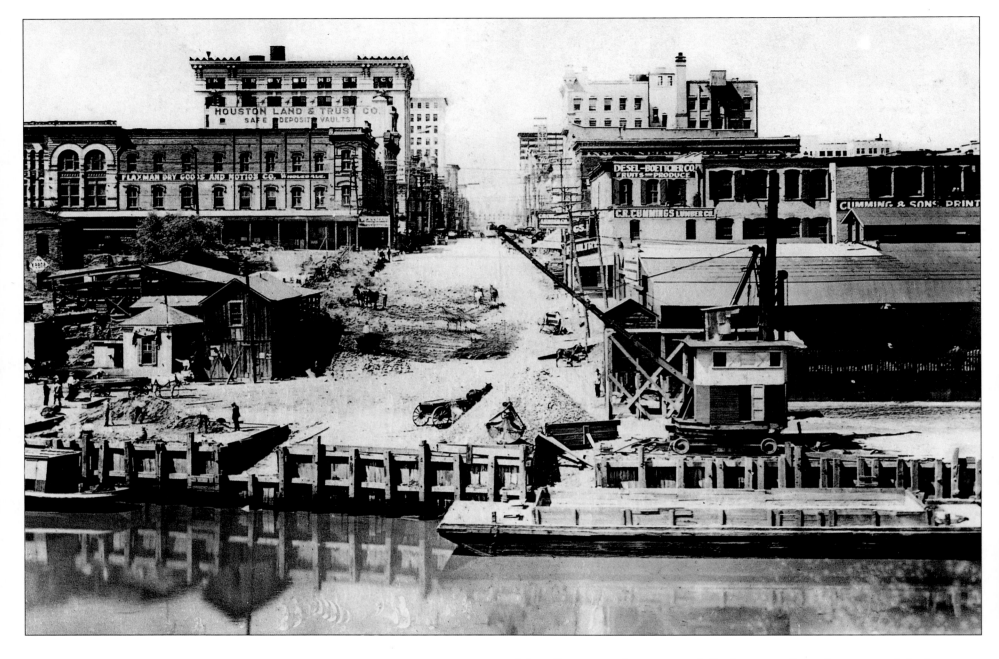

Main Street was always an anthill of activity. Steamboats parted the bayou as they docked to deliver everything from steel pipe to designer hats. The smell of sawdust, coal, and horses from the landing drifted down Main Street to mix with the aroma of fresh coffee, French perfume, and smoked meats. At the turn of the century, literally hundreds of Houston manufacturing facilities used the landing on Main Street.

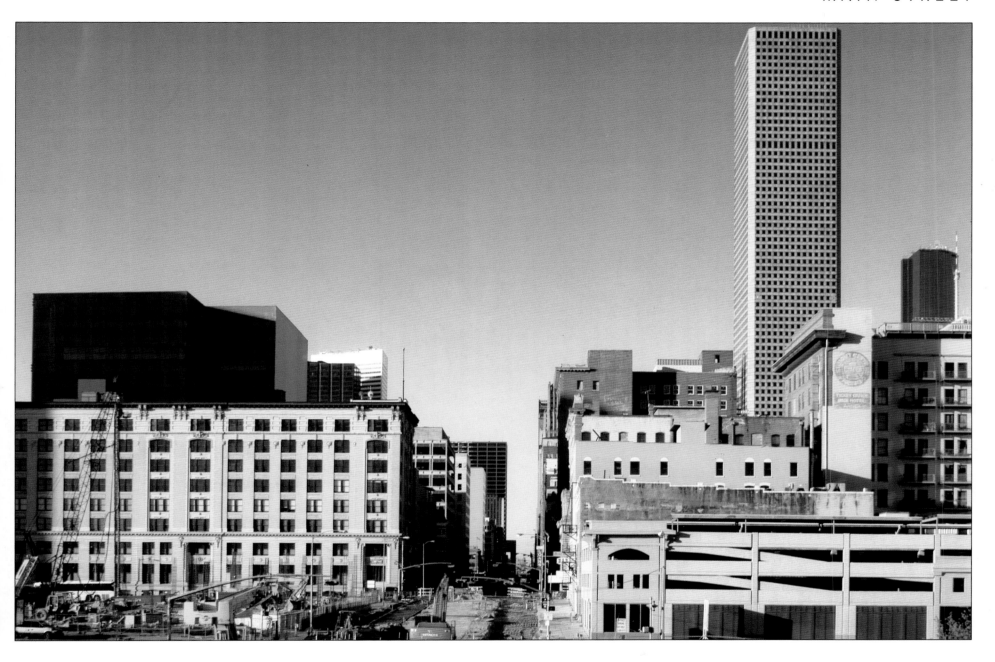

Main Street is still the center of Houston's swarm. But the opening of the ship channel and the Main Street viaduct in 1914, which allows Main Street to cross Buffalo Bayou, has made the area more suitable for parking than docking. Now the foot of Main smells of diesel fuel and gourmet coffee as crews of workmen rush to make street and property improvements in an attempt to quench Houstonians' thirst for downtown loft and office space.

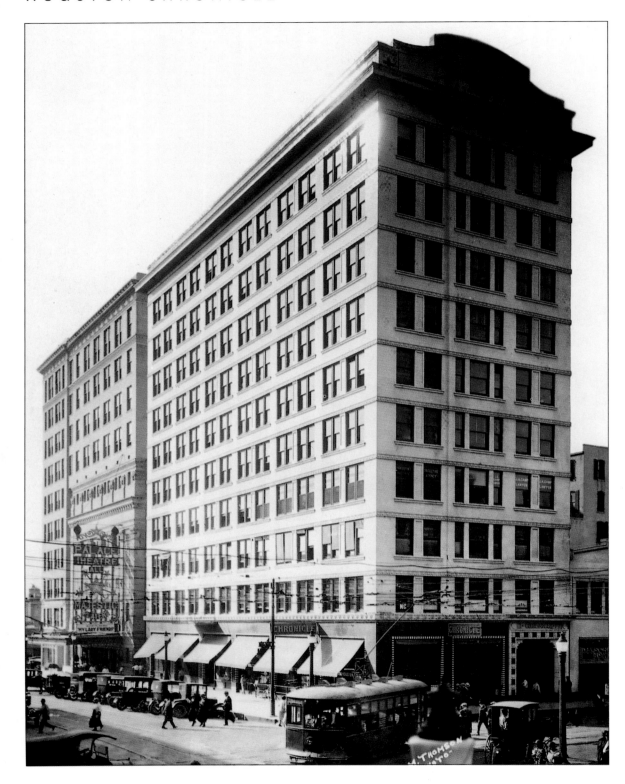

In 1901, Marcellus E. Foster was covering the Spindletop spectacle as a reporter for the *Houston Post*. While there he decided to buy some options. He was instantly wealthy. Foster soon resigned at the *Post* and started the *Houston Chronicle*. At two cents a copy, the *Chronicle* gained almost 5,000 subscribers its first month! Not ten years after Spindletop, it enlisted Jesse H. Jones to build this ten-story office at Texas and Travis.

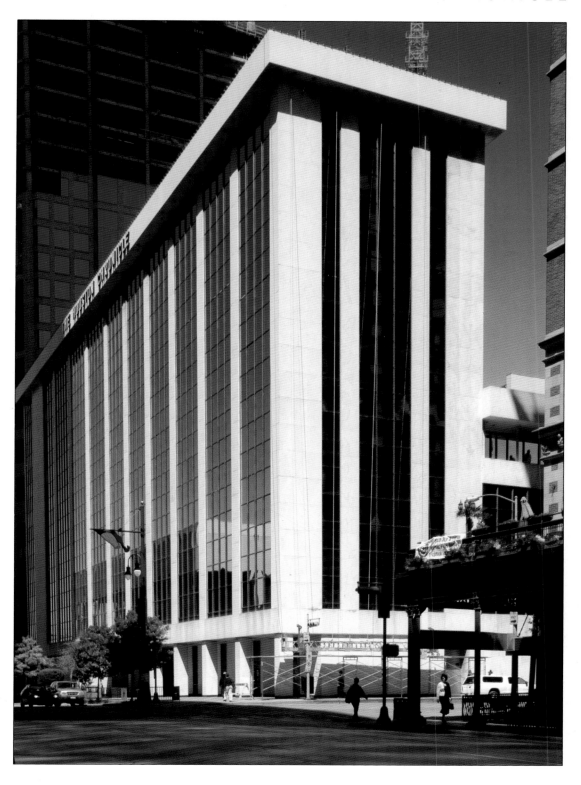

The building expanded considerably, swallowing several nearby structures including the old Palace Theater. Jones fell in love with the paper, eventually buying it. Today, the building is nearly 100 years old. Now owned by the Hearst Corporation, the *Chronicle* is Houston's largest newspaper and one of the ten largest in America. It has a Sunday readership of more than 1.7 million and bureaus across North America. The *Post* closed in 1995.

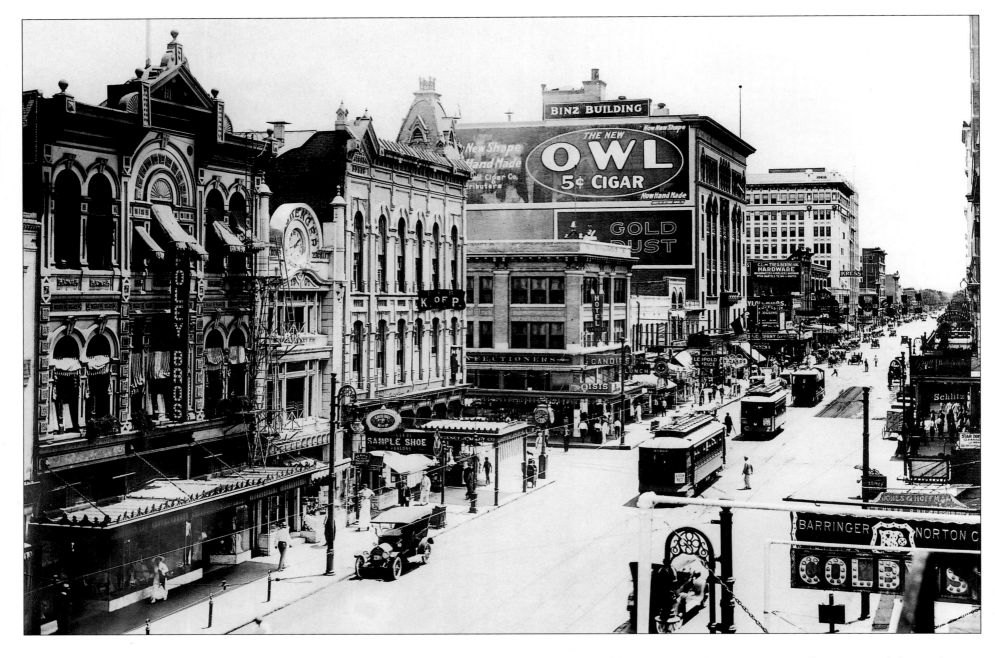

In this pre–World War I view of Main Street, trolleys, automobiles, and pedestrians made for a busy thoroughfare. Flush with newfound oil wealth, Houstonians found some of the city's finest retailers here. The bayou brought goods in from all over the world to the head of this very street, and Houston's ambitious entrepreneurs made the most of them. Irishman William L. Foley opened his first dry goods store in Houston in 1877.

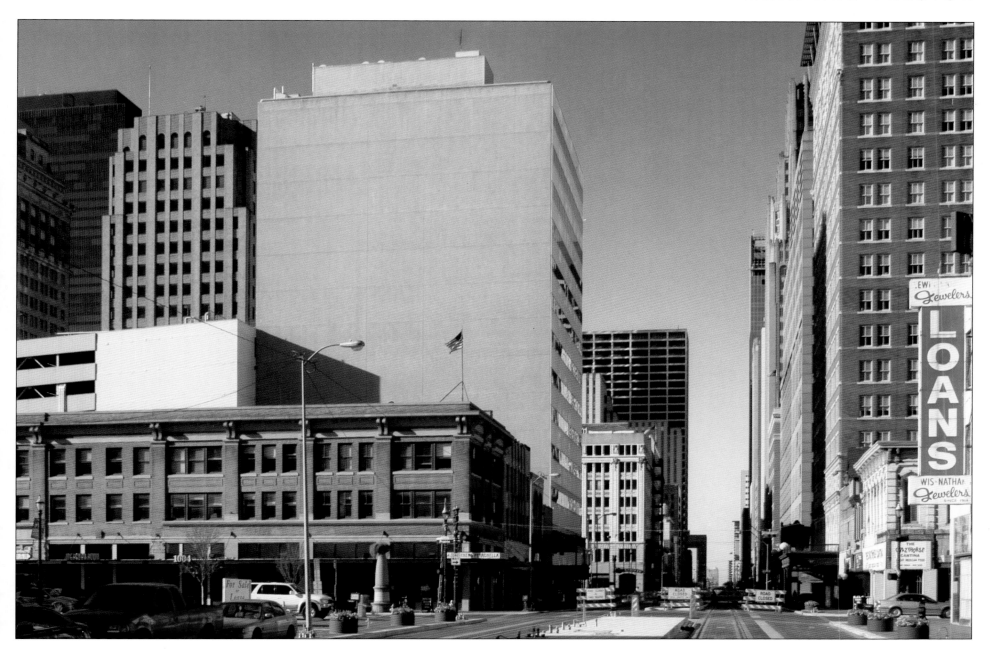

Main Street doesn't have as many retailers now, but Houstonians still like to shop. Gross retail sales in the area topped $60 million recently. Foley's little dry goods store grew to over $2 billion in sales and almost sixty stores; its new building at 1110 Main was one of the first downtown buildings with a tunnel (and a huge bomb shelter). Barringer-Norton, previously at 506 Main, is now called Norton Ditto.

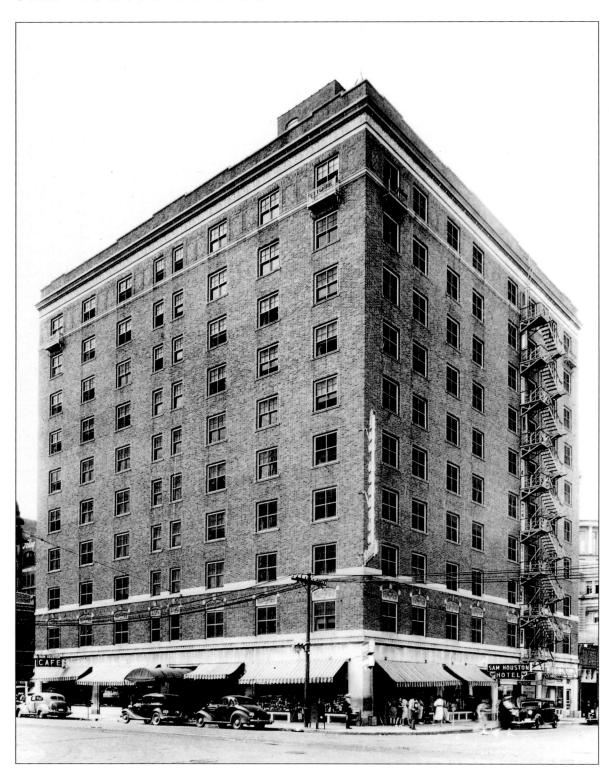

The Sam Houston Hotel was built in 1924 as buildings and bankrolls grew tall. Its proximity to Union Station brought everything from New York lawyers to German engineers. Sam Houston was still living when it was built. A true luxury experience, each room cost two dollars and sported both a private air conditioner and a restroom. Sadly, the hotel closed in the early 1980s and turned into a cheap, run-down establishment.

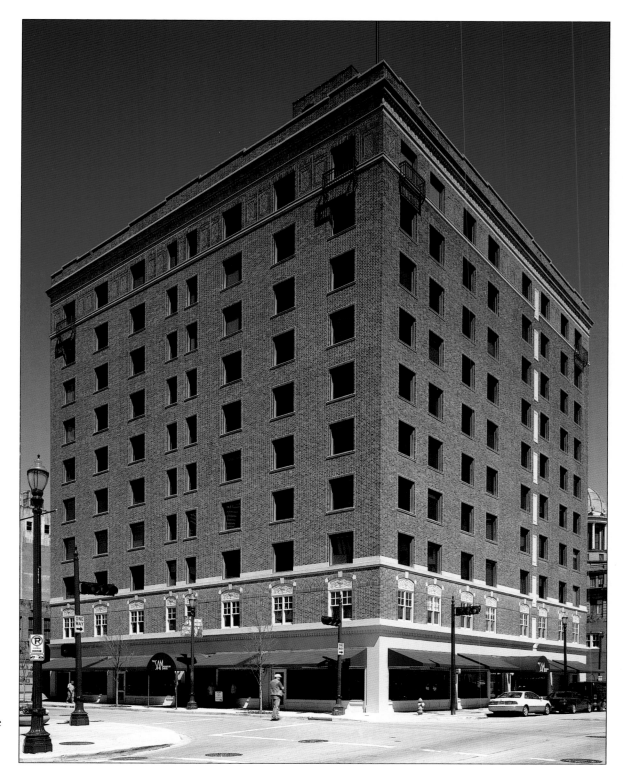

The hotel reopened in 2002, continuing its tradition of luxury near downtown's skyscrapers, the George R. Brown Convention Center, Minute Maid Park, Courthouse Square, and the Theater District. And it's more exquisite than ever. At its reopening, Mayor Brown noted that it "reminds us what Houston has always been about—a sense of the possible. That sense was there in 1924, and it is with us today."

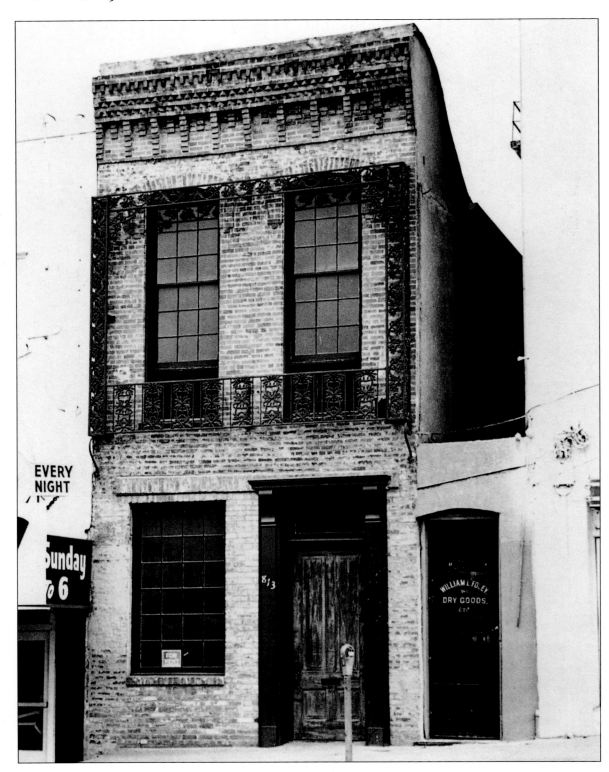

The Kennedy Bakery is recognized as Houston's oldest commercial building still standing on its original site. Nathaniel Kellum built the structure in 1847 and in 1860 John Kennedy, an Irish baker, moved into the narrow structure at 813 Congress. Kennedy was an Irish immigrant who came to Houston in 1842. Poor when he arrived, the hardworking Irishman quickly amassed his own Houston bakery, gristmill, retail store, and several thousand acres.

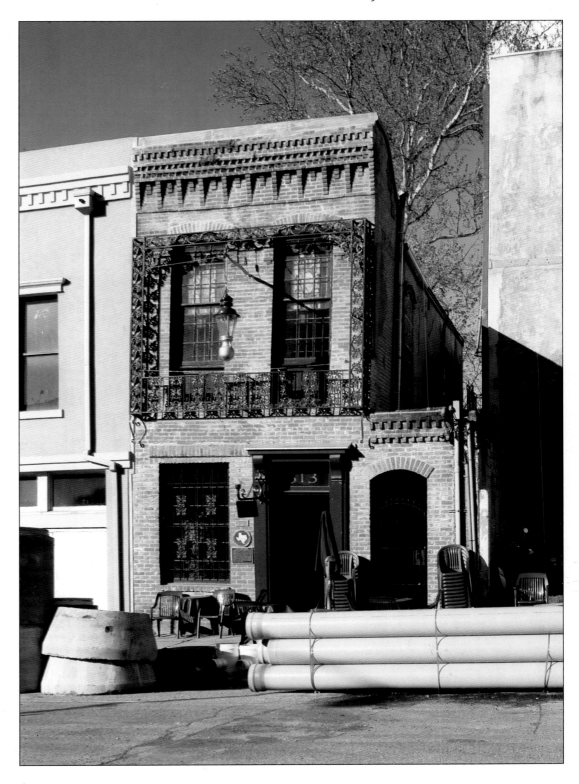

During the Civil War, Kennedy used his bakery to make hardtack for Confederate soldiers. It passed from the Kennedy family in 1970 and is now La Carafe, considered to be Houston's oldest bar. Its wine selection and atmosphere prompted one magazine to name it one of America's finest bars. Some say the building is haunted, complete with exploding bottles, eerie shadows, and cold spots.

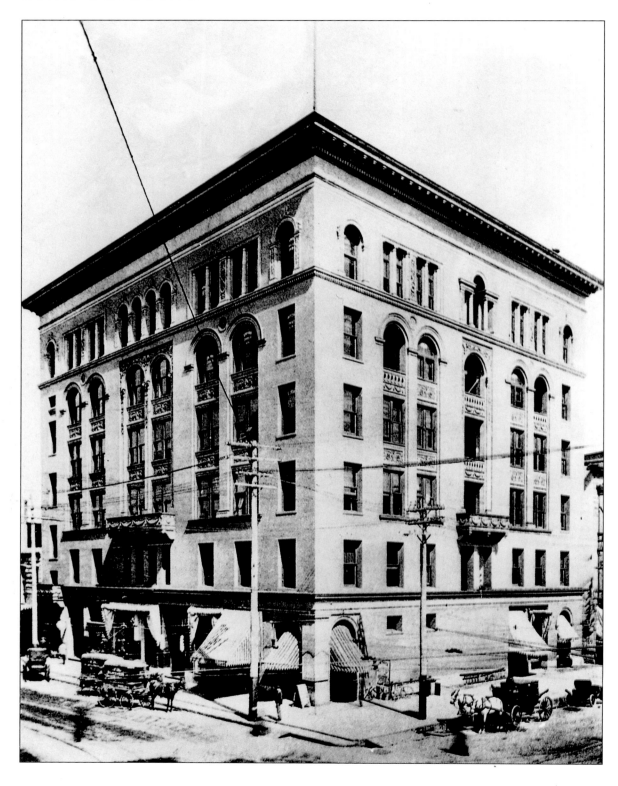

The original Binz Building, on the corner of Main and Texas, was Houston's first skyscraper. At six stories, it was an absolute marvel at the time of its construction in 1898. Riding up its elevator and overlooking the town's landscape became a popular pastime. The building was named for Jacob S. Binz, who was one of thousands of industrious immigrants comprising Houston's prolific German community.

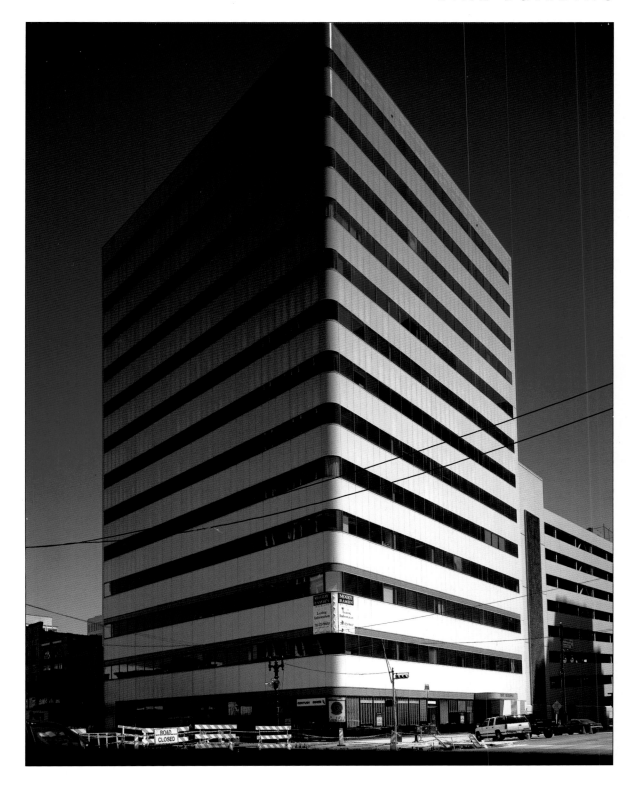

In its day, the old Binz Building's presence gave concrete (and steel) evidence of Houston's ambition. But the definition of "skyscraper" has changed over the years. The bar and the skyline have been raised. A new Binz Building was erected on the site in 1951 and was replaced by the current structure in 1982. Longtime manager Rhonda Taylor salvaged a few bricks from the original 1898 structure in memory of its grandeur.

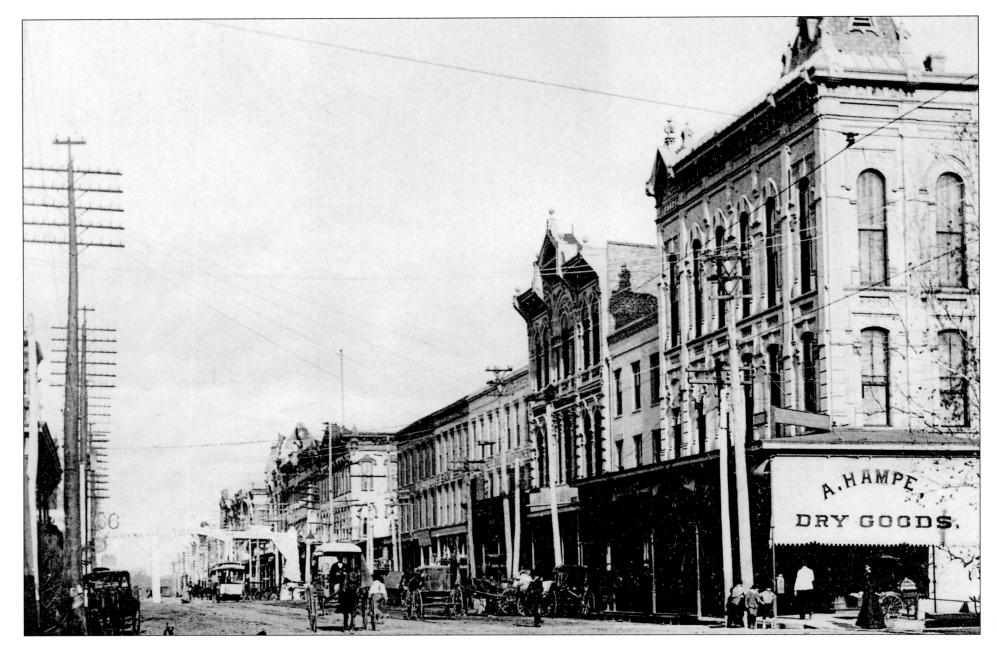

Looking north on Main Street at the Prairie Street intersection in the mid-1890s, both telegraph wires and trolley cars gave passersby a glimpse of the next century— even as horses still plodded through the mud. The Burns Building, front right, was built in 1883 by Hugh Burns. Born in County Roscommon, Ireland, Burns had a hand in much of Texas's railroad development at the turn of the century.

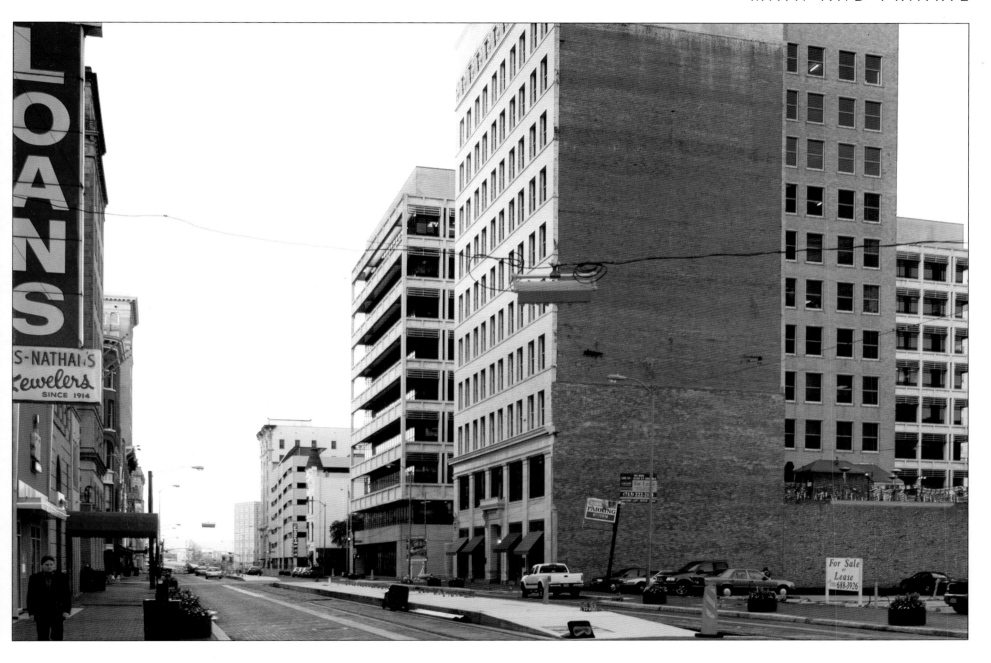

The Burns Building was 111 years old—the second-oldest building in Houston—and on the National Register of Historic Places when it was demolished. A noncommittal owner and lax ordinances governing historical buildings permitted its razing. Most of its contemporary neighbors had met a similar fate. Onlookers cried as the wrecking ball swung, but the event served to galvanize local historical activism. Several powerful groups now protect Houston's architectural heritage.

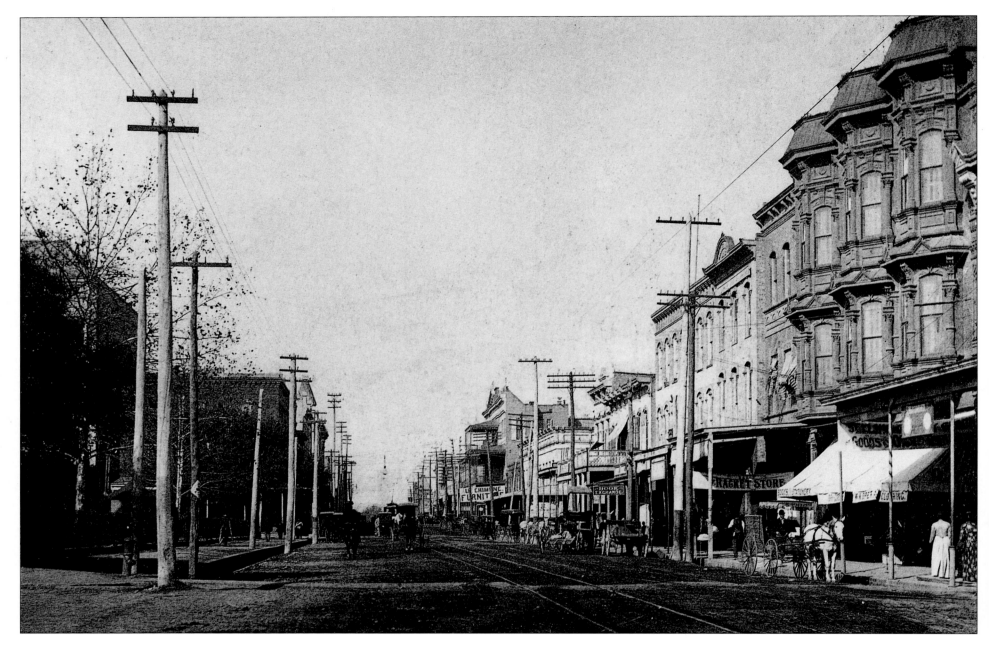

Congress Avenue looking west from San Jacinto Street at the turn of the century gives a glimpse of Houston's early construction—both architecturally and culturally. After the fall of the Confederacy, U.S. occupiers draped a huge Union flag over the Congress Avenue sidewalk. Many Houstonians, however, refused to walk under it. Even prim and proper ladies would rather soil their imported shoes in the thick mud than soil their principles.

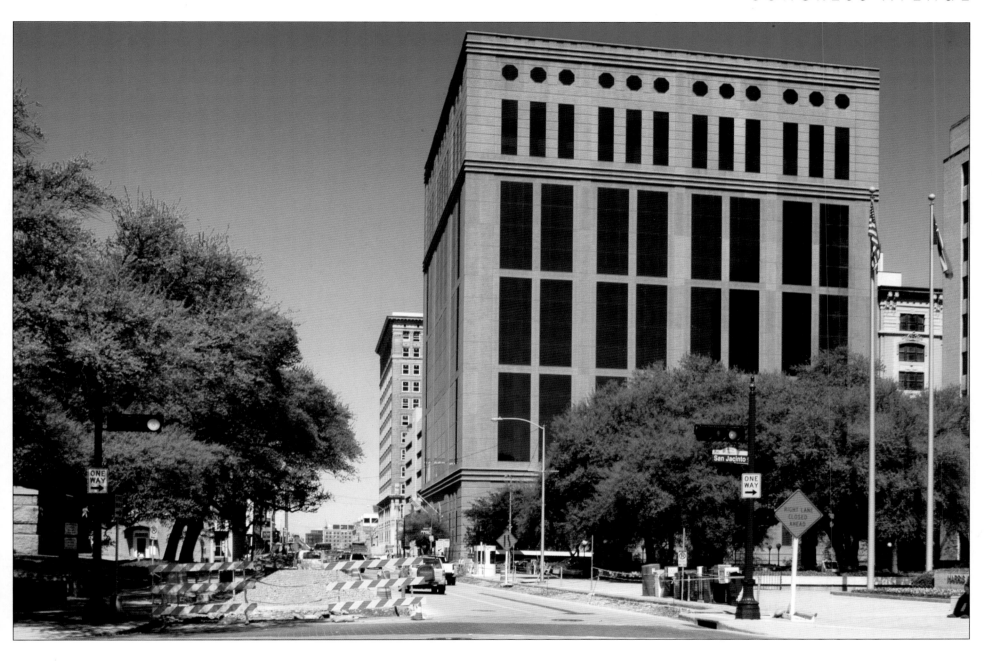

Government administration still holds a high profile around Congress Avenue, though most of the area's buildings are dedicated to regional government. Congress Plaza, shown here on the right, is, among other things, a jury assembly building and law library. Of the building's seventeen stories, thirteen are used for parking. The Federal government still maintains a few interesting historical buildings downtown, including the U.S. Customs House and the Federal Reserve Bank.

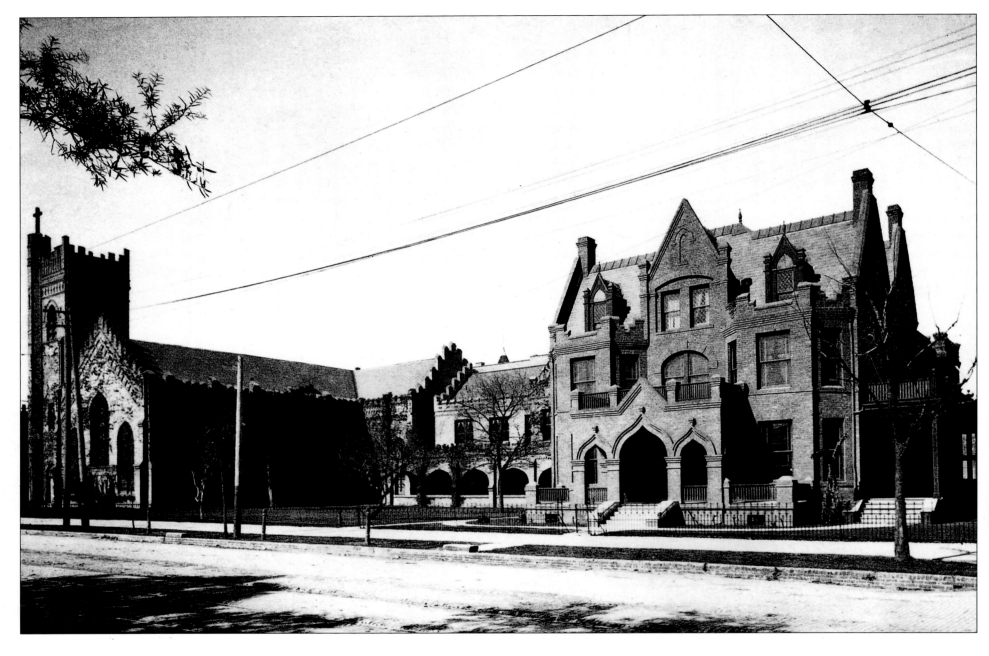

Houston was not known for its piety when Christ Church was built in 1893. The organization behind its Gothic Revival building was established in 1839, claiming Houston's first religious congregation of any kind. Its founders were foreign missionaries, bringing their faith not to the untamed lands of Africa or the South Pacific, but to the unruly Republic of Texas. Many of Houston's founders and early leaders were members.

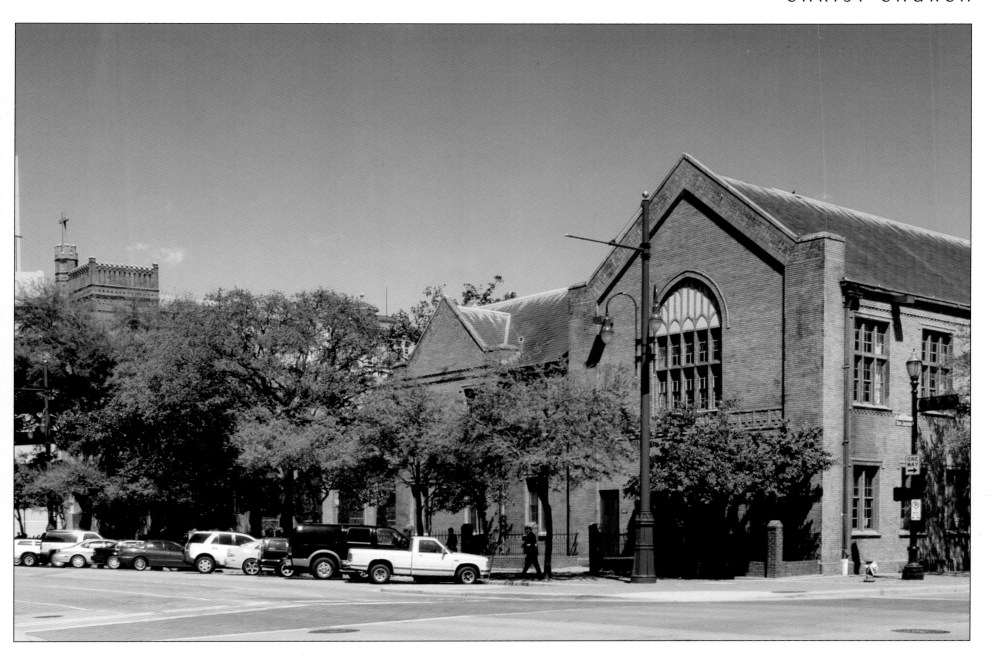

One of the oldest churches still standing downtown, Christ Church is today
a thriving center of worship, learning, and leadership. Despite a tragic fire
in 1938, the building looks virtually the same as it did in the days before
Texas Avenue saw its first horseless carriage. To this day it remains a highly
desirable location for wedding ceremonies.

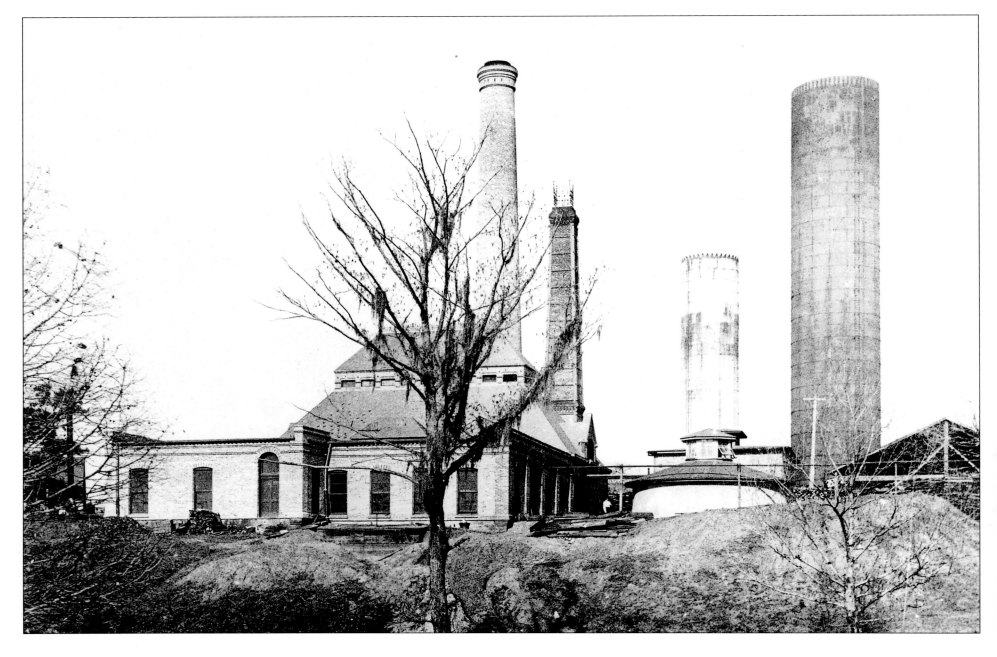

Buffalo Bayou was polluted even before the Civil War began. Houston Water Works, the city's first water facility, was built in 1879 at 27 Artesian Street. New York–owned, it pumped water directly from the then-sickly bayou into the water main. However, in the mid-1880s, recently drilled artesian wells supposedly comprised the plant's primary water source, thus causing the dirty bayou water to be used strictly for industrial purposes such as fire fighting.

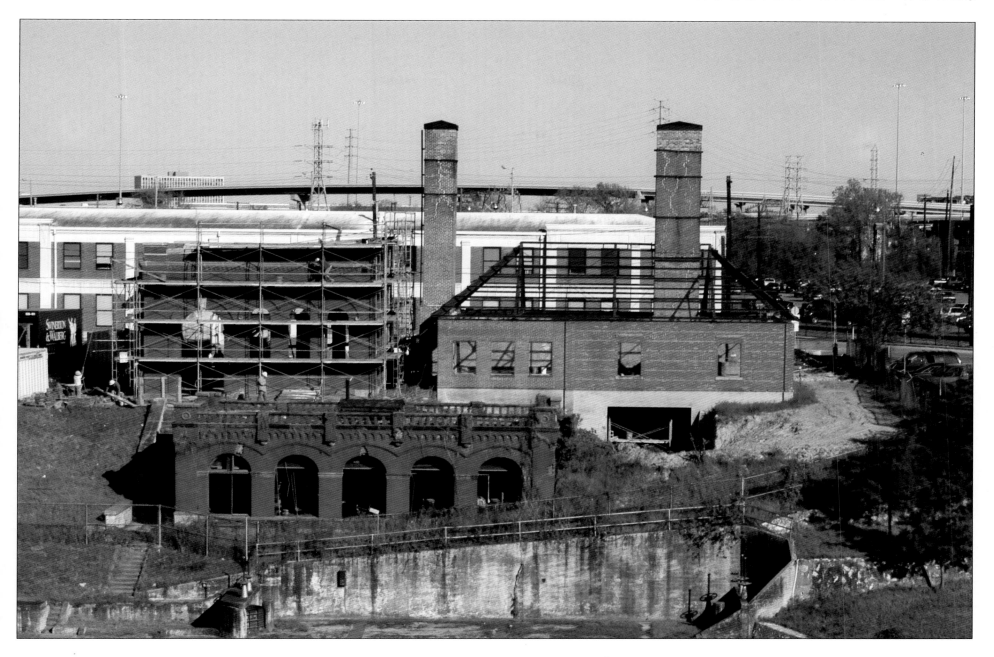

In 1906, a young lady came across a broken water main with some distinctly nonartesian attributes: fish! Showing her findings to city hall in a glass jar, her discovery confirmed a suspicion that the water company was cutting costs at the expense of public health. The mayor quickly prompted a city purchase of the facility. Today Houston consumes 382 million gallons of water daily through the use of 7,000 miles of water lines.

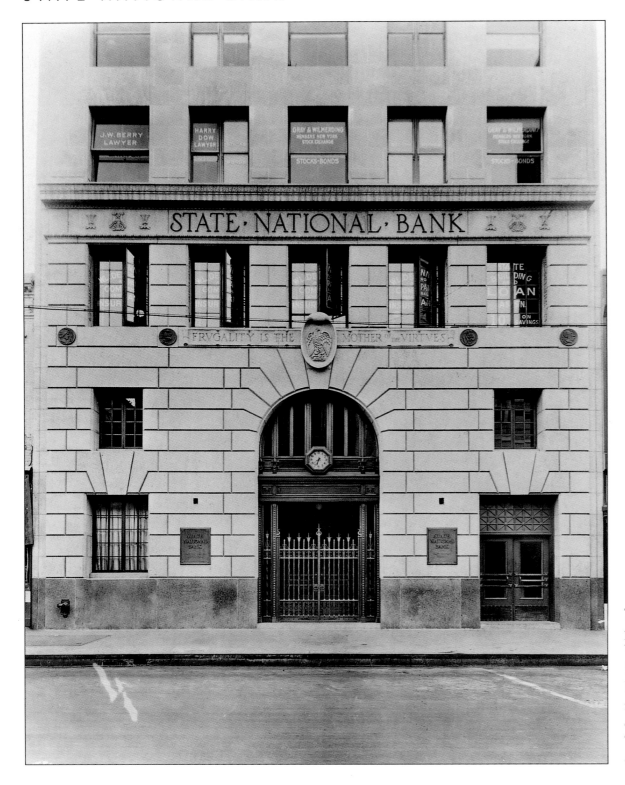

This lanky neoclassical gem was completed in 1924, the product of celebrated Houston architect Alfred C. Finn. When the State Bank and Trust Company started in 1915, it was decisively successful. Soon renamed State National Bank, it captured a huge share of the local market with its nine-to-five banking hours, enabling them to build this decadently expensive structure ($800,000 in 1923 dollars). The rooftop penthouse was designed as a clubhouse, complete with showers.

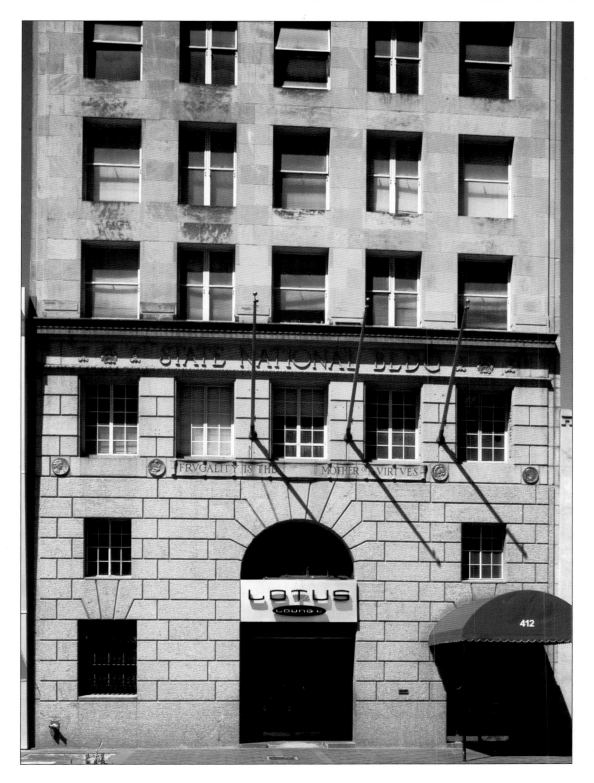

Once wedged between similar neighbors, the building now looks taller than its twelve stories due to its relative isolation. A number of tenants have occupied it, including many lawyers. Today the inscription above the entrance still states, "Frugality is the Mother of the Virtues," while the first floor houses the trendy Lotus Lounge, a popular nightclub.

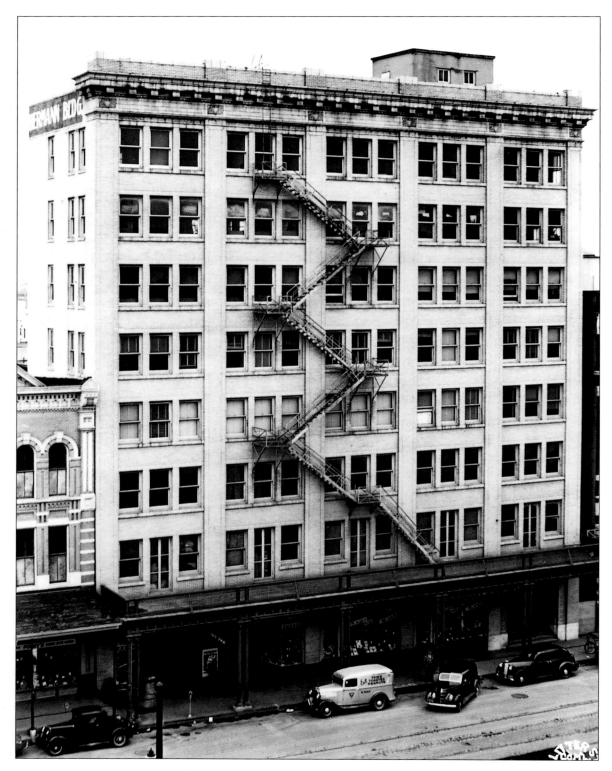

George Hermann fought the urge to spend a nickel as hard as he fought Yankees when he was in the Texas Cavalry. As a result, he became a self-made millionaire. It was no surprise when his keen capitalist eye noticed the cramped quarters and fat pockets of the bustling Cotton Exchange on Travis Street. He quickly built this eight-story office in 1917 to help the cotton merchants spread out—and spread their wealth.

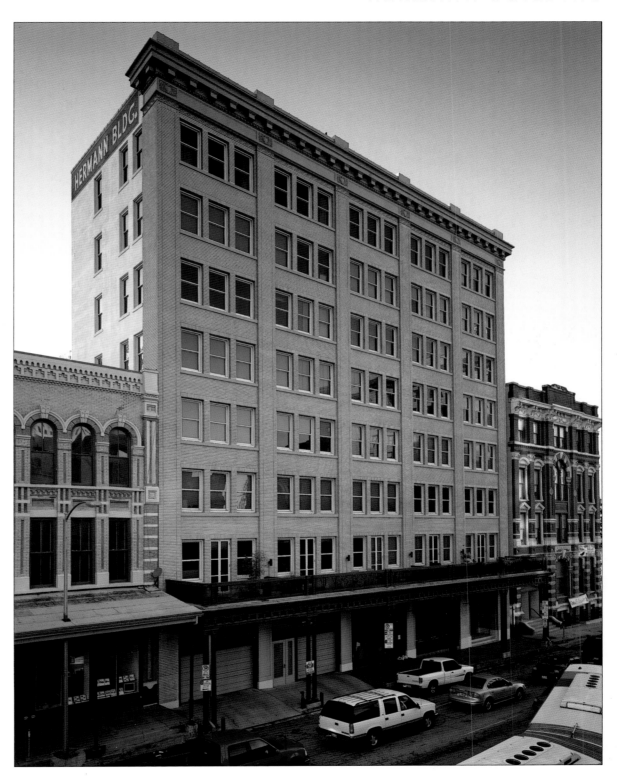

In 1924, the old Cotton Exchange was abandoned for its roomier, more modern successor. The Hermann Building's occupants bailed, leaving hardly enough tenants to keep the building profitable. In World War II the Selective Service rented several floors. Its popularity surged and waned with professionals and the building eventually fell into disrepair. Later, the Salvation Army used it for a shelter and soup kitchen. Restored in the 1990s, it's now an attractive loft.

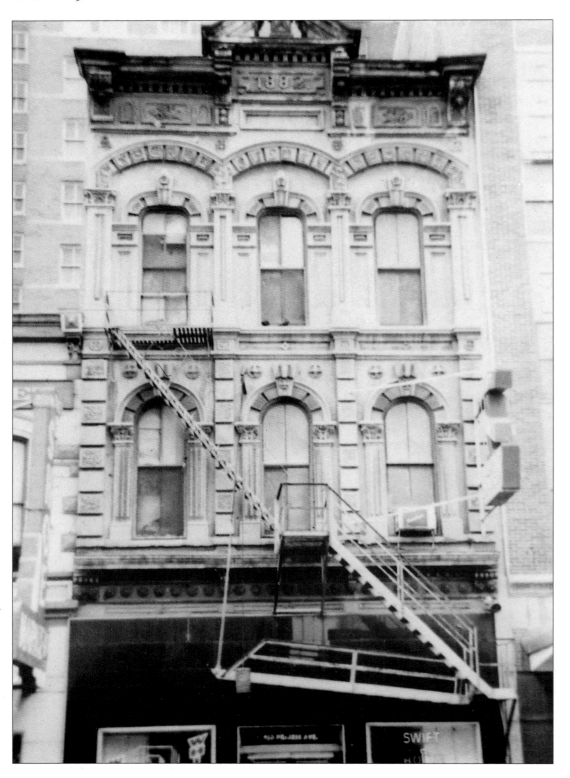

The Henry Brashear Building was built in 1882 on Prairie Avenue, between Main and Travis Streets. It was designed by the same architect who conjured up the old Cotton Exchange building. Its progenitor and namesake, Henry Brashear, was a politician and banker who bought it as an investment. Businessmen lusted over its prime location. As was common in its day, the floors above the ground retail space were used for apartments.

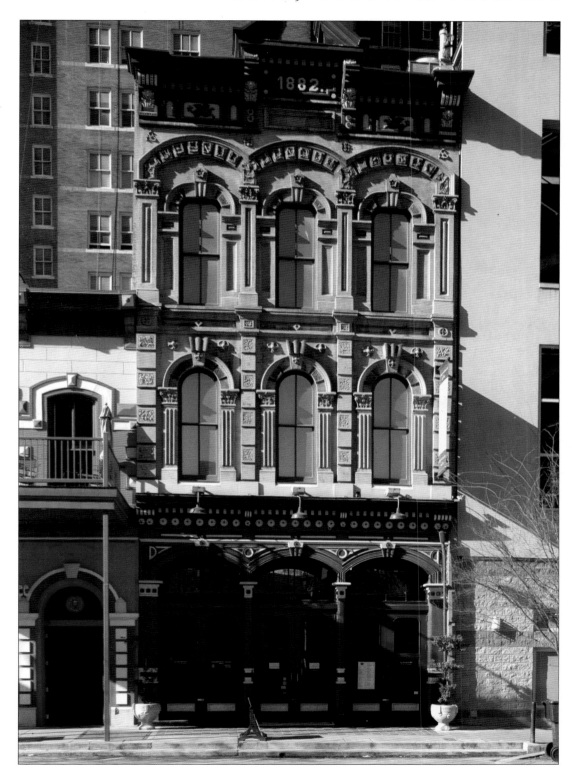

Today the Brashear Building is one of downtown's most charming, even though it vies for attention with its higher-profile neighbors on all sides. It's been used for a number of businesses, including Gorman's Jewelers, which specialized in the now romantic railroad watch. It currently houses Solero, a hip but casual tapas restaurant widely renowned as one of the area's top eateries. Replete with an upstairs lounge, the restaurant's menu is as satisfying as its history.

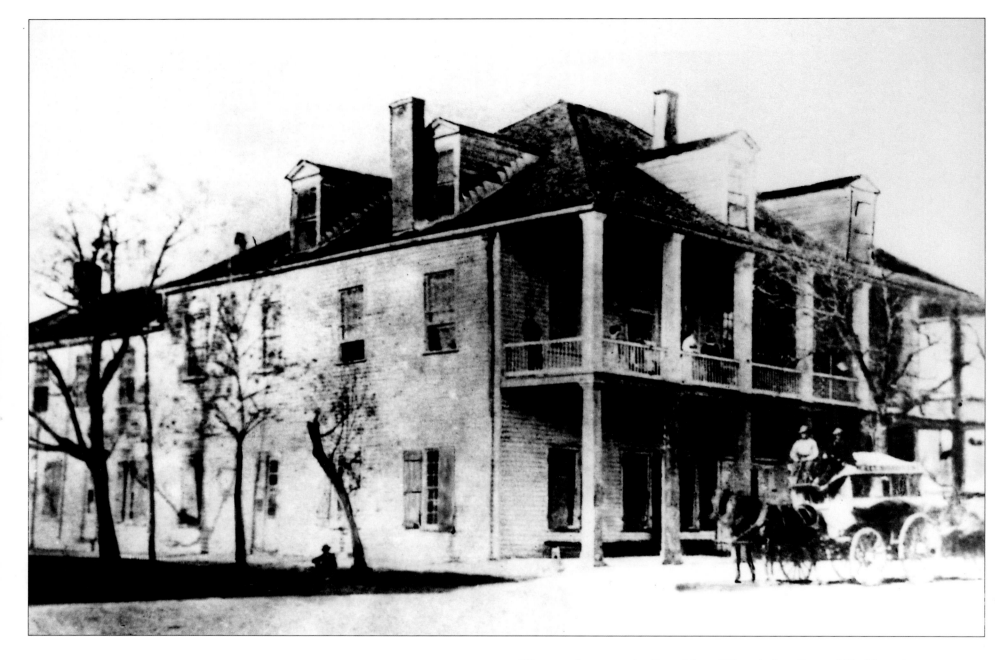

This was home to the Republic of Texas's first Capitol Building from 1837–39. After its service as the Capitol, the building housed a series of popular hotels. Demolished in 1881, it was replaced by the Capitol Hotel. The Capitol was popular, but was razed to make room for the Rice Hotel. After opening in 1913, the Rice was arguably the most exciting place in town until its closure in the mid-1970s.

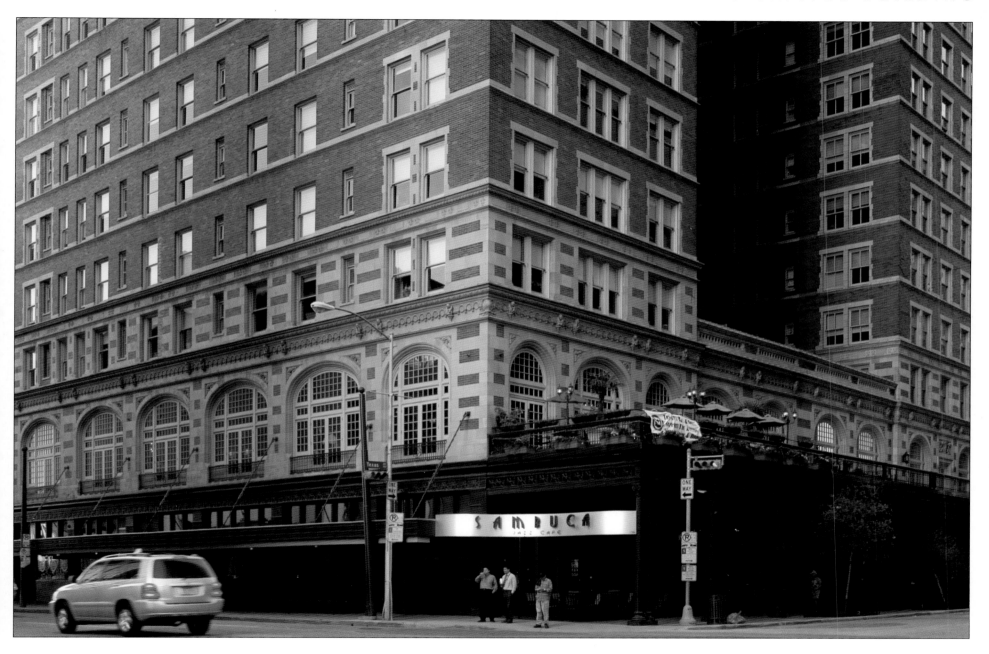

Everyone from John F. Kennedy to Houston's business elite ate, slept, and drank at the Rice. Neglect was unacceptable. In 1998, it was renovated for $27.5 million and converted into luxury apartments. Among countless other amenities, its residents enjoy a sumptuous, 7,000-square-foot dance hall. It also sits on 25,000 square feet of retail space, occupied by businesses such as the State Bar and the Sambuca Jazz Café.

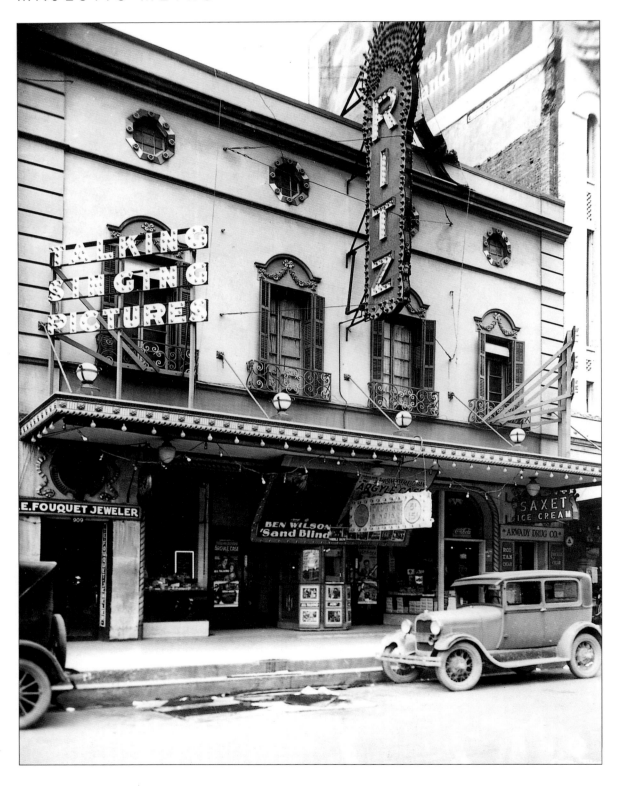

Originally known as the Ritz Theater, this lovely showplace was one of several downtown theaters offering Houstonians a diversion from the daily grind. Completed in 1926, its grand opening featured Miss Le Moyne Veglee, promoted as a "Dare Devil Girl Movie Performer." Admission was 15 cents for one adult. For decades, the Ritz Theater was modestly promoted and provided casual, low-key shows to countless Houstonians.

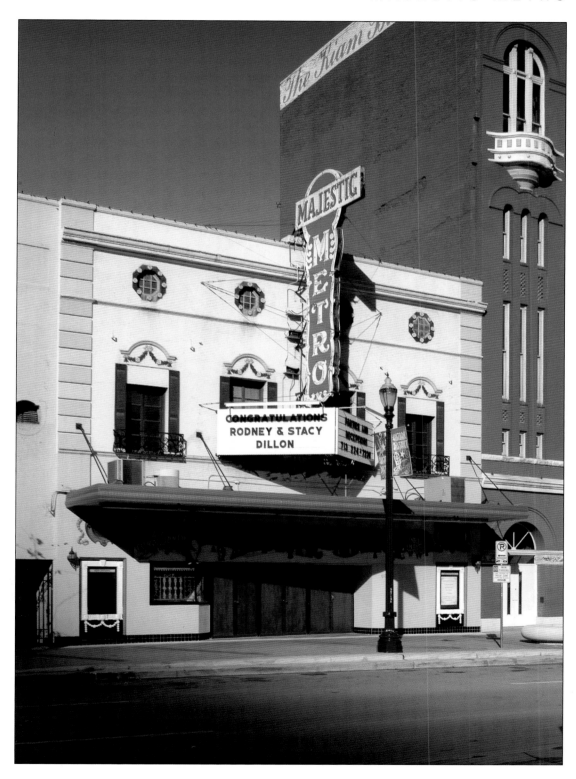

While it wasn't the grandest of Houston's early cinema gems, it is one of the few of its kind to dodge the wrecking ball. The Metropolitan, Majestic, and Loews theaters, all more famous and upscale in both buildings and billings, were razed by 1970. Known as the Majestic Metro today, it serves as a fashionable entertainment hall. It is highly sought after for wedding receptions and corporate affairs.

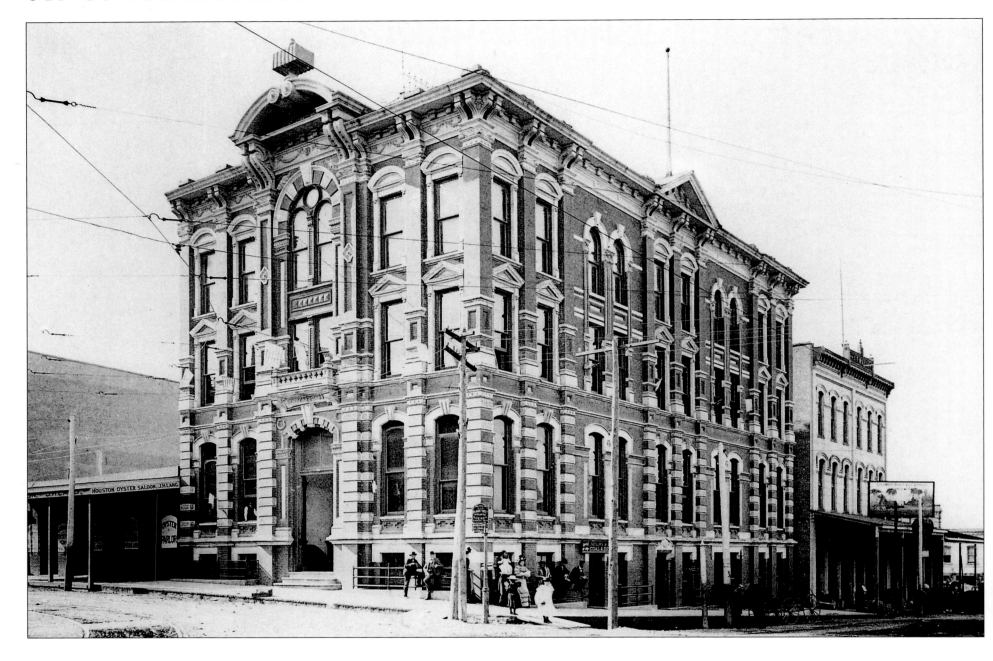

Oil put Houston on the map, but cotton was the main source of income for its earliest citizens. Houston was a prime spot for buyers and sellers of this global commodity, and the Houston Cotton Exchange at Travis and Franklin was where its fortunes were harvested. Built in 1884 by Eugene T. Heiner, the red Philadelphia brick building sported a crowned bale of cotton above the entrance—a reminder that cotton was king.

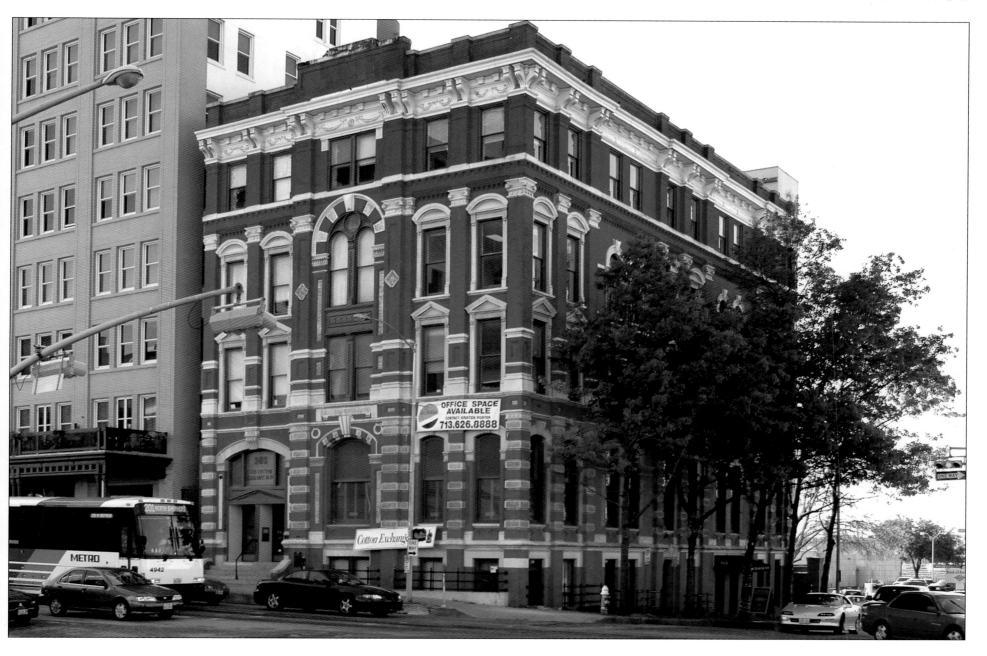

In 1922, the Houston Cotton Exchange outgrew Heiner's structure and moved into a sixteen-story building at Prairie and Caroline. The old Cotton Exchange is now chic commercial real estate for a variety of tenants, from a law firm to a writers' group and a nightclub. The angels carved into its facade reportedly represent Heiner's four daughters.

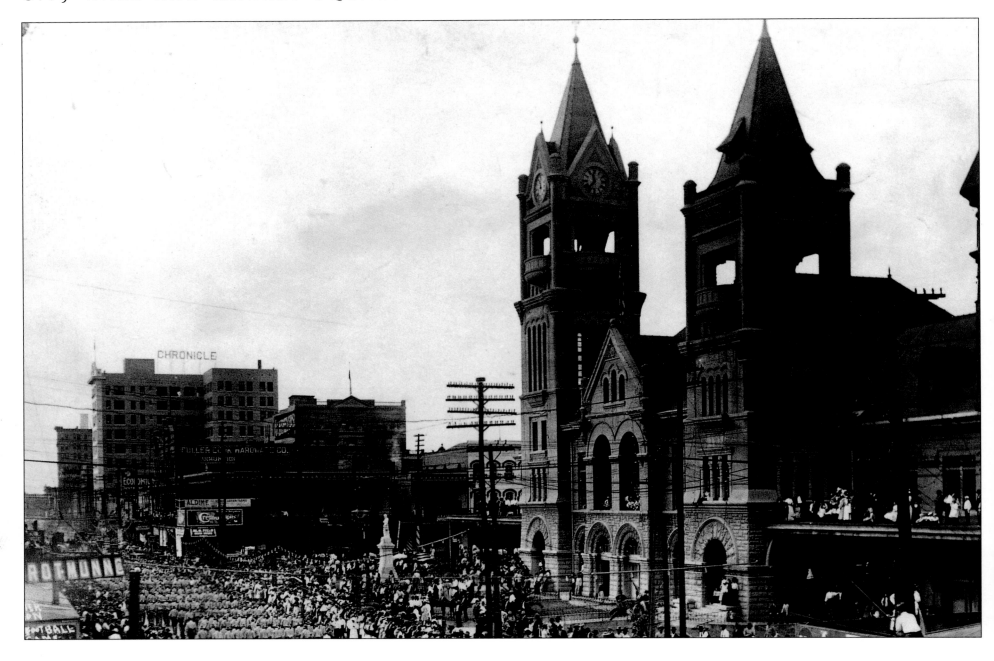

The striking City Hall and Market Square complex, a popular destination, was completed in 1904. Fish markets, vegetable stands, and butchers sold their goods right next to the hub of city management. The statue in front was of Confederate hero Dick Dowling, but the crowd seen marching in the square consists of Texas A&M cadets in town for a football game against their archrival, the University of Texas.

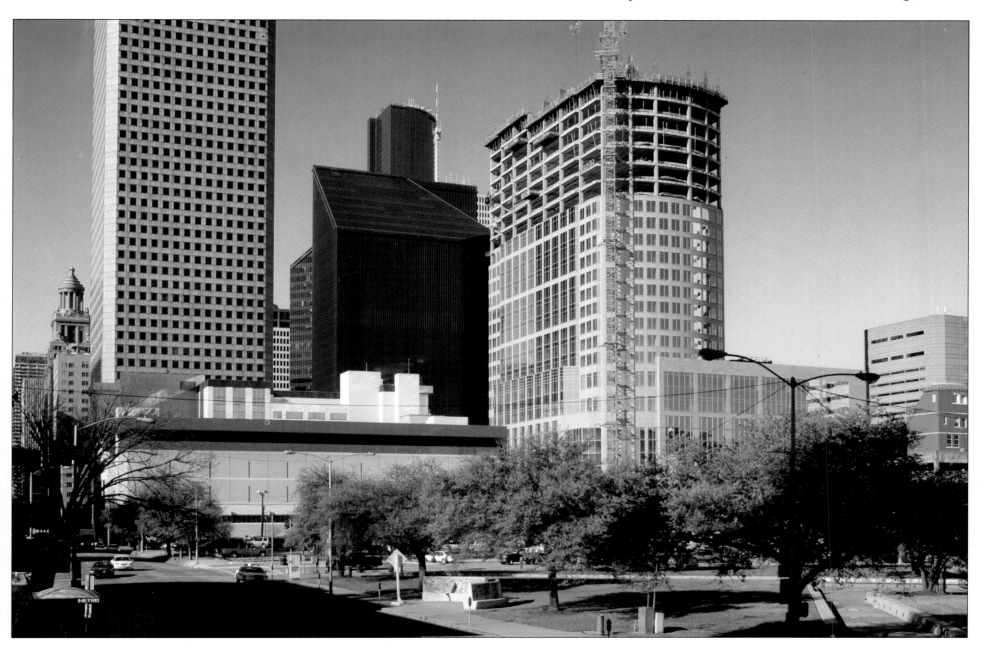

When the new City Hall was built in 1939, the 1904 City Hall was converted into a bus terminal for Market Square shoppers. After a fire in 1960, the whole complex was razed. Today Market Square is a park. The 1909 football game was won by Texas A&M, but Houstonians still enjoy razzing each other about the rivalries between the University of Texas, Texas A&M, and their new mutual enemy, Texas Tech.

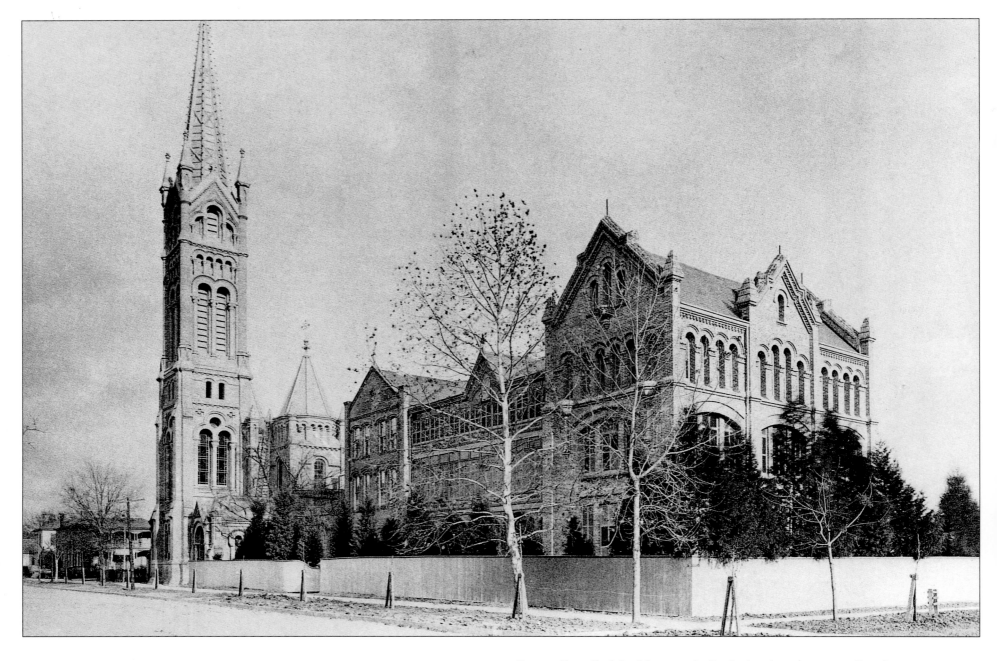

Originally called St. Vincent de Paul, the Annunciation Parish was Houston's first Catholic congregation. Its founders were sent from France to restore the area's faith in Catholicism in the aftermath of the Texas Revolution. The building was built in 1869 from plans drawn up in France, and its foundation was made from bricks salvaged from the old Harris County Courthouse. The tower was added in 1884.

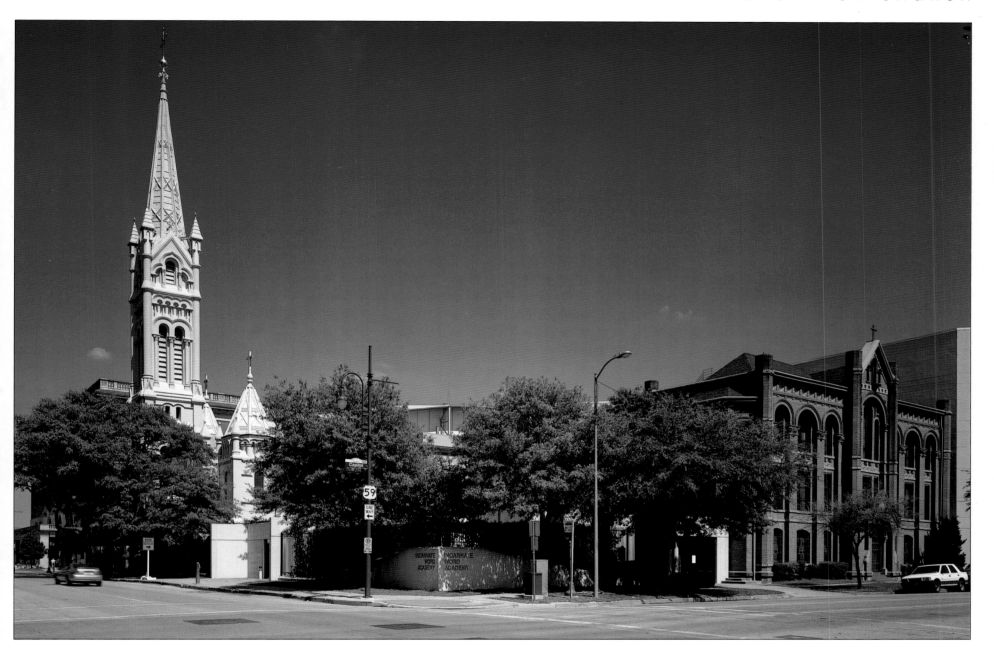

The church's 175-foot tower was knocked down in the disastrous hurricane that struck the area in 1900. Quickly rebuilt, it has been a spiritual symbol for Houstonians throughout the city's existence. Its masses have delivered comfort and service to the community, even as the neighborhood has grown into a labyrinth of glass and concrete (Minute Maid Park peeks over the top). Today, 18 percent of Houstonians embrace Catholicism.

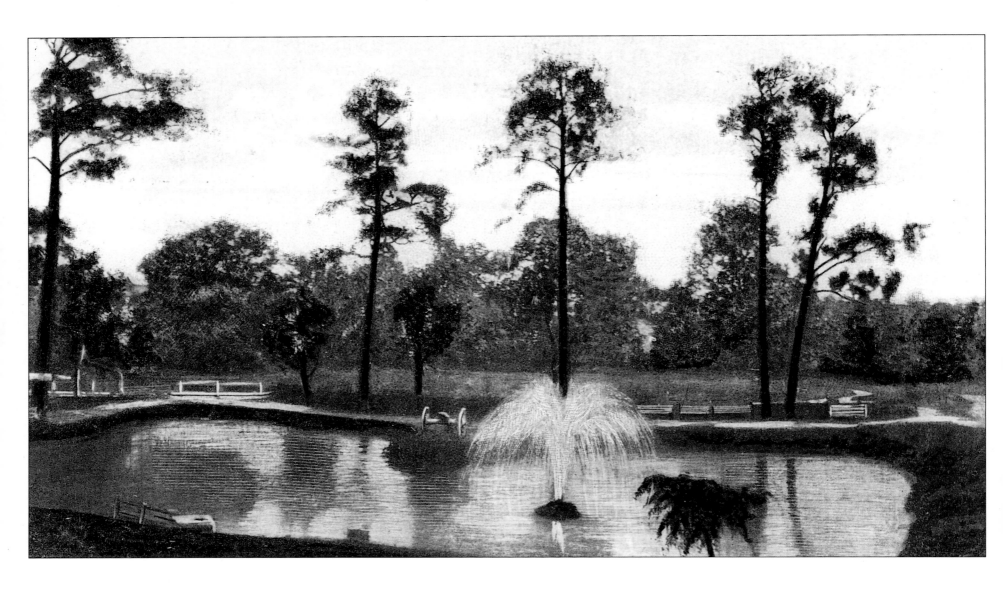

The city's first major park opened in 1899 when Mayor Sam Brashear bought the Kellum-Noble house and surrounding property to create what is now Sam Houston Park. The endeavor was taken seriously and the park was adorned with lavish landscaping, walkways, a rustic bridge, and a fountain. Brashear's intention was that it "remind Houstonians of the days when Texas had a president instead of a governor, a congress instead of a legislature."

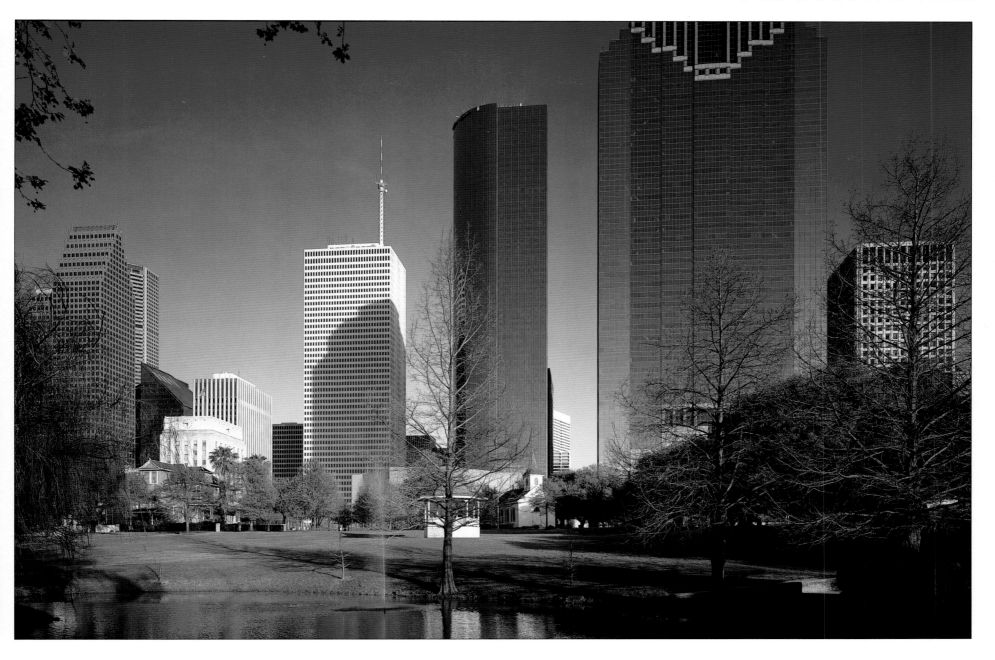

Progress threatened both the park and Kellum-Noble House. But a group
of prominent Houstonians made an effort to save them. Today the park
is more pleasant than ever, showcasing the city's history across a backdrop
of urban modernity. Visitors enjoy eight historic Houston structures, the
Museum of Houston Heritage, a tearoom, and a plaza, as well as ample park
space. Downtown dwellers love losing themselves in its tranquil terrain.

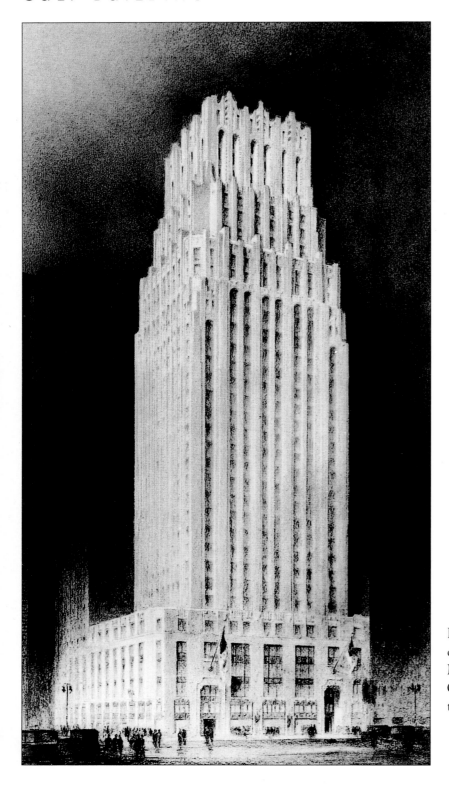

Designed by renowned architect Alfred C. Finn, the Gulf Building at Main and Rusk is one of the finest Art Deco skyscrapers in the Southwest. The site was once the home of Mrs. Charlotte Allen, the "Mother of Houston," wife of Houston founder Augustus Chapman Allen. The corporate headquarters of Gulf Oil, it reportedly cost $3.5 million to build. When completed, it was the tallest building west of the Mississippi.

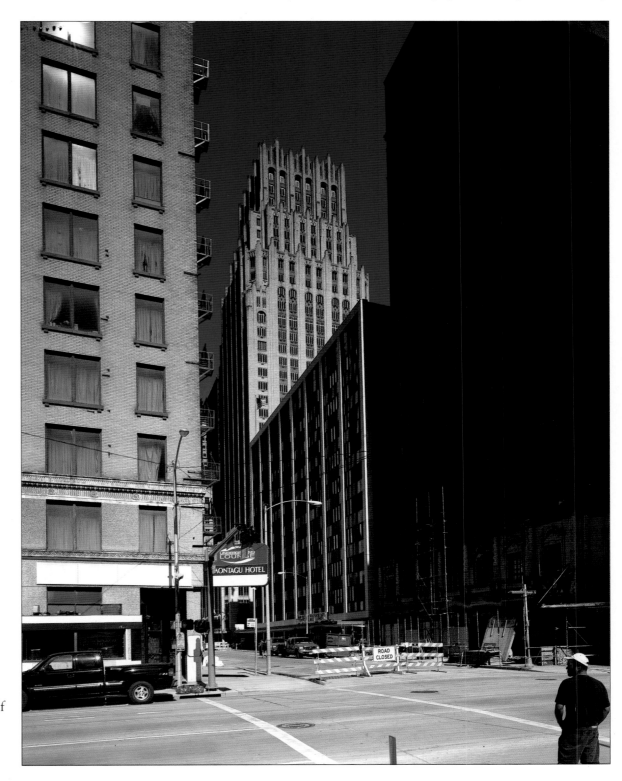

Listed in the National Register of Historic Places, the Gulf Building no longer soars above the skyline, but its grandeur remains. A number of interesting elements have been added over the years, including two annexes, an industrial-grade telescope, a heliport, and a fifty-foot "Gulf lollipop" neon logo (no longer extant, much to the relief of many). Now known as the J. P. Morgan Chase Bank Building, it's a brilliant, elegant sight at night.

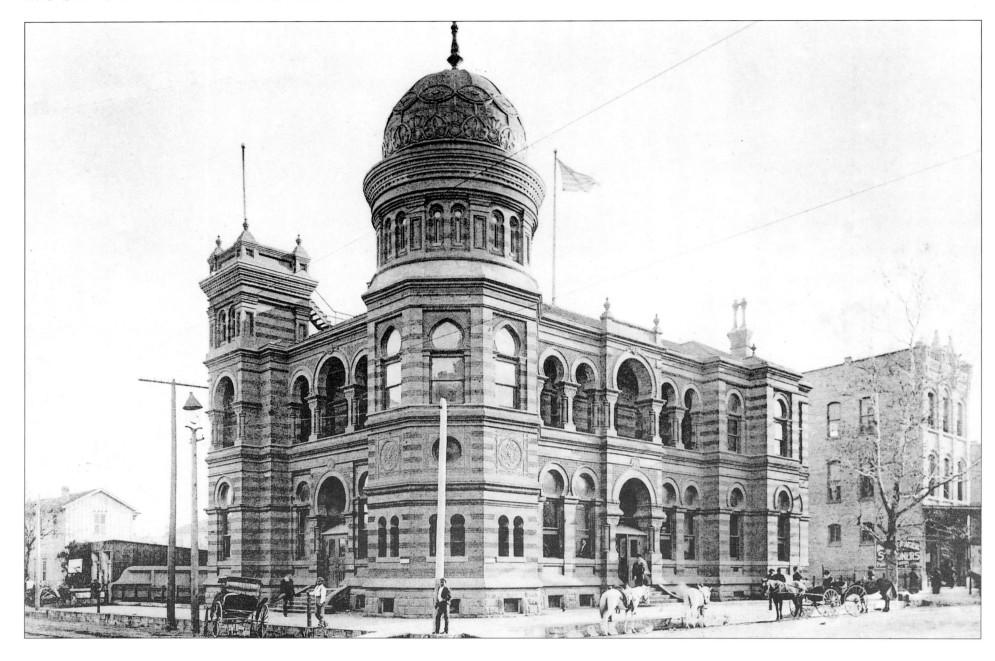

Completed in 1889, U.S. Treasury Department architects designed the Moorish Federal Building, which housed a post office and federal courthouse, at Fannin and Franklin. Houstonians didn't really know what to make of it. Its designers—who were not from Houston—assumed it would be appropriate for the local climate. Many rolled their eyes at this Northern arrogance, though some thought it attractive and exotic—perhaps maybe a bit too exotic for such a mundane purpose.

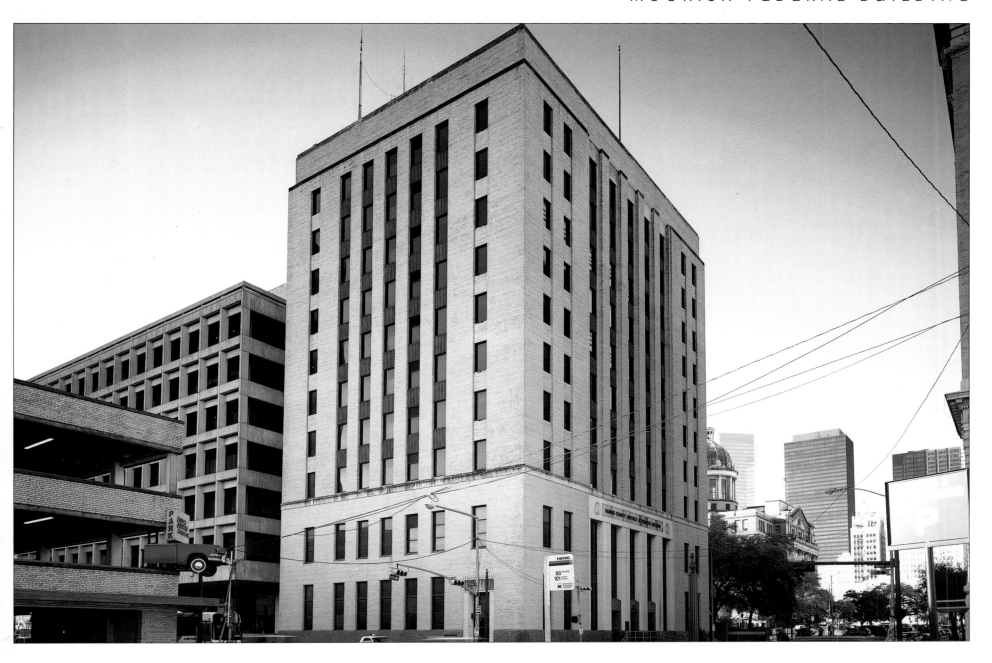

While yesterday's architects may have overstated the association between palm trees and Moorish architecture, today's Houstonians would have cherished this distinctive structure. Though eventually razed, the site—next to the 1904 capitol—is still used for government administration. Today it is occupied by the Harris County District Attorney's office.

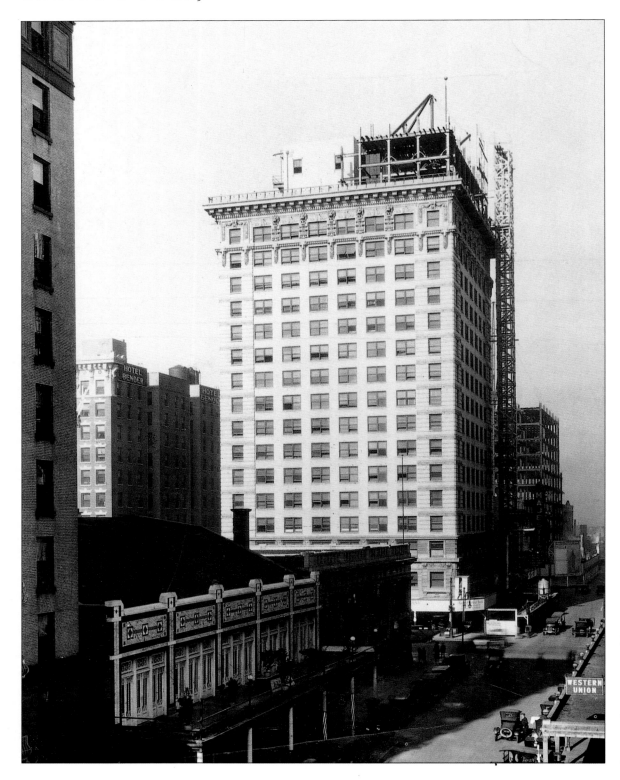

Alabama-born Samuel Fain Carter was a self-made lumber king who worked hard and dreamed big. His vast lumber interests led him to organize what would become the Second National Bank. People mocked him when he announced plans for its sixteen-story building. The building came to be known as "Carter's Folly," because in 1910 the consensus was that bricks could not be stacked that high.

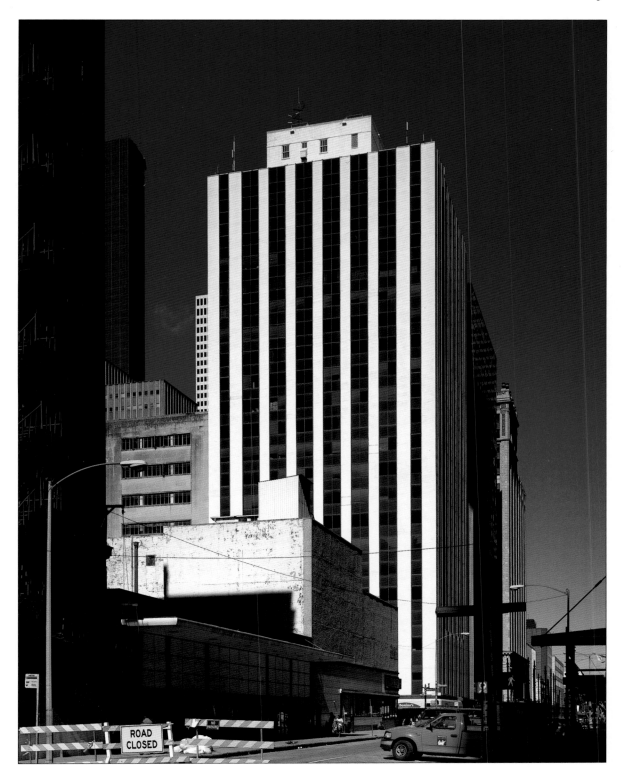

When finished, Carter's building not only stood—it stood proud. Every floor was adorned with handsome marble and it had every conceivable modern convenience, from electric fans to cold water fountains fed by the artesian well in the basement. Jesse H. Jones, not to be outdone, quickly expanded the Rice Hotel to seventeen stories. Six stories were added to Carter's Folly in the 1920s; the building is now completely remodeled.

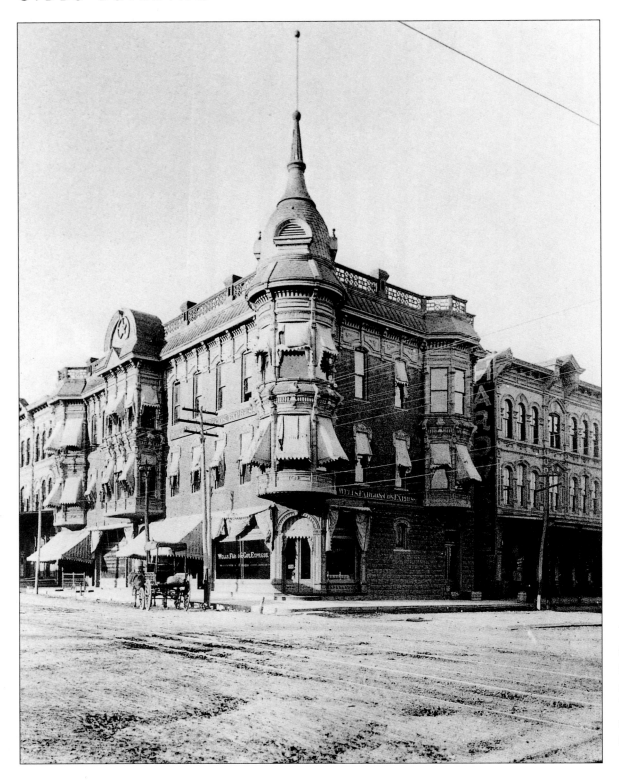

This gorgeous Victorian office at Franklin and Fannin, shown here in the 1890s, had a number of prestigious tenants, including Wells Fargo and Company, which was more about mail drops than savings accounts at the time. Their upstairs neighbor, Baker, Botts, and Baker, were attorneys for a number of railroad interests, including the Southern Pacific, whose office was across the street.

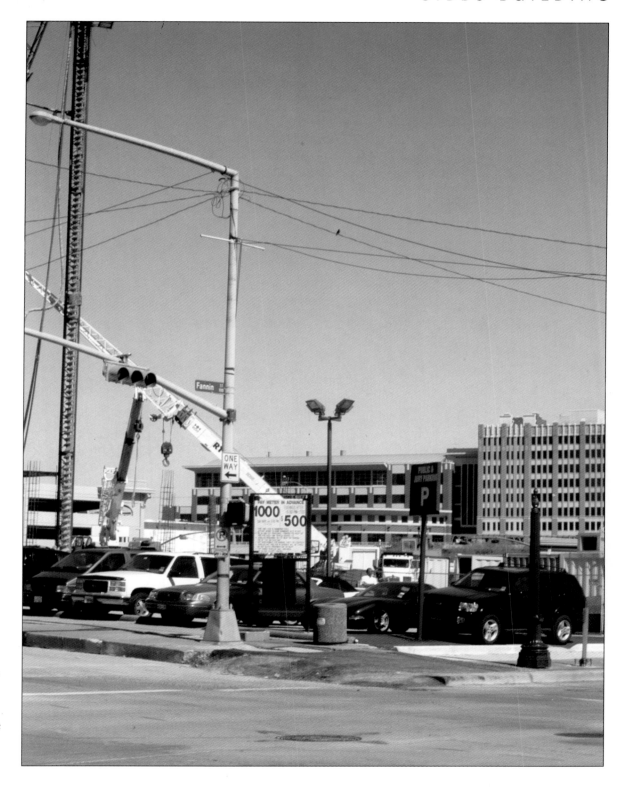

The Gibbs Building far outlived the Moorish Federal Building, which stood across from it, surviving until the 1950s when it was condemned by the city and demolished. The Merchants and Mercantile Building now dominates the street corner view of the site, which now serves as a parking lot. The site's proximity to Courthouse Square, the Theater District, and other downtown hot spots make it a highly desirable piece of real estate.

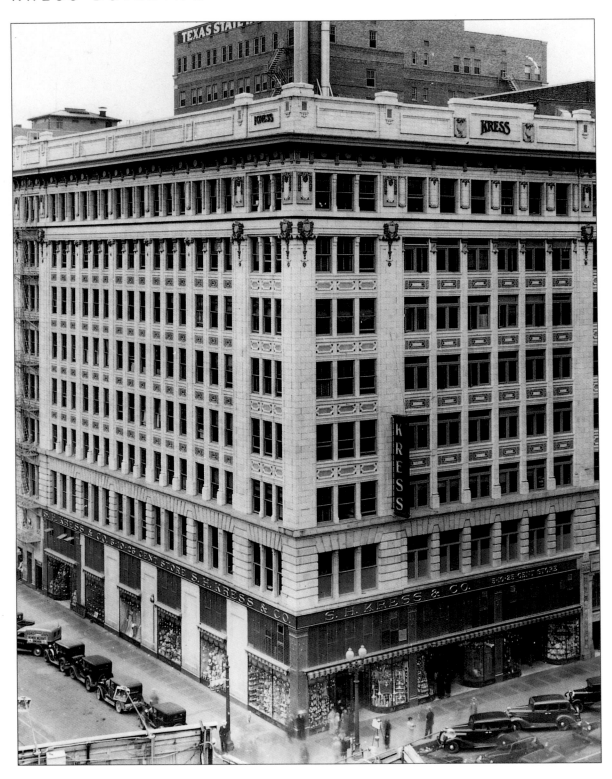

S. H. Kress & Co. was a chain of five-and-dime stores that proliferated standardized, stylish storefronts in downtowns across America. The company had their own in-house architectural staff. More than just places to purchase soap or cigars, they were designed to be social places as well. Their slogan at one time was "Meet Your Friends at Kress." The soda fountain and candy counter were among the store's main attractions.

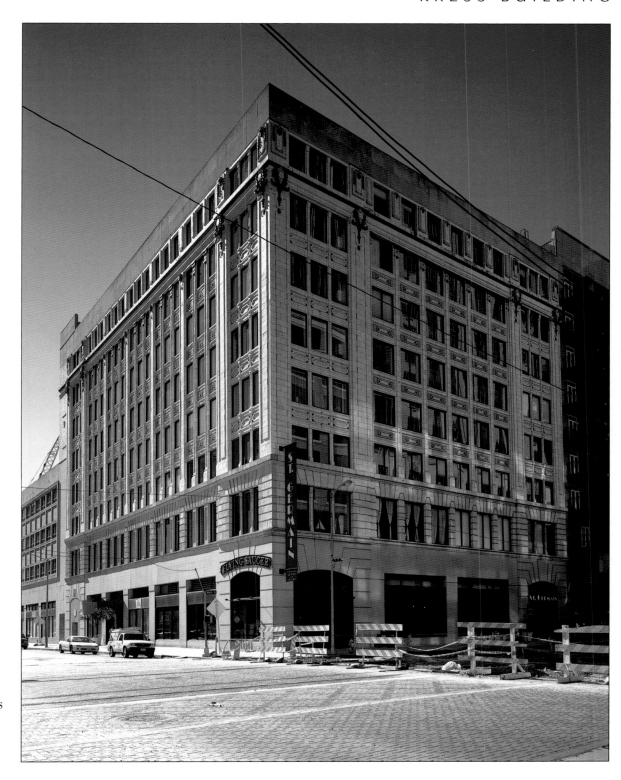

Today the building houses the St. Germain Lofts, beautifully remodeled lofts and flats. Tenants enjoy a rooftop deck, billiard parlor, theater room, and other urban luxuries. Downstairs, the Flying Saucer offers a relaxing atmosphere where one can enjoy the finest drinks and cigars. Also downstairs is Zulu, an outstanding and elegant modern American restaurant whose handpicked wine selection is reason enough to reside there.

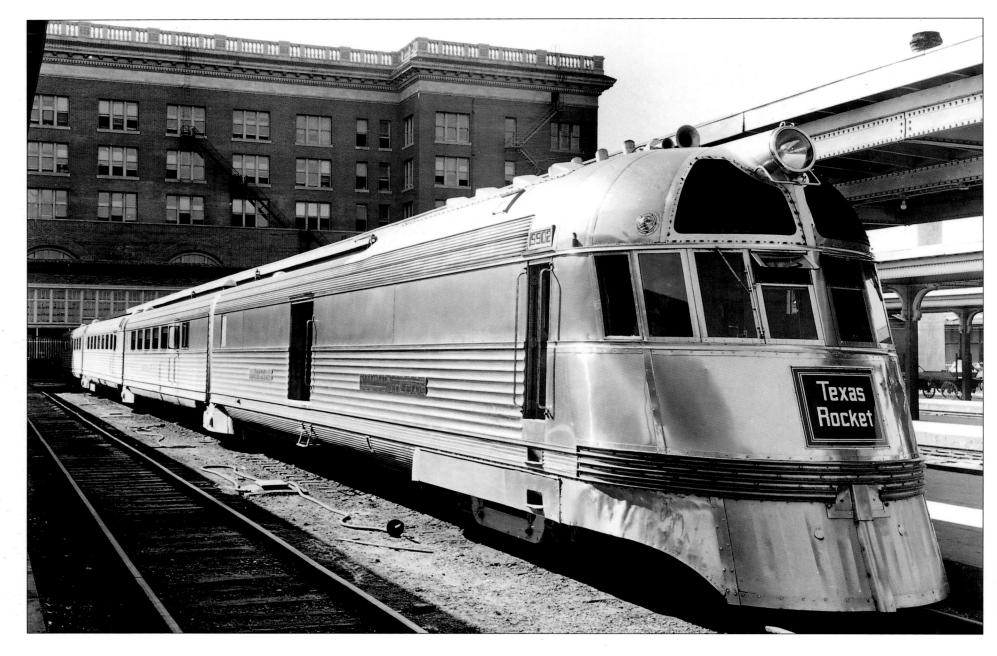

Designed by the architect of New York's Grand Central Station, Union Station was spinning with footsteps, train whistles, and hurried handshakes at the turn of the century. When finished in 1911, it was the largest in the Southwest. The Texas Rocket, owned by the Burlington–Rock Island Railroad, ran between Dallas and Houston in the late 1930s. Its counterpart, the Sam Houston Zephyr, also shuttled passengers between the two cities.

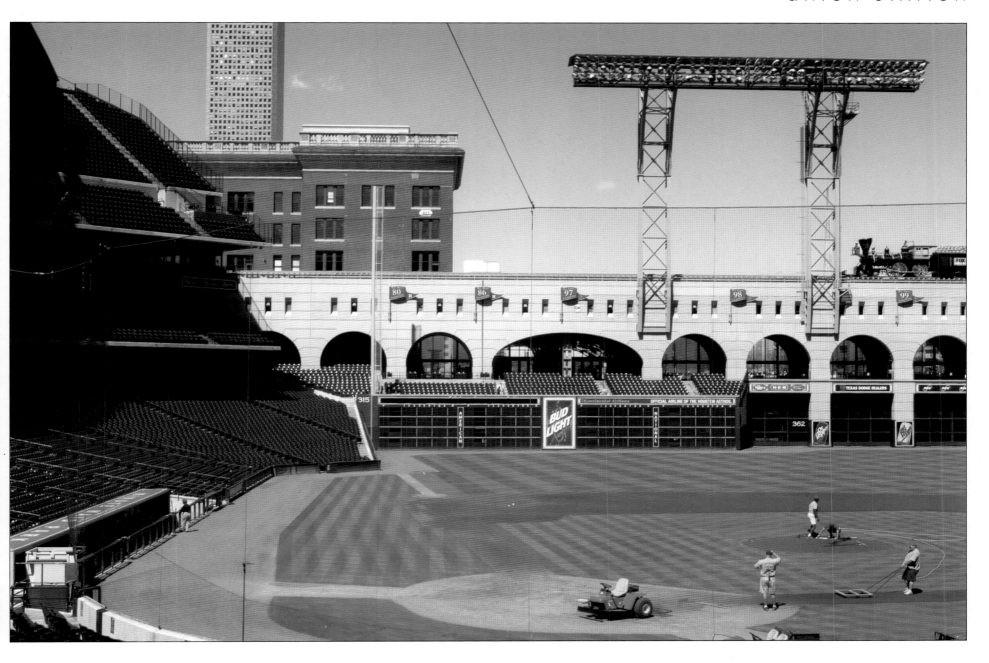

Today the only rockets at Union Station come from the pitching mound. Though the site's history as a major depot is still evident and celebrated, it's now the entrance to Minute Maid Park—home of the Houston Astros. The stadium seats over 40,000 under a retractable roof. Dilapidated in its later years as a train station, it regained celebrity status when it hosted its first game, an exhibition between the Astros and the New York Yankees, on March 30, 2000.

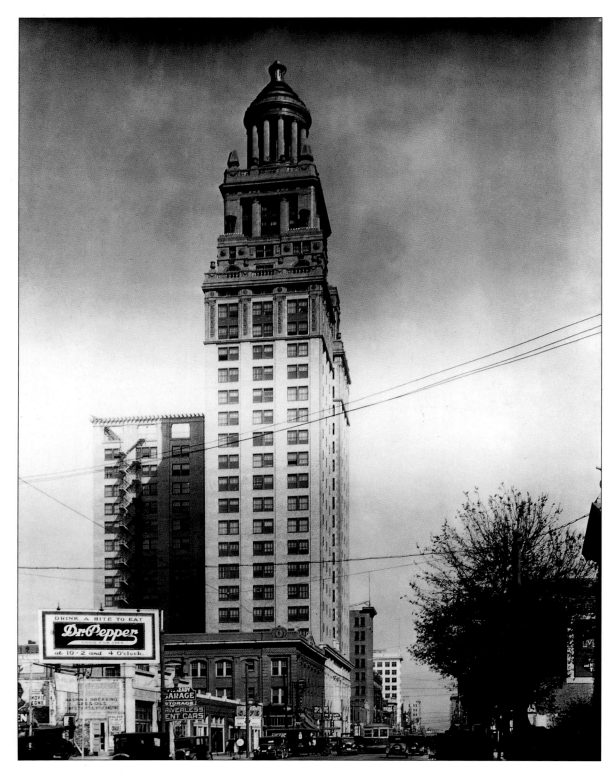

Niels Esperson was born in Denmark, eventually migrating to Houston with hopes of striking "black gold"—and he did. The Humble oil field made him millions, which he quickly diversified into a number of ventures. Esperson dreamed of building a skyscraper at Travis and Rusk, but died in 1922 before he could follow through. His widow, Mellie, built it for him in 1927, naming the beautifully ornamented skyscraper in his honor.

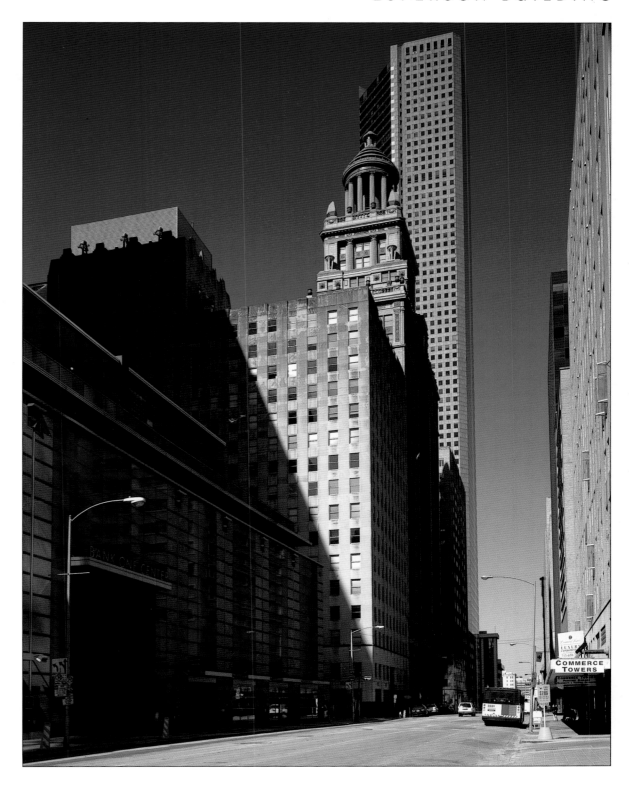

In 1928, Mellie Esperson sold the building with the condition that its name would not change. The buyer eventually defaulted on the mortgage and she bought it back for 75 percent of what it had cost her to build. In 1941, she completed the Mellie Esperson Building next to (but shorter than) her husband's. The Niels Esperson Building's detail and six-story Grecian top make it one of Houston's most beloved.

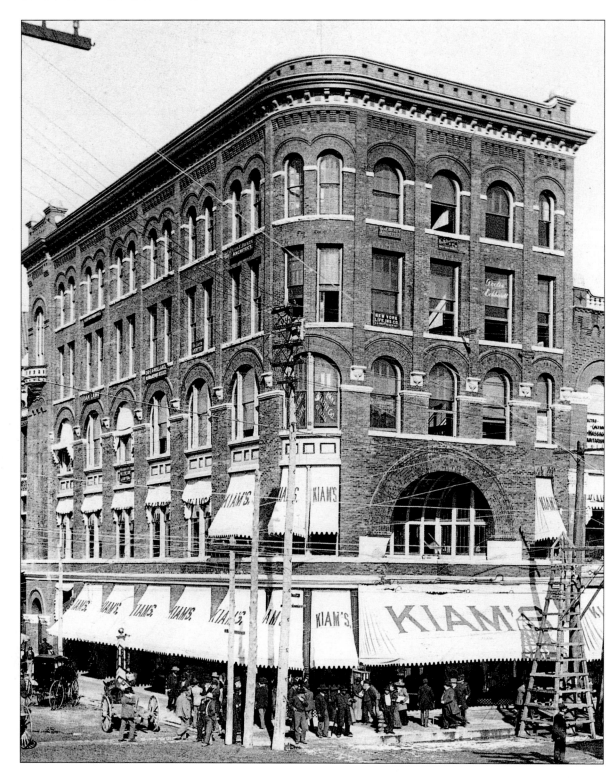

The Kiam Building, which housed Houston's finest clothier when it opened, is the city's only extant example of Richardsonian Romanesque architecture. It was completed in 1893 and was used for offices and retail space. Over 15,000 people attended the opening, which featured giveaways and a concert. Advertisements boasted: "5,000 square feet of counter space in the best lighted store in America." The building's architects were upstairs tenants.

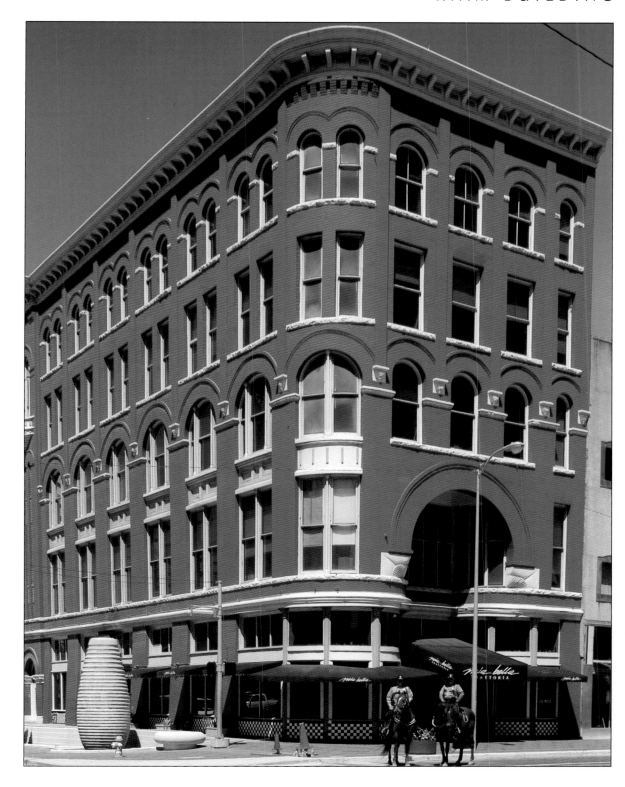

Alexander Kiam, the last of his family to manage the store, died in 1915 and in two years the once-grand venture was bankrupt. The Sakowitz department store bought the building and occupied it until moving into the Gulf Building in 1928. Today it houses Mia Bella Trattoria, a popular Italian restaurant. In this view, Houston's finest are seen keeping the streets safe and enjoyable for visitors and residents in the 1,178-acre downtown district.

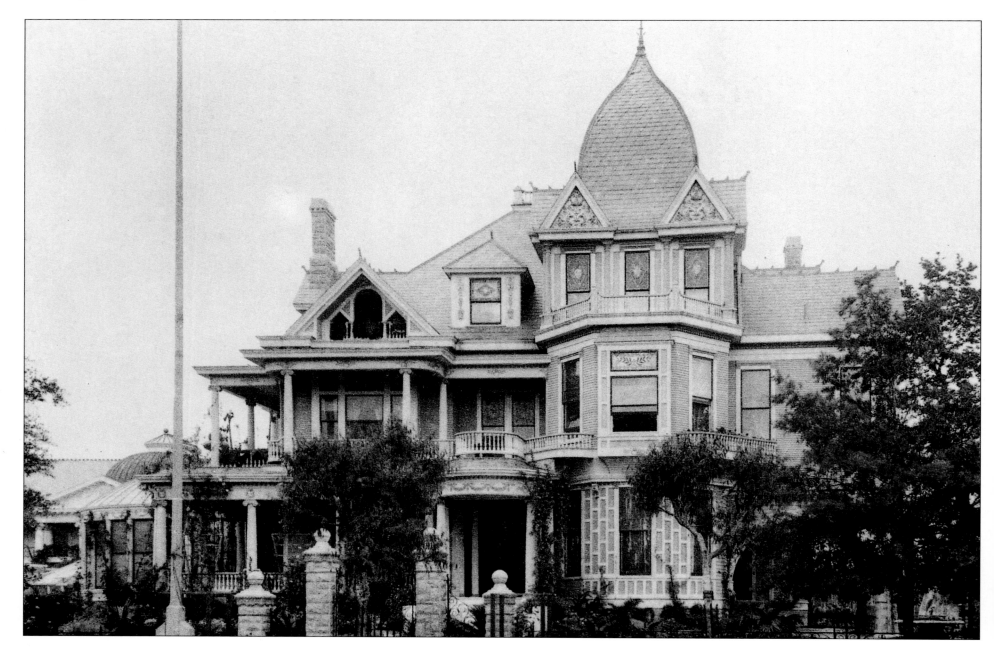

Despite the lack of a formal education, John Henry Kirby would eventually retire from a career in law to form the Kirby Lumber Company. At one time it had an estimated 1.5 million acres of timberland (and potential oil wealth). Too superstitious to tear down the modest Victorian home that was on the land they bought at Pierce and Smith Streets in 1897, they turned it into a thirty-six-room mansion.

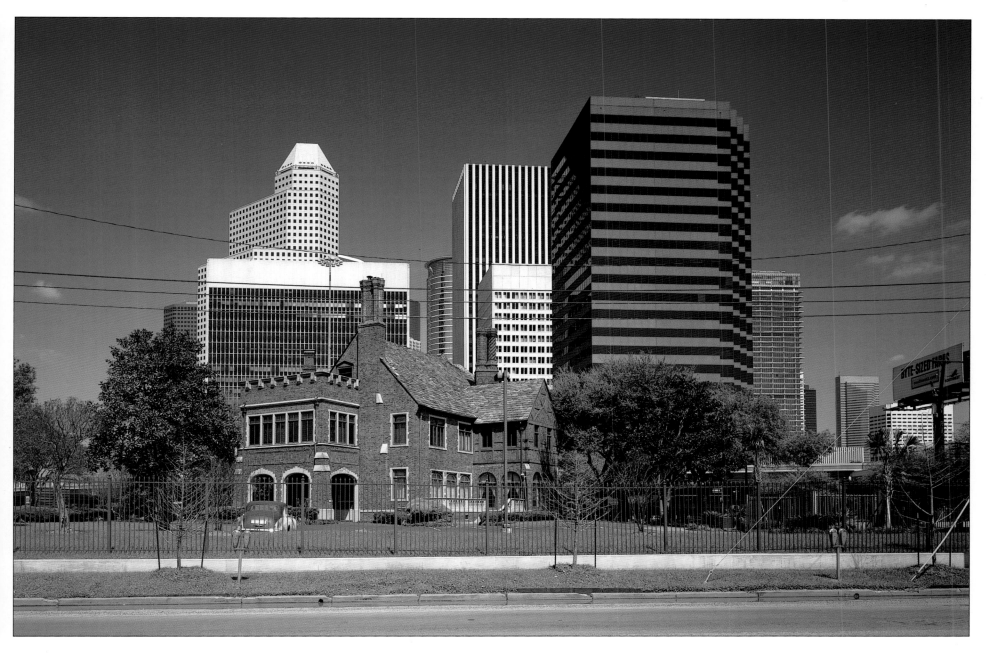

A major renovation—some called it a rebuilding—in 1926 gave the mansion its current old English look. Kirby's wife, Lelia, sold it when her husband died in 1940. After a short occupation by the Red Cross, the mansion became the offices of Gulf States Oil and Refinery Company (now Chevron) in 1978. It's one of the few old downtown mansions still standing. The Kirby Corporation also survives and is now the nation's largest inland marine barge operator.

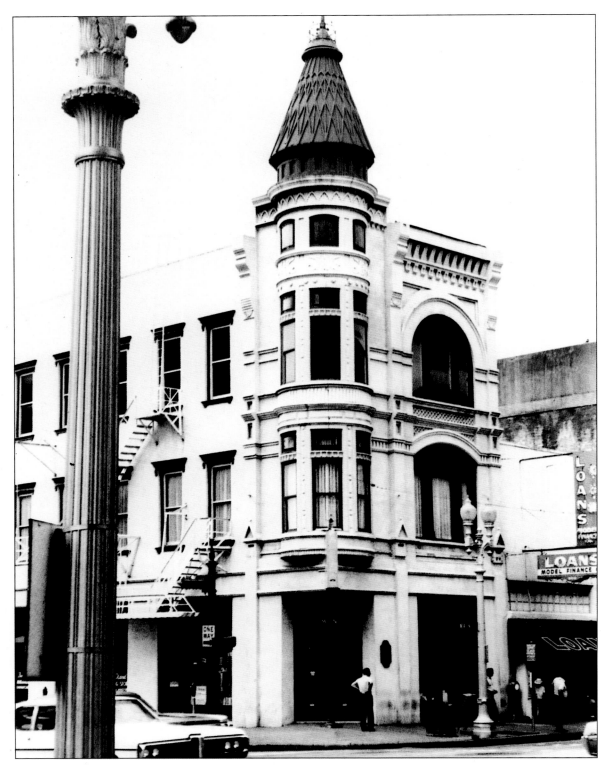

Originally the site of the Van Alstyne Building, the Sweeney, Coombs, and Fredericks Building at 301 Main is one of Houston's few examples of Victorian commercial architecture. When the building—and business—was started in 1889, it was directly in the center of the growing city. Designed by noted architect George E. Dickey, it originally housed a jewelry store.

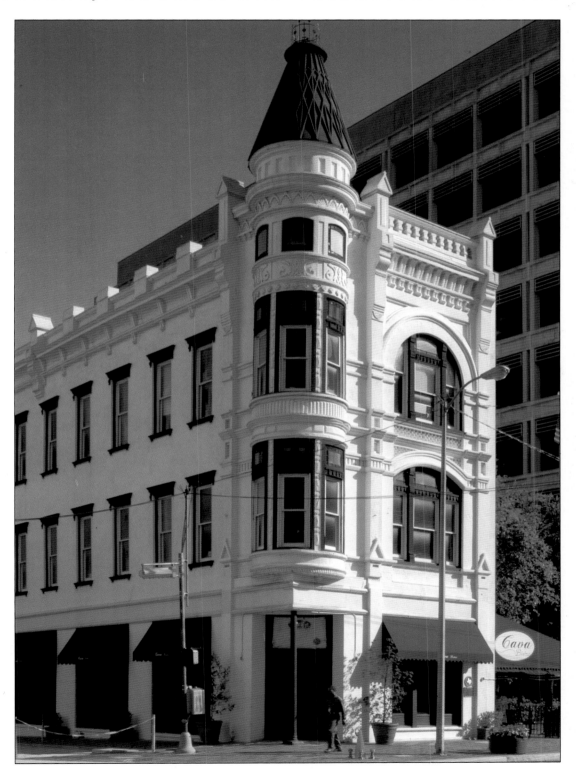

After its run in the jewelry business, the Sweeney, Coombs, and Fredericks Building housed the Burgheim Drug Store. The drugstore enjoyed a long life—one of the longest in Texas—in the building until the Harris County Engineering Department moved in. Today its location and visual appeal hold unlimited potential, most recently as a restaurant. Some say it still retains pieces of the old Van Alstyne building.

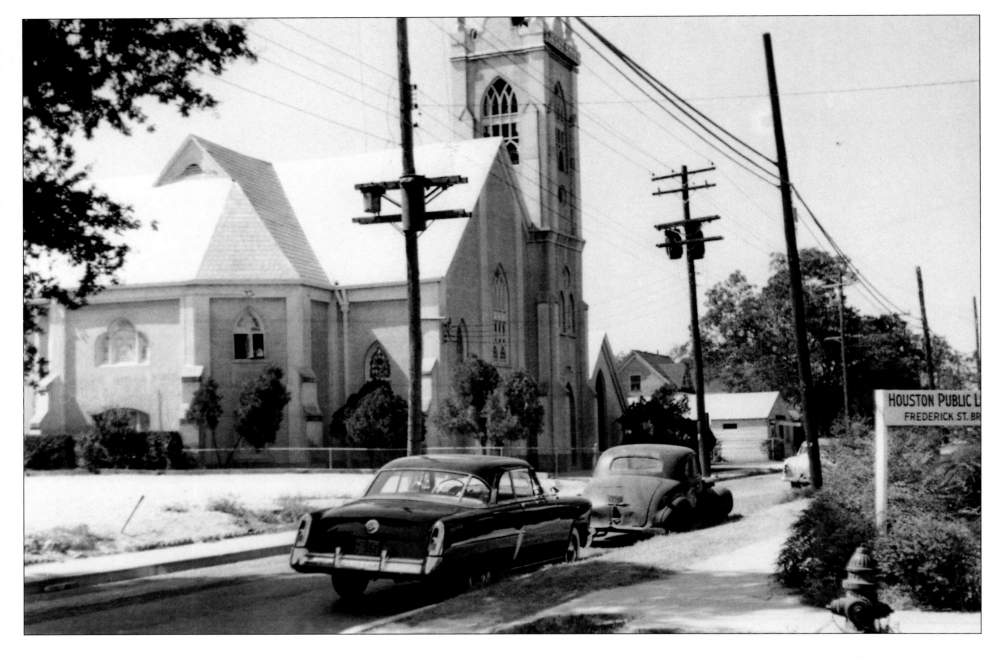

Houston's first black church, the Antioch Missionary Baptist Church at 313 Robin Street was started in 1865 by a pair of white Baptist ministers and nine former slaves upon hearing of their emancipation. Not the congregation's first, this building was erected for the church in 1875. Once the heart of Freedman's Town, the church not only gave spiritual guidance, but also helped former slaves better themselves academically and financially.

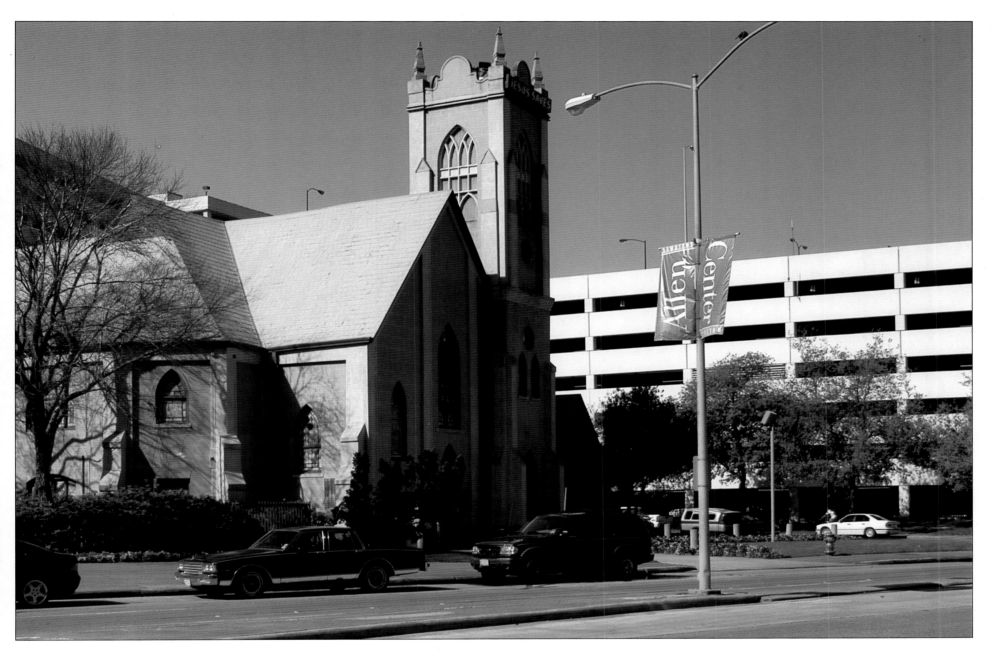

Today structures such as the rambling, multiskyscraper Allen Center and—most notably—the shimmering Enron Center fence in this important part of Houston's history. The church continues to support the community, providing food and shelter to the area's homeless, delivering educational opportunities and promoting bible study. The intellectual origin of what is now Texas Southern University is a source of pride for all Houstonians.

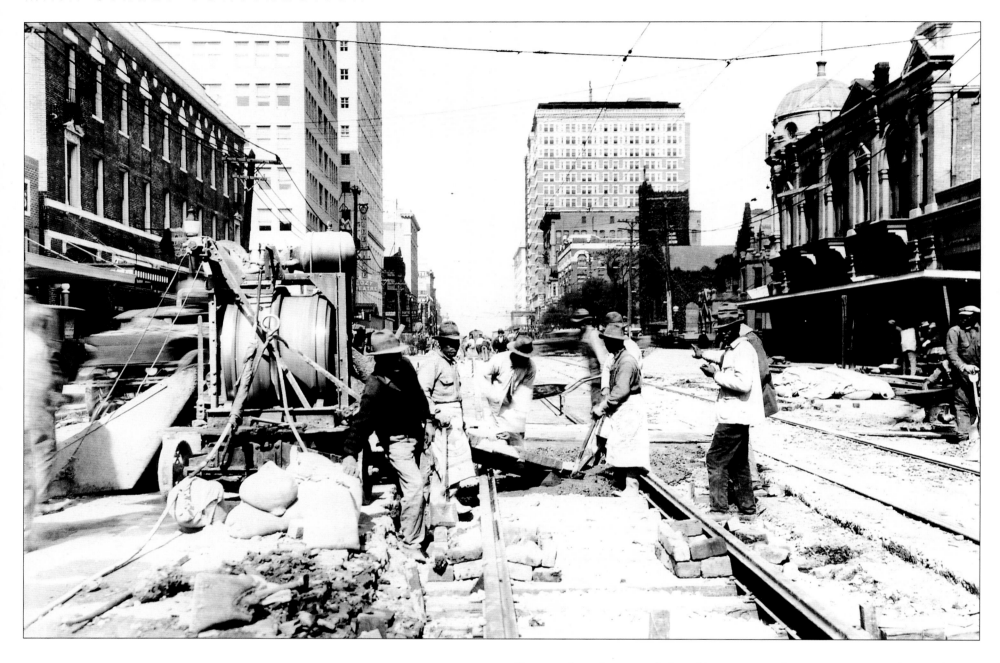

Houston has always prided itself on continual improvement. Its first mule-drawn trolley cars appeared in 1868. In 1882, Houston paved its first road and, along with New York, was one of the nation's first cities to build a power plant. Houston's first electric streetcar appeared in 1891. By 1912, almost 200 streetcars clanged across a dozen main lines. This pre–Great Depression photo shows the installation of a Main Street rail line.

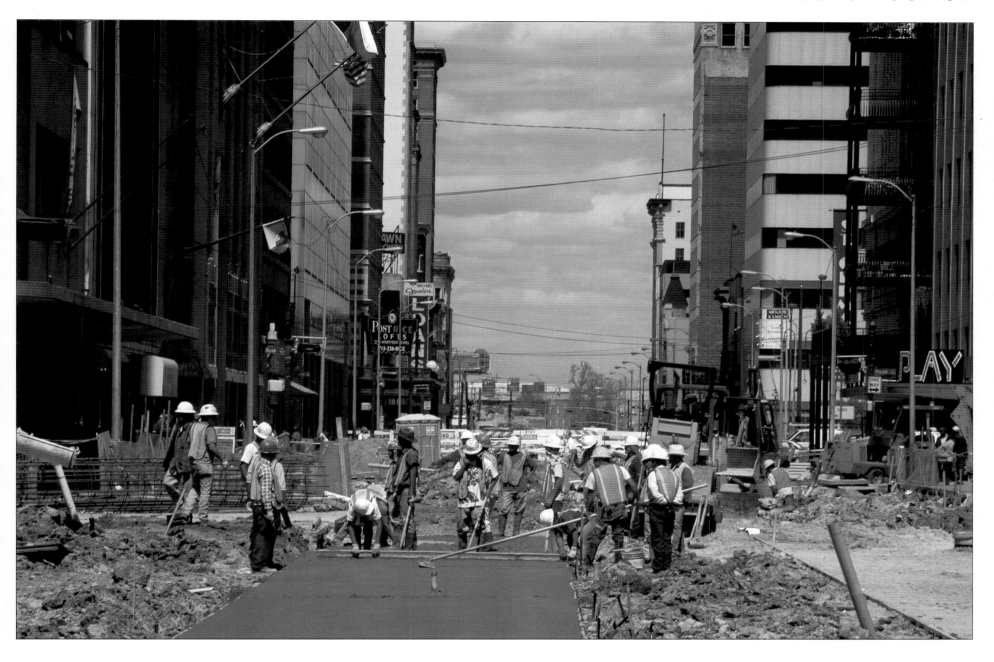

Houston's first automobile arrived in 1897, the result of a promotional gimmick by Montgomery Ward—and the town would never be the same. By 1927, buses would officially replace the electric trolley for everyday travel. Today over 1,500 city buses and 2.5 million cars cruise Houston's streets. City workers are now again tearing up Main Street to install streetcar lines. The $324 million project will connect downtown to Reliant Park.

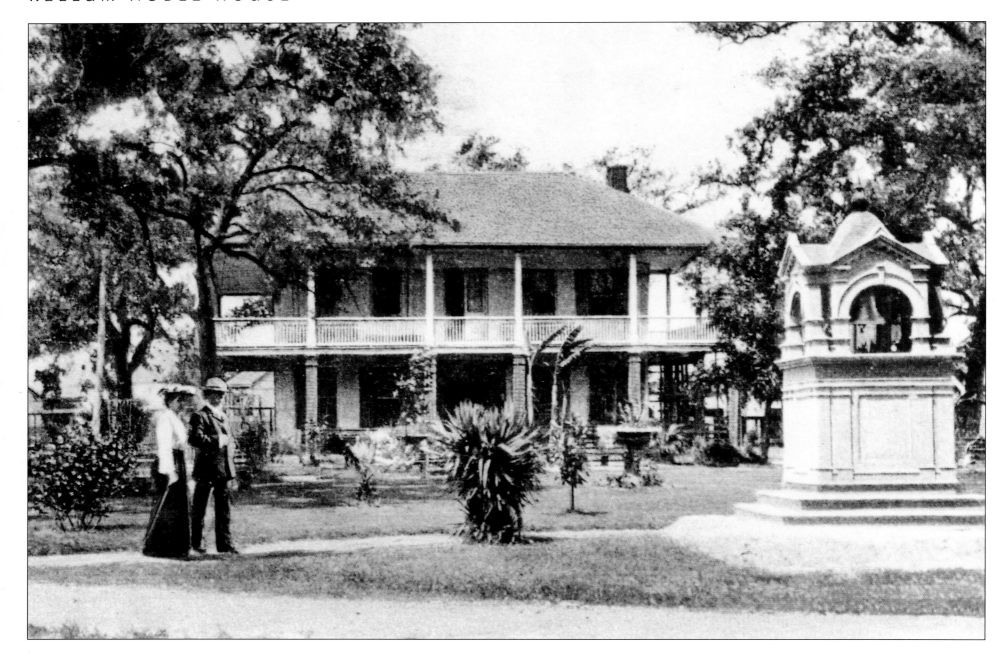

Dating to 1847, the Kellum-Noble House is the oldest brick house in Houston. Virginia-born Nathaniel Kellum built it for his young wife, Elmyra. Its bricks were made in Kellum's own kiln. They would prove much sturdier than his marriage, however, which ended in divorce—and with Kellum shooting his brother-in-law. It was then sold to Zerviah Noble, who ran a private school from the house.

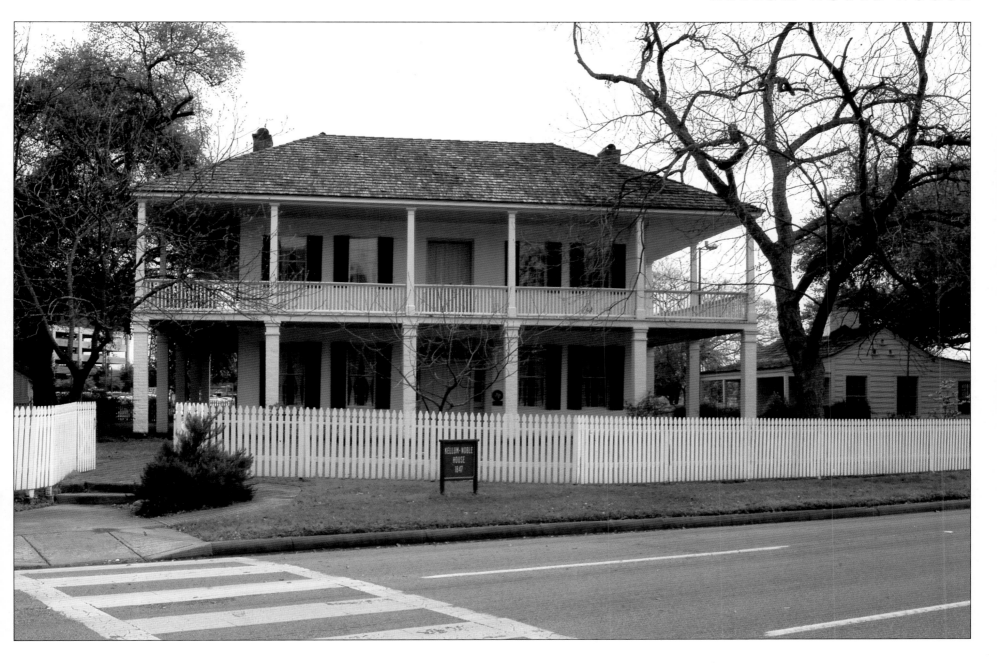

In 1900, the house and surrounding land was purchased by the city to be used for Sam Houston Park. By the 1950s it had become run-down and was destined to become a parking lot. However, concerned citizens formed the Heritage Society to save it from the wrecking ball. While there are a number of historical structures in Sam Houston Park, the Kellum-Noble House is the only one still in its original location.

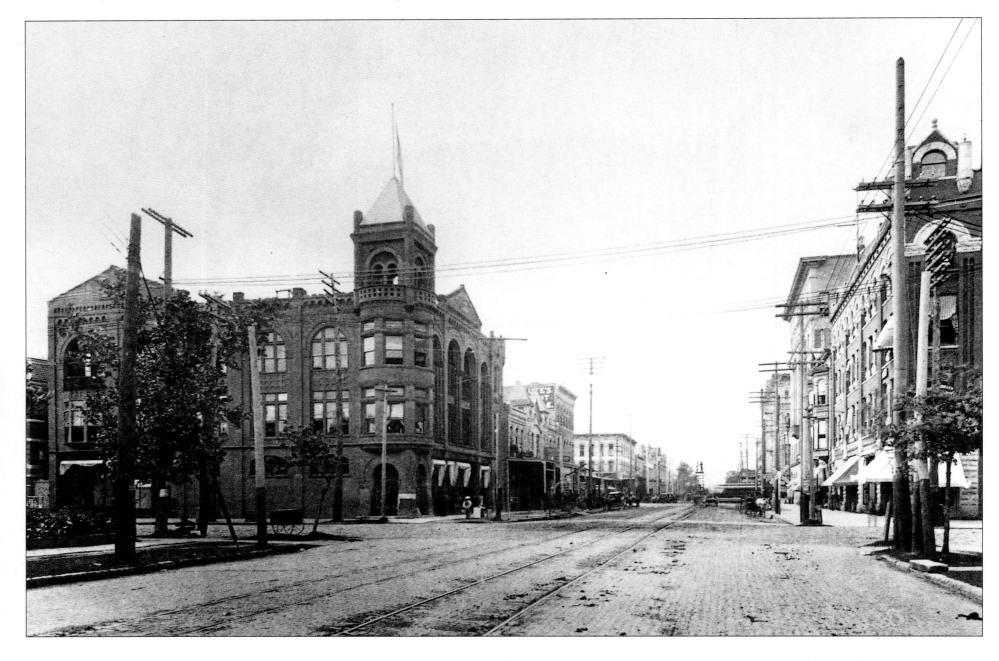

Formed in 1873, the Houston Light Guard was a nationally famous militia unit. With prize money from drilling competitions, they constructed this armory at Texas and Travis—replete with billiard tables, game rooms, and a reading room. It was a powerful social network of leaders in civic, economic, and social circles. They proved themselves fighting in Havana under Theodore Roosevelt, as well as in a number of civil engagements.

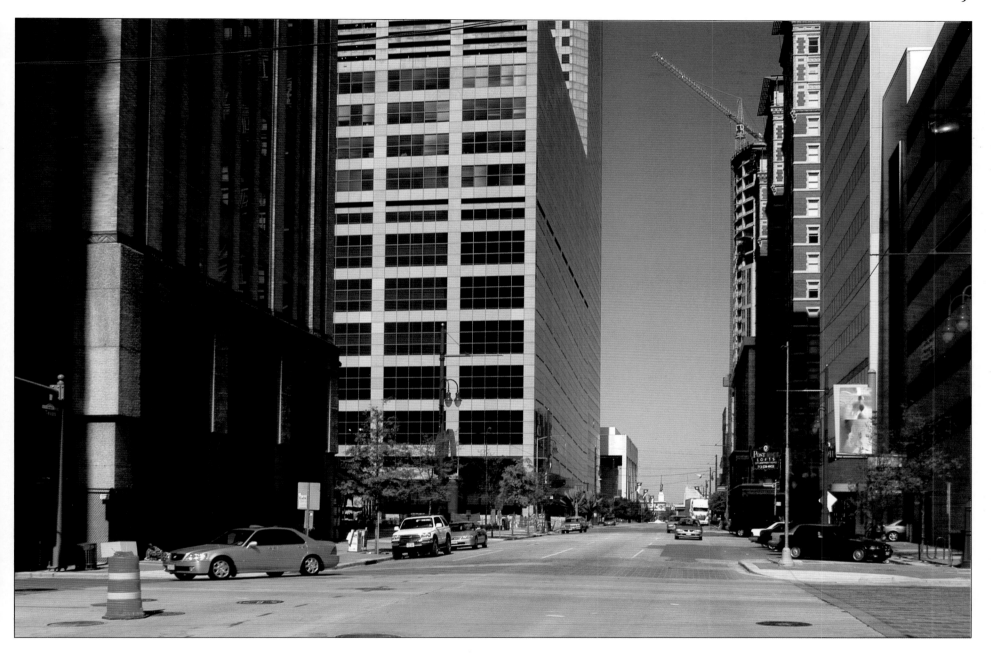

After World War I, the site of the old armory was sold and a new one was constructed in 1925 at 3816 Caroline Street, where it's still standing. The original site at Texas and Travis holds giants such as the Texas Tower and J. P. Morgan Chase Tower. Finally known as Company G (Airborne), 143rd Infantry Regiment, one of the Houston Light Guards' last duties before eventual deactivation in 2001 was to help during Hurricane Allison.

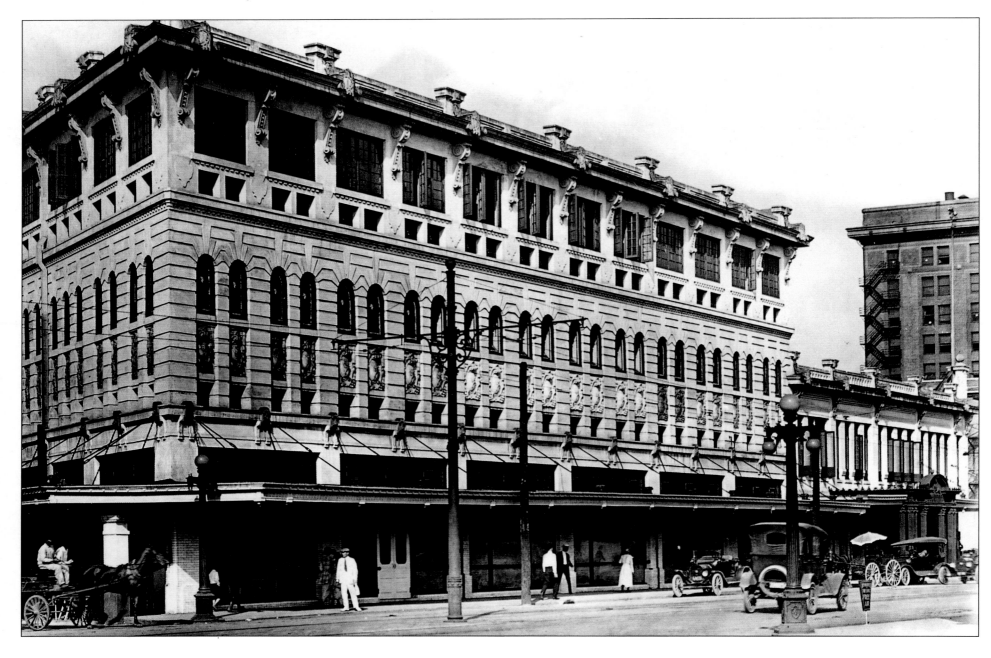

Houston Ice and Brewing Company was founded in 1892. At one time, this complex of several buildings engulfed Buffalo Bayou on both sides and comprised a major component of the local economy. The small addition on the far right was completed in 1912. At one time, the factory could make 750 tons of ice and 600 barrels of beer per day. Favorite brands included Magnolia Pale, Southern Select, and Richlieu.

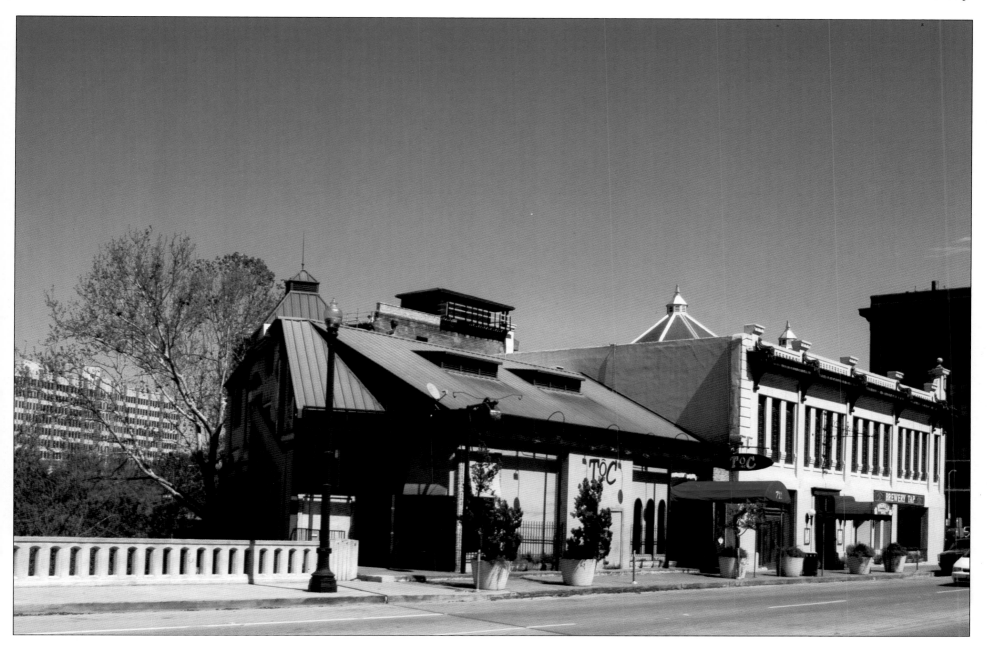

Prohibition and the big 1935 flood overwhelmed the Magnolia Brewery, which finally closed in 1950. On the National Register of Historic Places, the addition at Franklin and Louisiana, seen on the right, is the only portion of the original complex not in ruin. The Brewery Tap, popular for its beer selection, service, and space, occupies the lower floor. The upper floor houses the Magnolia Ballroom, an elegant reception facility.

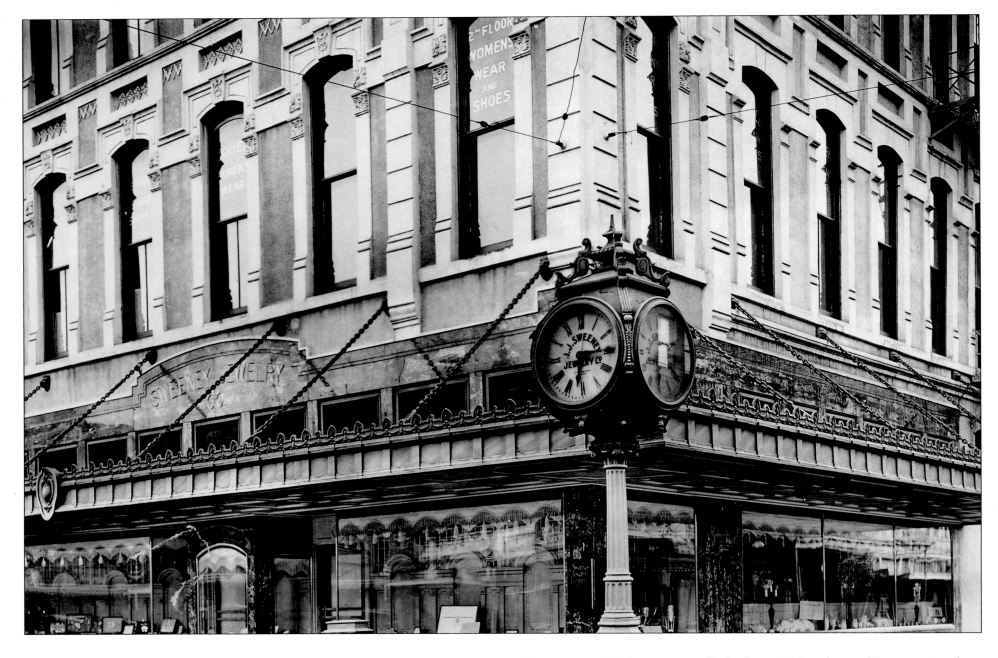

The Sweeney Clock was originally built in 1908 in front of Sweeney Jewelry on 409 Main Street. It's been said that Irishman J. J. Sweeney once paid his $10 rent in sweet potatoes. A sound businessman, Sweeney became the proprietor of a pawnshop, which in 1875 became the Sweeney and Coombs jewelry shop. He soon founded J. J. Sweeney Jewelry Company, diversifying his interests and eventually becoming a very prominent Houstonian.

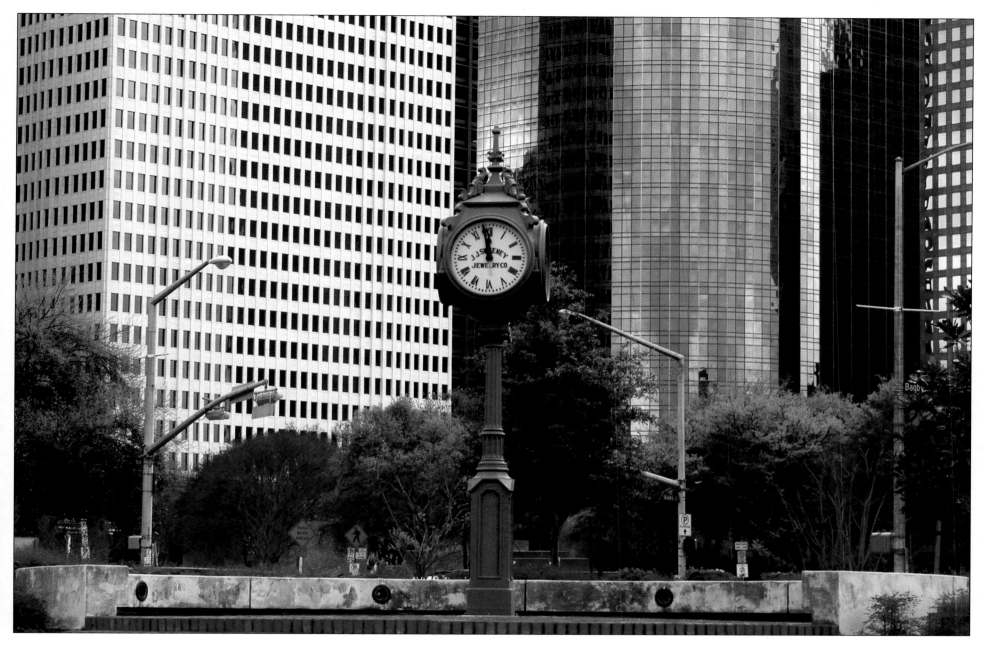

In addition to his retail ventures, Sweeney was director of both a bank and
a brewery. He left behind a considerable estate. The clock was purchased
by the city and in 1975 moved to the intersection of Capitol and Bagby.
Surrounded by a triangular landscape of beautifully cultivated roses, it keeps
perfect time and is a precious example of Houston's newfound commitment
to historical preservation.

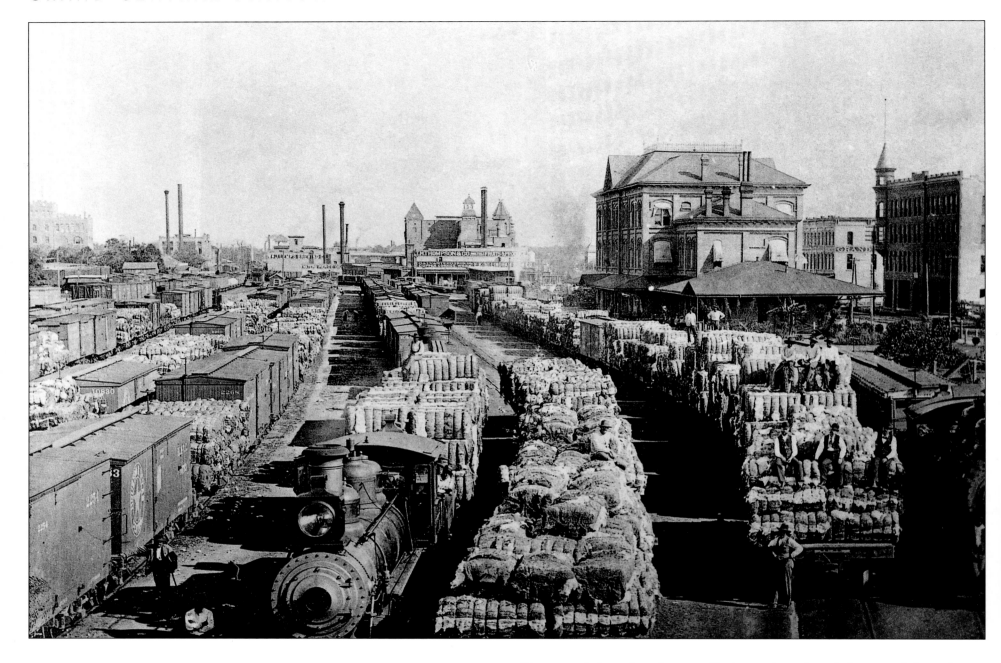

Cotton and the railroad were still giants when these bales passed through Houston in the early 1900s. On the right was the Southern Pacific Grand Central Station. The site saw more than one building, the last dedicated in 1934. A $4 million project done during the Great Depression, it featured black walnut woodwork, intricate murals, and marble flooring. The old city hall and Market Square can be seen in the background.

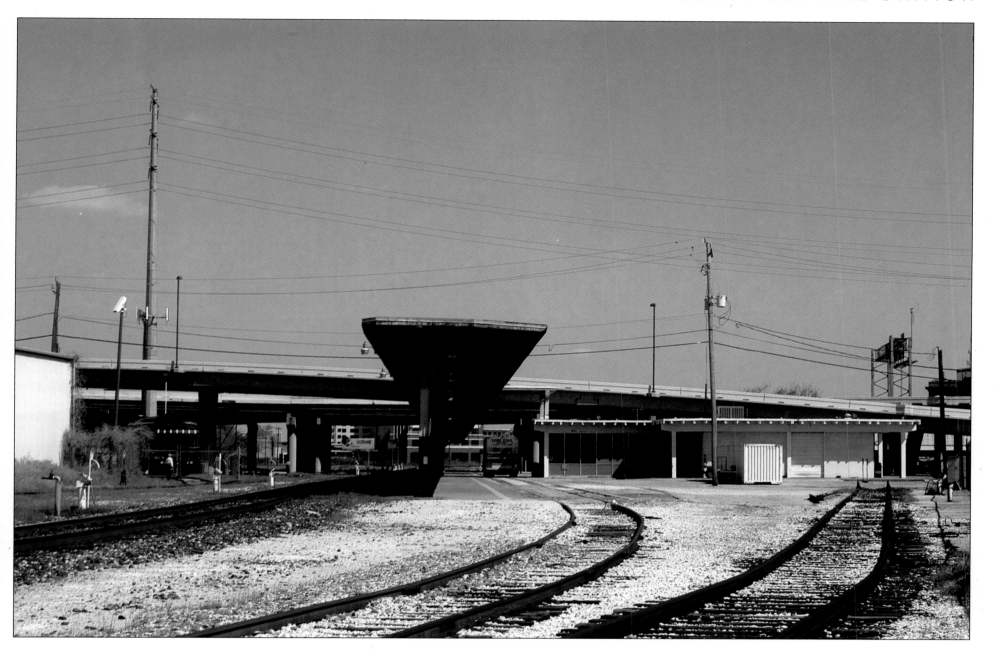

The beautiful Grand Central Station was razed in 1961 and a central post office was built in its place. The tracks still follow the same path as the old rail station and the site now serves as an Amtrak terminal. But affordable automobiles have long since made passenger trains less popular and all but unheard of in today's Houston. The Gulf Freeway, Houston's first freeway, opened in 1948 and now passes over the site.

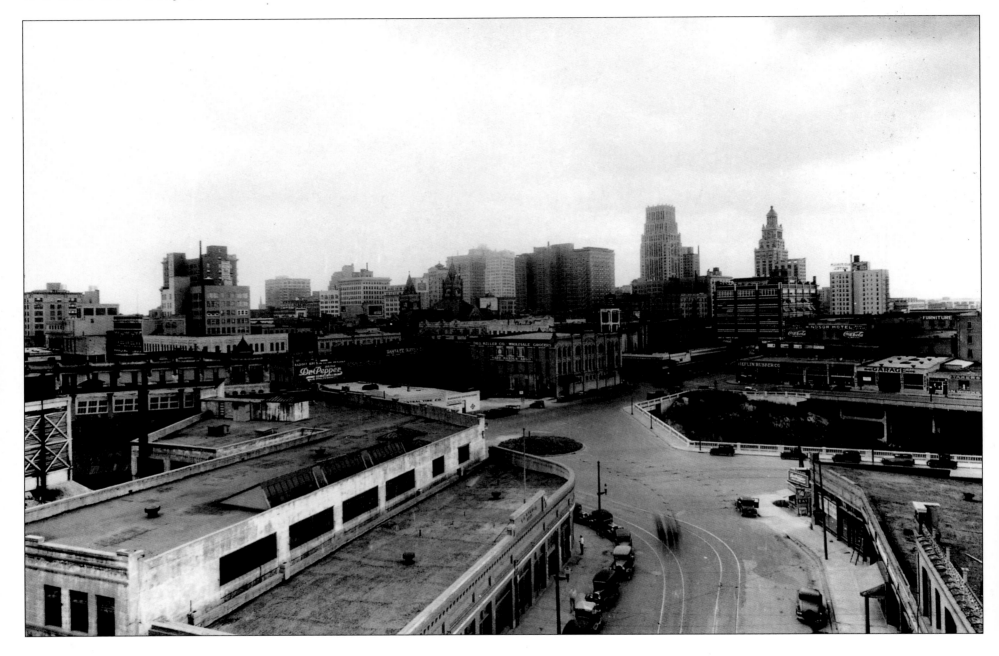

When this picture was taken in 1932, Houston had just become Texas's most populous city. Cotton was drying up; oil was flaring. Thanks to men like Jesse H. Jones, not one Houston bank failed during the Depression—though the skyscraper craze paused. The Work Progress Administration hired artists to paint murals and the first annual Fat Stock Show and Livestock Exposition (now the Houston Livestock Show and Rodeo) was celebrated that year.

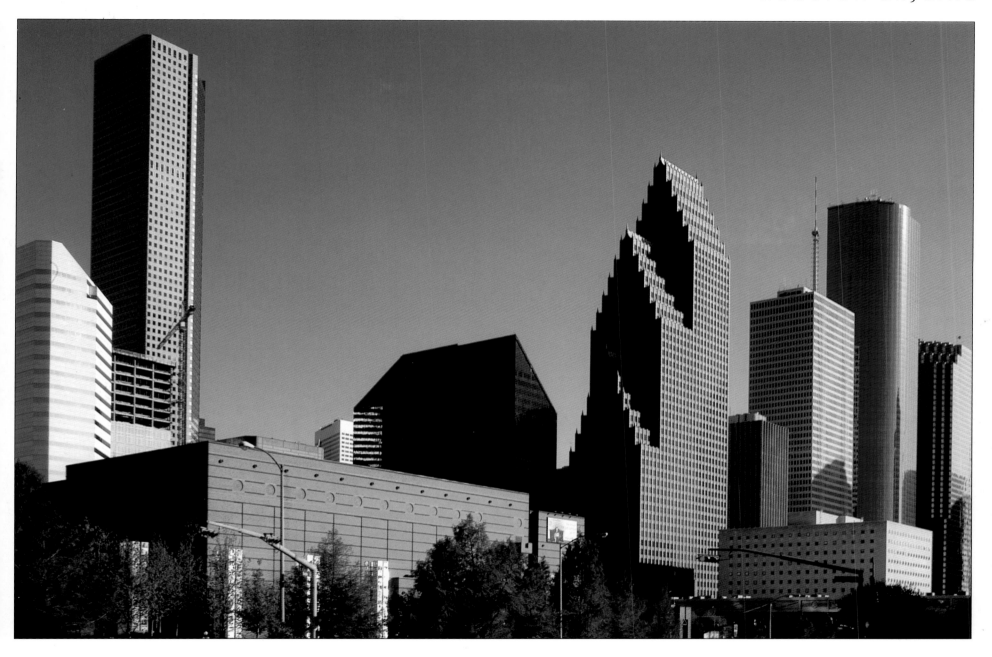

Today Houston is the fourth-largest city in the United States. The Great Depression would prove to be a minor speed bump, as the city's skyline continued to soar. Houston now has almost 850 commercial banking businesses worth $58 billion in deposits. The Houston Livestock Show and Rodeo has grown apace with the skyline; in 2002 it drew over 1.5 million people and raised $8.5 million for charity.

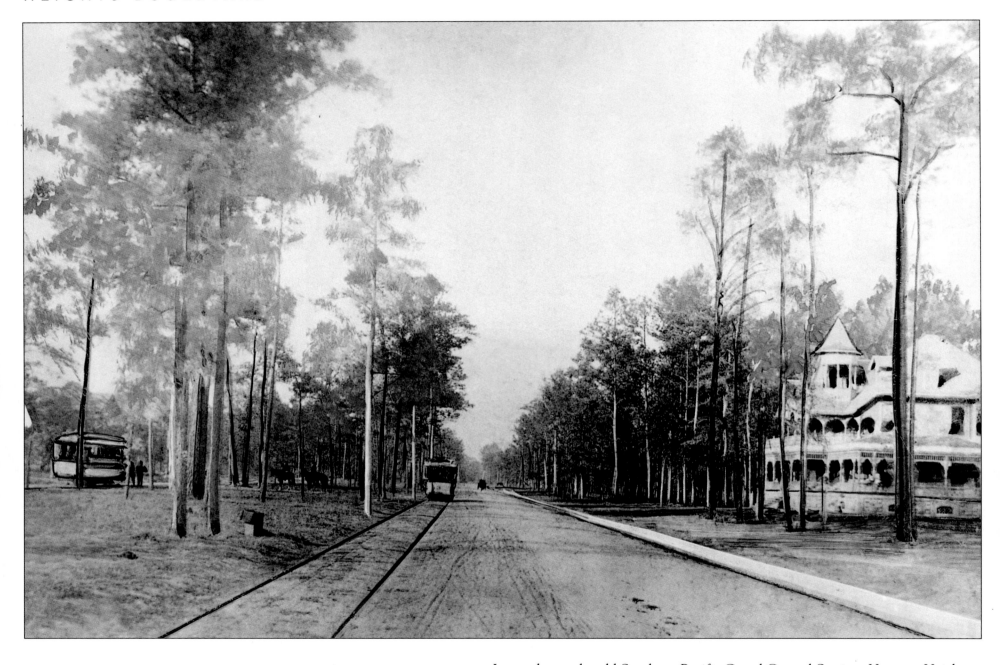

Located near the old Southern Pacific Grand Central Station, Houston Heights was the brainchild of the Omaha and South Texas Land Company. Daniel Denton Cooley was sent to Houston on its behalf to develop the city's first suburb. Houston Heights was officially incorporated in 1896, complete with electric railcars connecting it to downtown. Soon dozens of grand Victorian mansions would line Heights Boulevard.

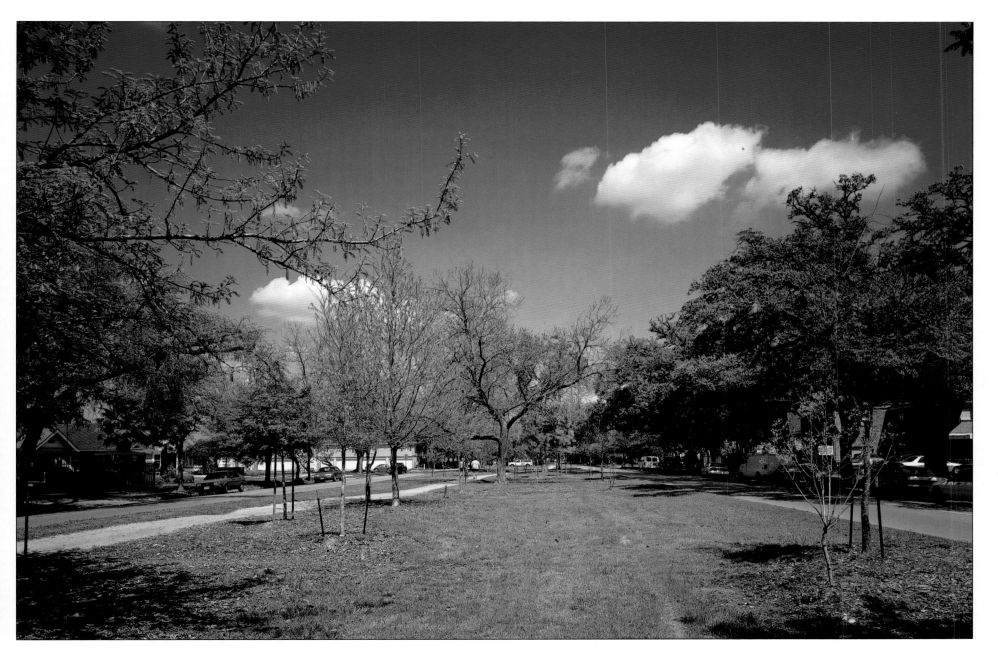

In 1900, a little more than 800 people lived in the Heights. Favorable land, stylish real estate, and a number of thriving businesses—including a pickle factory and a textile mill—would make it a hot spot for the next century. In 1991, a Texas Historical Commission marker was placed on Heights Boulevard to celebrate its history. It retains a small-town feel even as skyscrapers peek over the oak trees.

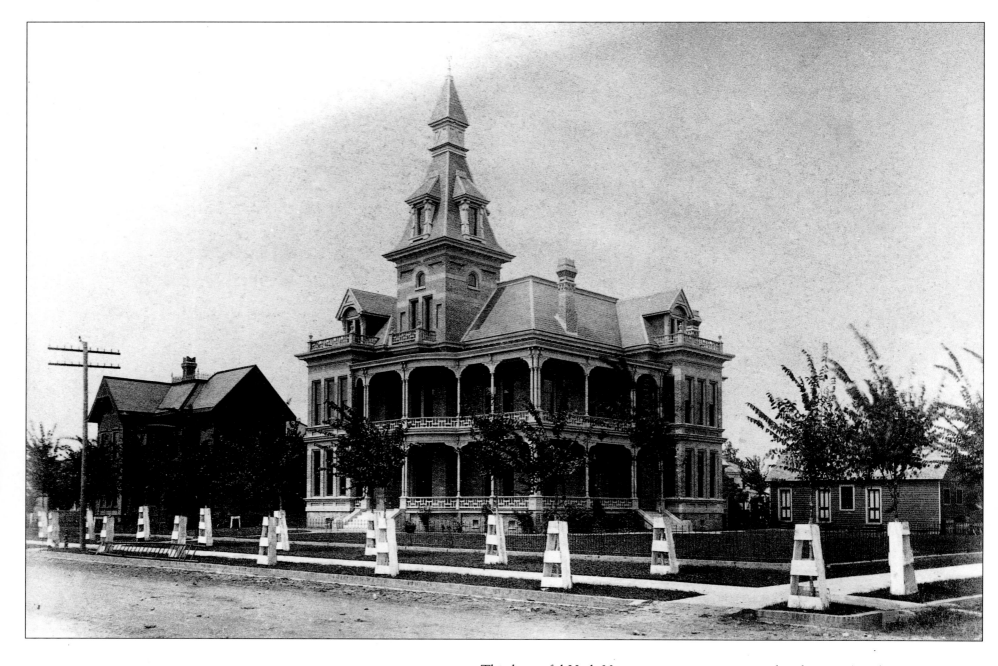

This beautiful High Victorian mansion was completed in 1885 at the corner of Rusk and Caroline Streets. The home of Jedediah Porter Waldo, a successful railroad executive, its luxurious interior includes ten rooms and nine fireplaces. The ornate tower cupola and wide verandas made the home quite a sight. It was the product of renowned architect George E. Dickey, designer of the Houston Light Guard Armory and other Houston landmarks.

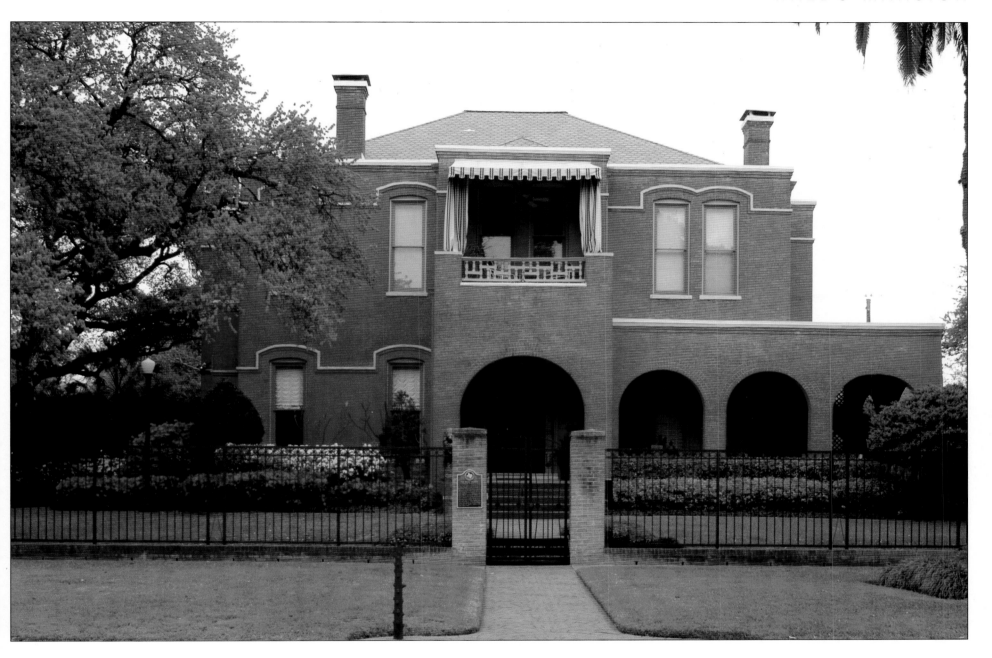

The oldest continuously occupied house in Houston, the Waldo Mansion was meticulously remodeled and relocated to Westmoreland Place in 1905 by Jedediah's son, Wilmer. Wilmer was a Princeton-trained civil engineer who oversaw the home's transport and reconstruction and gave it its current Italianate look. Wilmer had personally developed the Westmoreland Place subdivision. The home stayed in the Waldo family until the 1960s and remains a beautifully kept private residence.

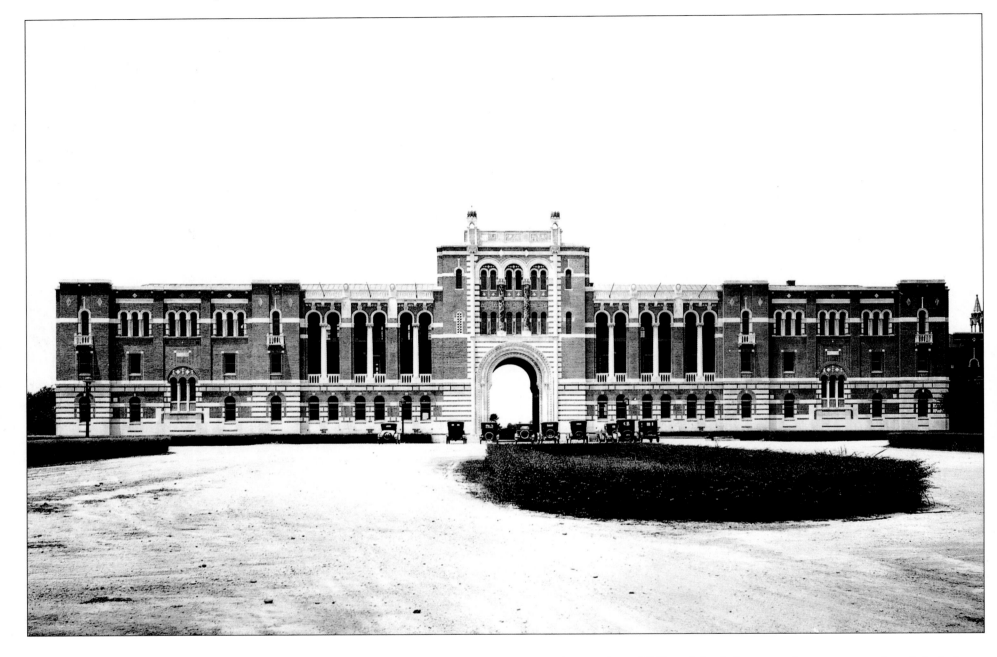

Massachusetts-born William Marsh Rice rose from an empty-handed clerk to a Houston multimillionaire by way of hard work and sound investing. He agreed to endow Rice Institute upon his death—giving back to the city that made him. Planning extensively for the school he'd never see, he appointed Princeton professor Edgar Lovett as its president. Rice was poisoned in 1900 in an attempt to steal his fortune; Rice Institute opened in 1912.

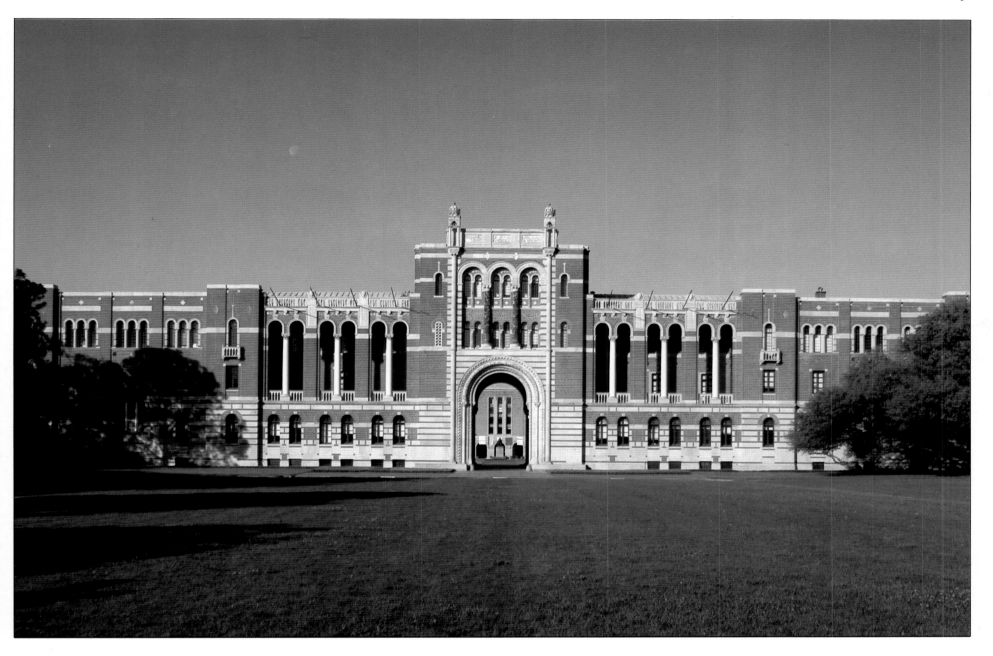

Rice University is today one of the finest universities in the country. Both academically elite and extremely hip, it gets ten applications for every student opening. It has a five-to-one undergraduate-to-faculty ratio and enjoys the fifth-largest endowment per student of any U.S. university. Lovett Hall, shown here, is named after its first president. William Marsh Rice's ashes are buried beneath a statue of his likeness on campus.

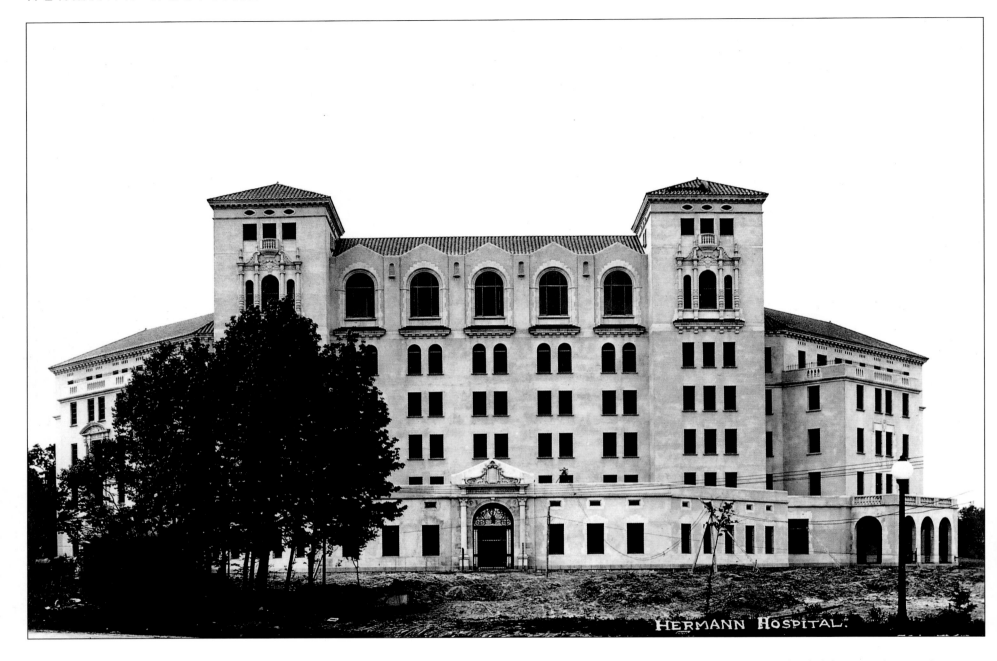

HERMANN HOSPITAL.

George Hermann, the son of Swiss immigrants who left him a substantial inheritance, was a native Houstonian. While visiting New York, Hermann fell ill suddenly, passing out right on the sidewalk! He awoke in a charity hospital, where he was treated horribly. He vowed that such a fate would not befall any Houstonians, and in 1925—eleven years after his death—Hermann Hospital opened to give humane treatment to Houston's poor.

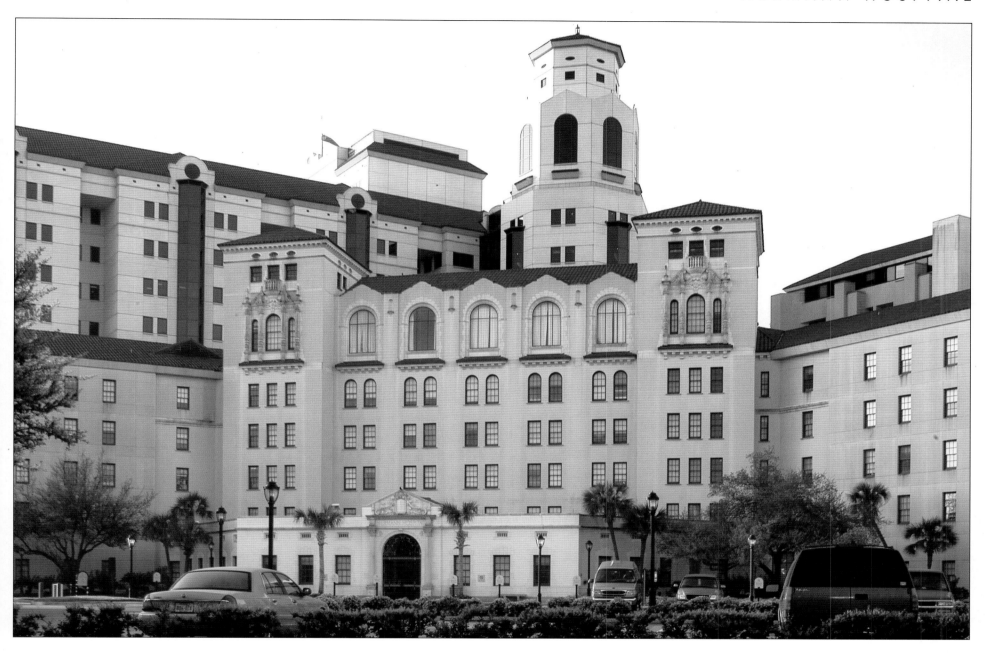

The hospital was designed for Houston's poor, but not poorly designed. Its Spanish Renaissance architecture, complete with a red barrel tile roof, is a tasteful complement to nearby Rice University. Now known as Memorial Hermann Hospital after merging with another early hospital, it manages multiple facilities that receive over 300,000 emergency visits and deliver almost 20,000 babies every year.

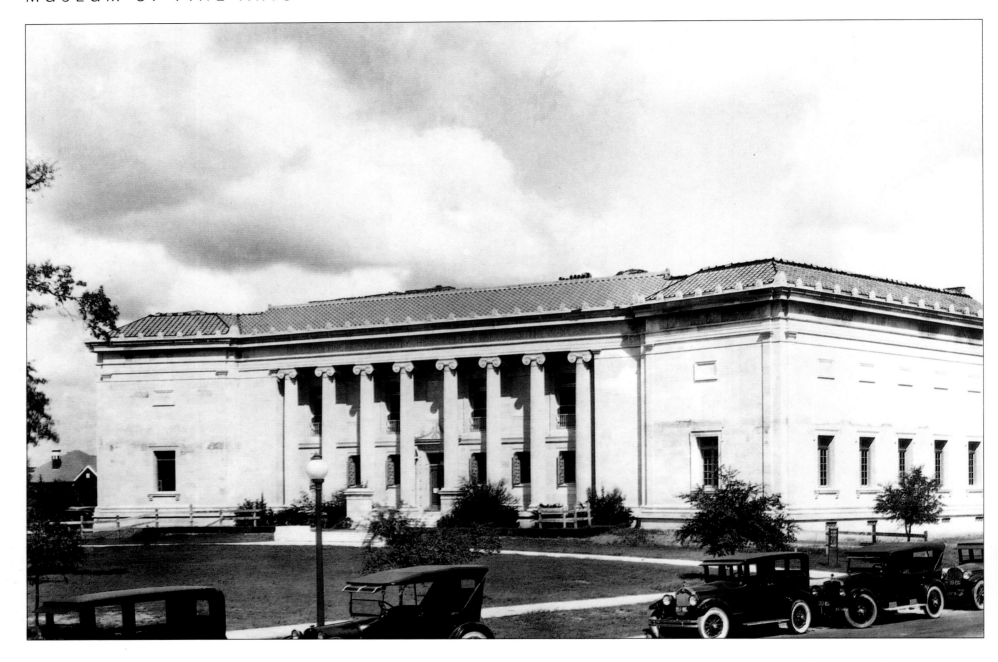

The Museum of Fine Arts, Houston (MFAH) opened in 1924. The organization was originally known as the Houston Public School Art League, chartered to make Houston's children more art-literate. The group went into debt putting a classic work of art in every Houston school. William Ward Watkin designed the original building. The collection started off slow, but grew exponentially, especially after the Great Depression. It was Texas's first municipal art museum.

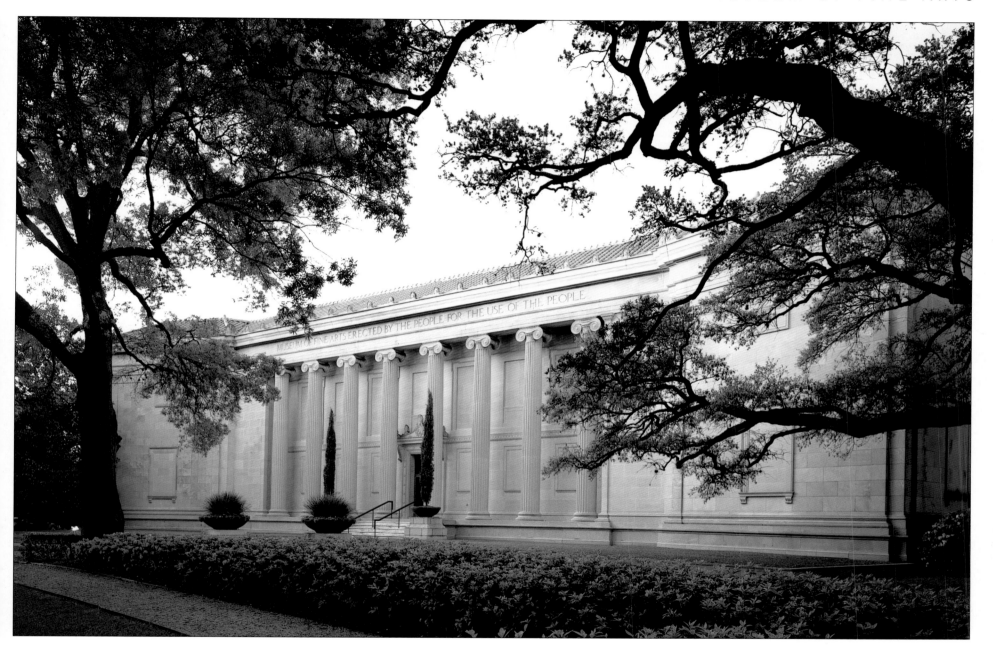

Today the MFAH is a generous complex of facilities displaying 300,000 square feet of art. It includes art schools, houses for the display of decorative arts, a sculpture garden, eighteen acres of public gardens, and one of the largest art libraries in the Southwest. It houses works from ancient times to the modern day, from all of the world's civilizations. Over 2.5 million people visit the museum each year.

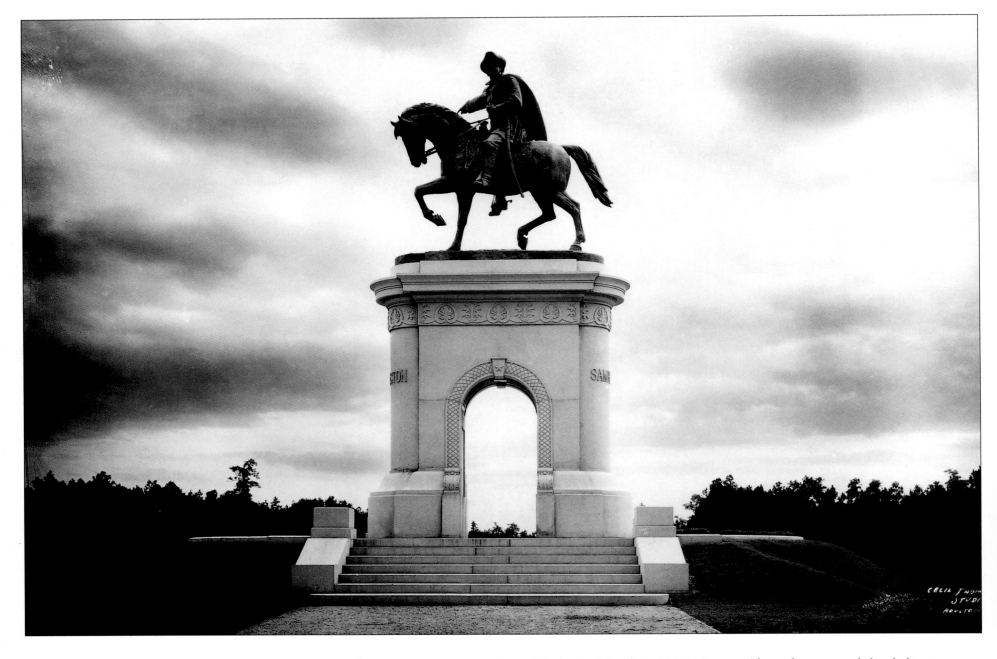

An article in the March 1, 1917, *Houston Chronicle* prompted the dedication of a statue to Texas hero Sam Houston. With the Women's City Club raising the cash, this beautiful bronze sculpture was unveiled in 1925. It was sculpted by the Italian-born Houstonian, Enrico Filiberto Cerracchio, who studied at the Institute Avellino in Italy. Depicting Houston's leadership at San Jacinto, the statue's finger is actually pointing toward the battlefield.

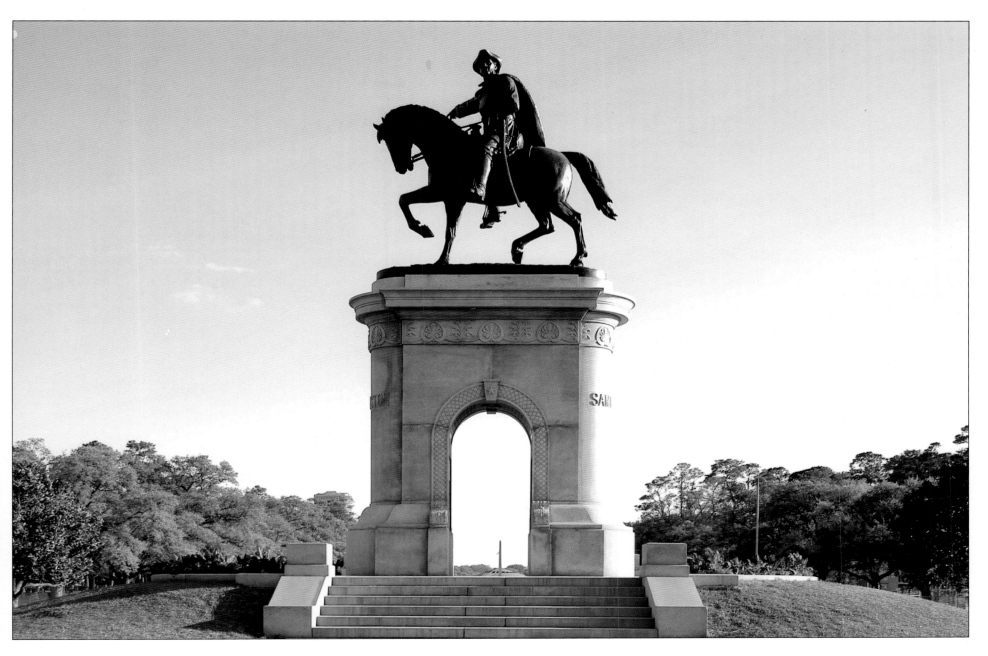

Over the years, the statue's granite arch base began to deteriorate, threatening its fitness for public service. In response, the City of Houston formed the Houston Municipal Art Conservation Office (MACO), which started an Adopt-a-Monument Program that saved not only the statue, but also dozens of other weathered Houston treasures. The obelisk appearing beneath the arch is Pioneer Monument, a tribute to the city's founders that was dedicated in 1936.

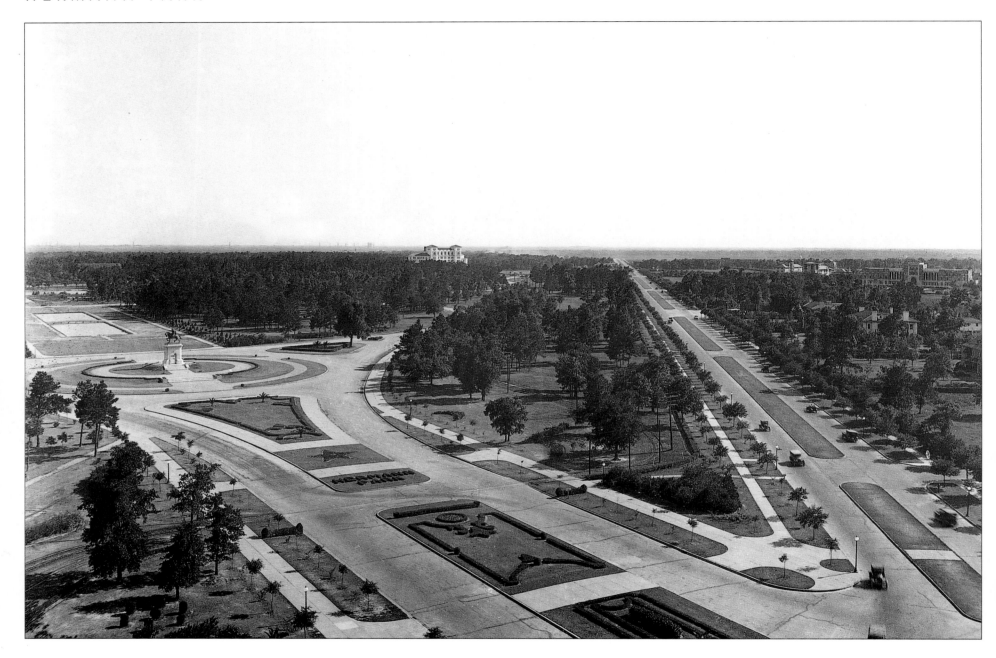

Less then six months before his death, George Hermann donated 278 acres of land for a city park. Said to be one of Houston's most frugal citizens, his civic service spared no expense. Hermann Park was Houston's first large-scale public park. When this picture was taken, its fresh esplanade was still lined with young trees and shrubbery—Hermann Hospital can be seen in the distance.

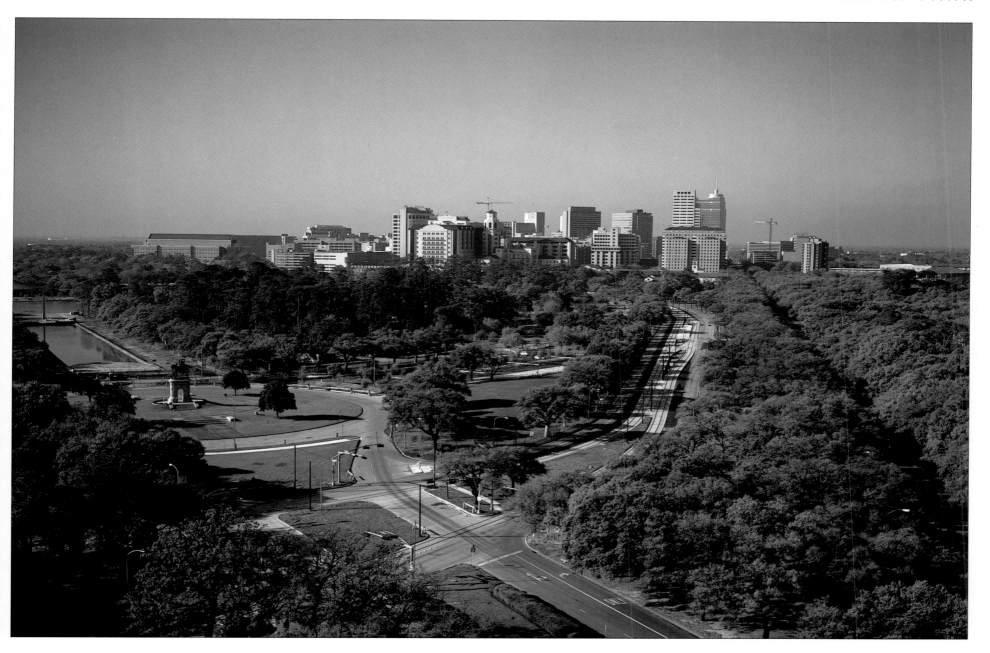

Today Hermann Park's songbirds and greenery are a welcome respite for urban-dwelling Houstonians. Drawing 5.5 million visitors annually, Hermann Park has accumulated a number of attractions, including the city's first public golf course, a zoo, an outdoor theater, and several nearby museums. Hermann Hospital is now surrounded by the Texas Medical Center—the largest medical center in the world, with close to one hundred hospitals and employing well over 50,000 people.

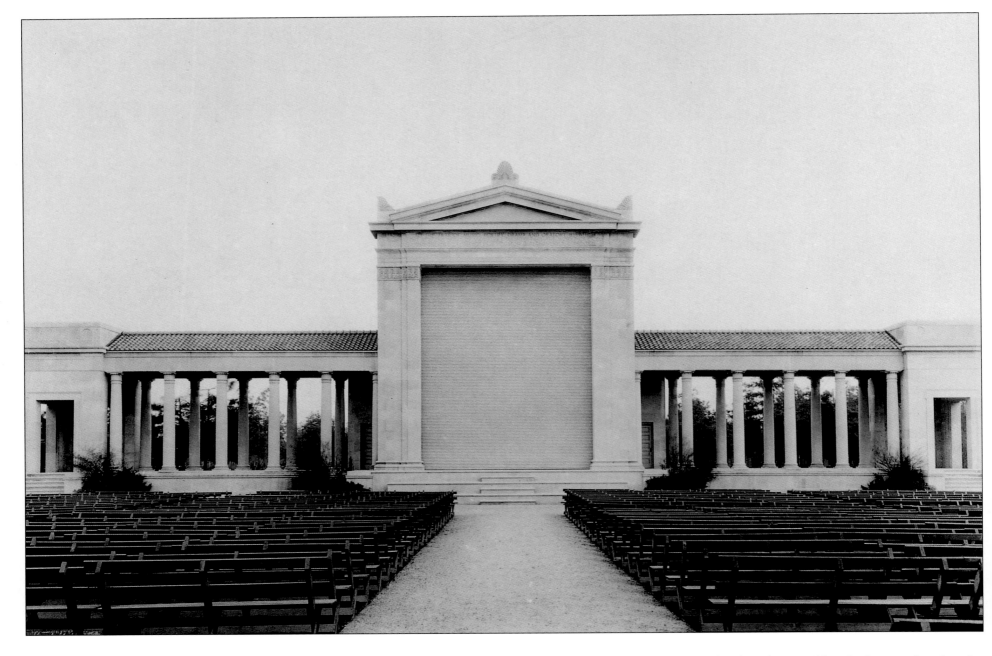

Early Houstonians gladly traded the day's heat and hustle for a cool night of *Hamlet* under the stars. The first of its kind in America, the Miller Outdoor Theatre opened in 1923. William Ward Watkin built this beautiful Doric proscenium in Hermann Park at the bequest of Jesse Wright Miller, a successful Houston mining engineer. Employed by the architectural firm Cram, Goodhue, and Ferguson, Watkin also built most of Rice Institute.

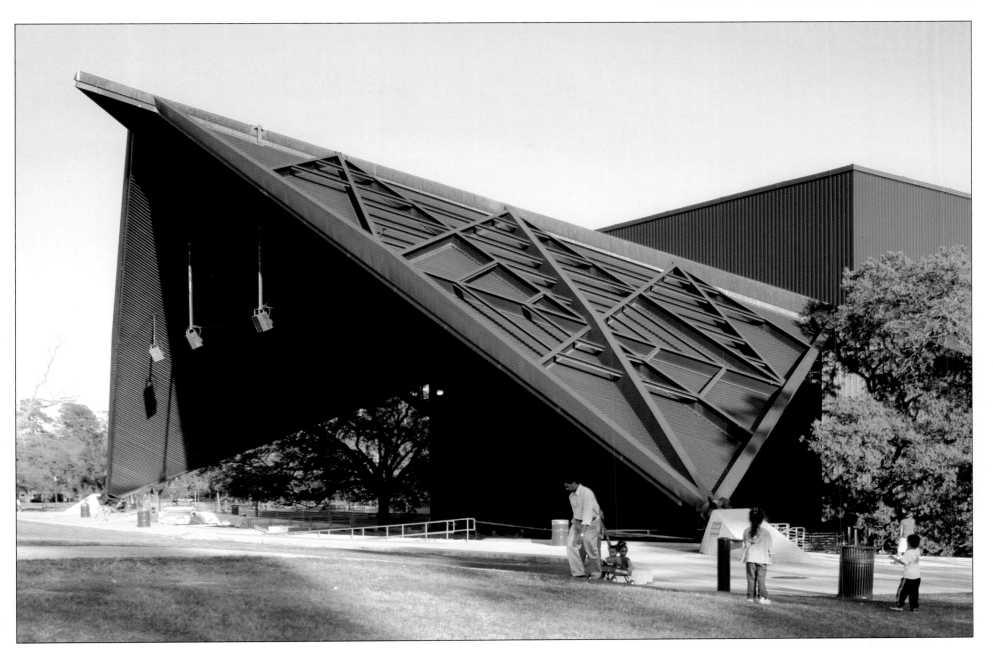

In 1969, a new Miller Outdoor Theatre was constructed on the site. The pavilion seats almost 1,600, and more can be seated on the beautifully manicured lawn. Popular for its summer symphony performances—and astonishingly diverse selection of fun, cultural entertainment—all shows are free. Some of the columns from the 1923 structure were saved and now adorn the Mecom-Rockwell Colonnade at the park's entrance.

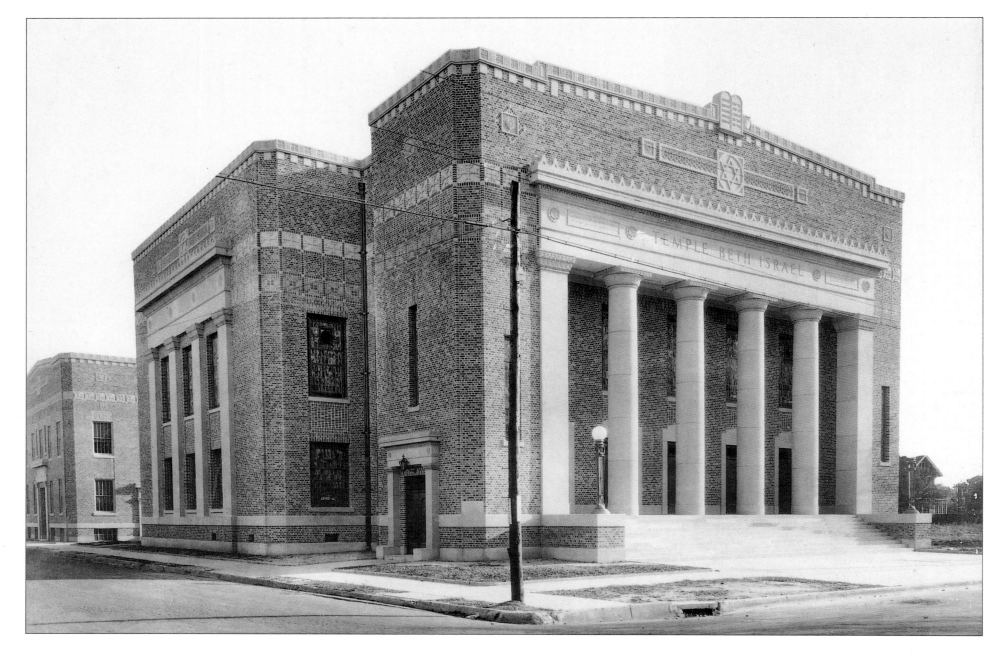

Houston's Congregation Beth Israel dates back to 1844. Its membership and administration developed itself over the following decades, creating a strong Jewish community in Houston. This temple, the congregation's third, was designed by renowned architect Joseph Finger, who was also a member of the congregation, and completed in 1925. At the intersection of Austin Street and Holman Avenue, its cost was estimated at $250,000.

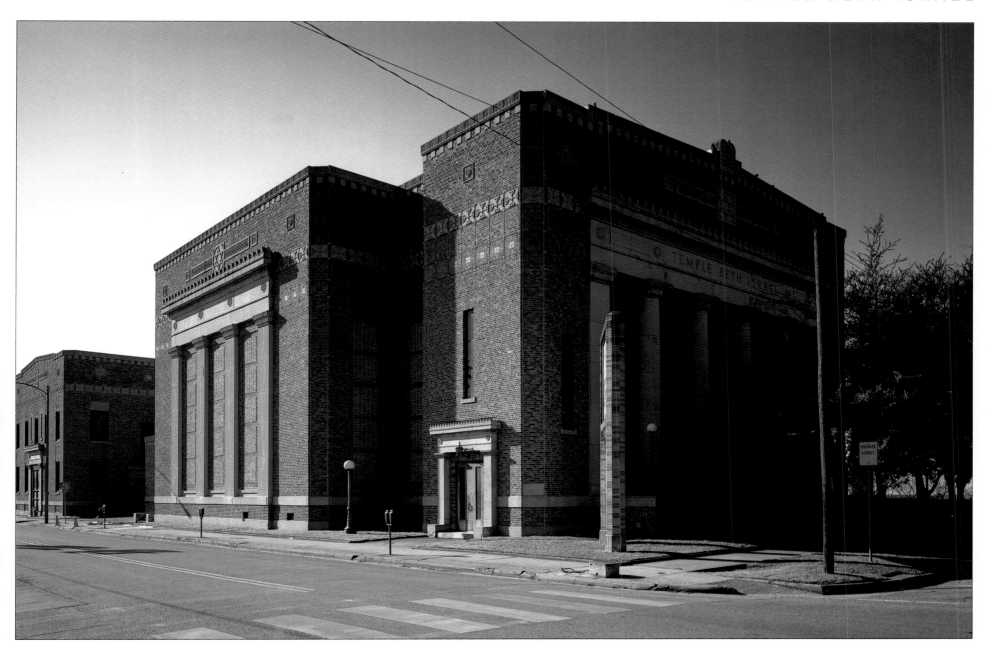

In the late 1960s, Beth Israel moved out and the building was occupied by
the High School for the Visual and Performing Arts, the first public school
in the country to provide gifted young artists the focused, intensive training
required for global competition in the arts and integrate this rigorous training
with academics. Today the building is the Heinen Theatre, a part of Houston
Community College's Fine Arts Department.

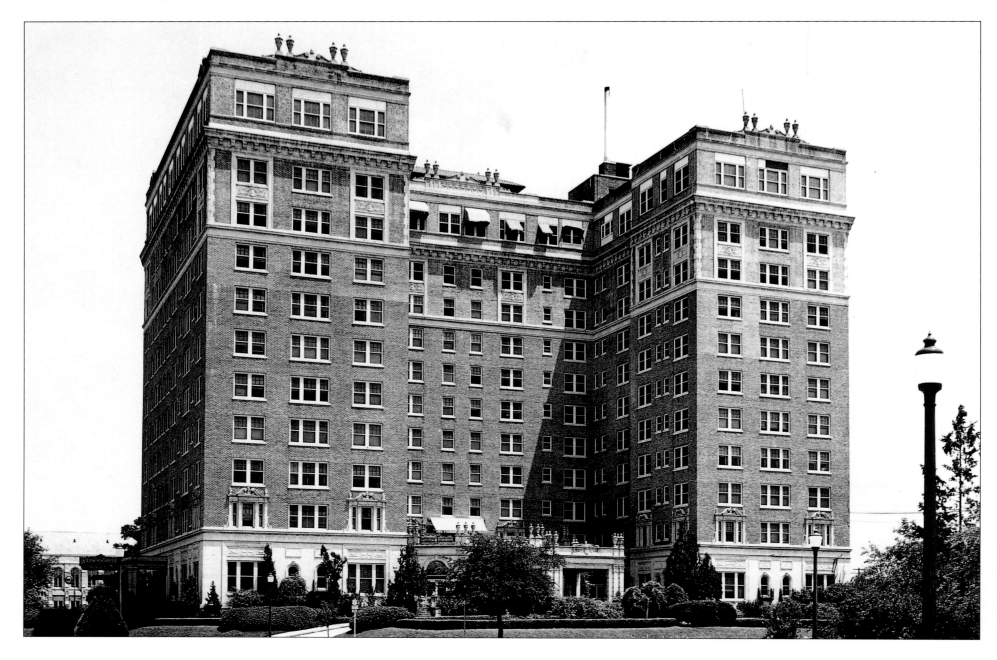

The Warwick was completed in 1926 as an upscale apartment building. It was sold to oilman John Mecom in the early 1960s. He and his wife plundered Europe for its furnishings, including wall panels owned by Napoleon's sister. When it was relaunched as a hotel, a waiting list of 500, including Cary Grant, couldn't get in to see the gold-plated Rolls Royce rise from the ballroom floor, filled with presents for the guests.

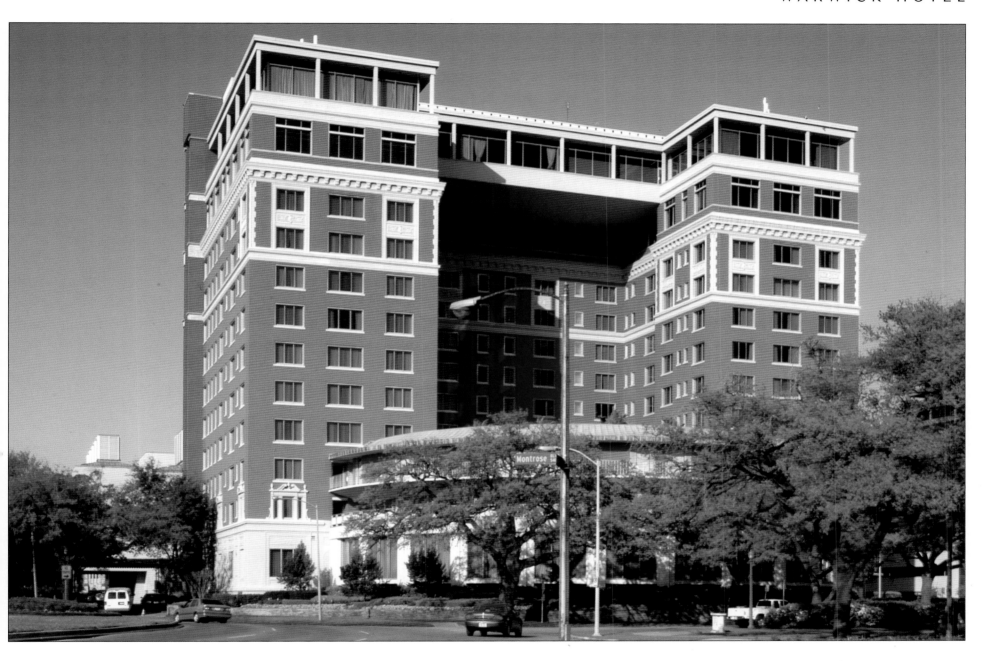

For decades, if you had money and traveled to Houston, you stayed at the Warwick. But the 1980s were not kind to the Bayou City, ushering in a painful era of economic diversification from a purely oil-driven business base. In 1987, Mecom was forced to liquidate the Warwick. Now owned by Dolce International, it's more beautiful and convenient than ever, and offers first-rate service to all its guests.

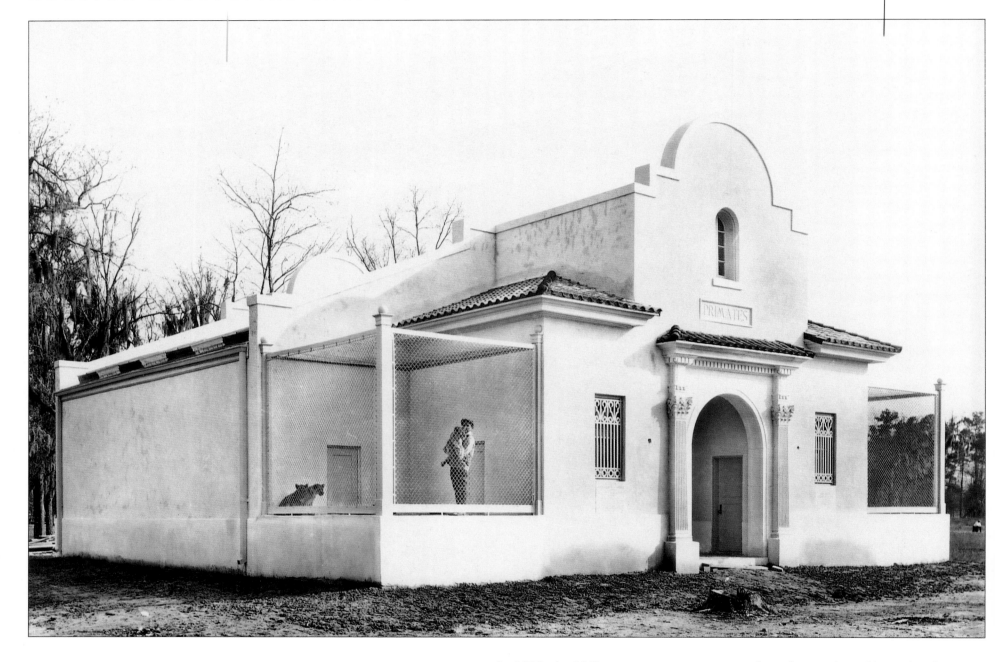

In 1920, the U.S. government set out to reduce the number of bison herds at national parks. One bison was donated to Houston. Earl, as he was affectionately known, was placed in Sam Houston Park, where he had the place to himself. He gradually picked up hundreds of neighbors over the years. By 1925, the impressive collection of animals was moved to Hermann Park and became the Houston Zoological Gardens.

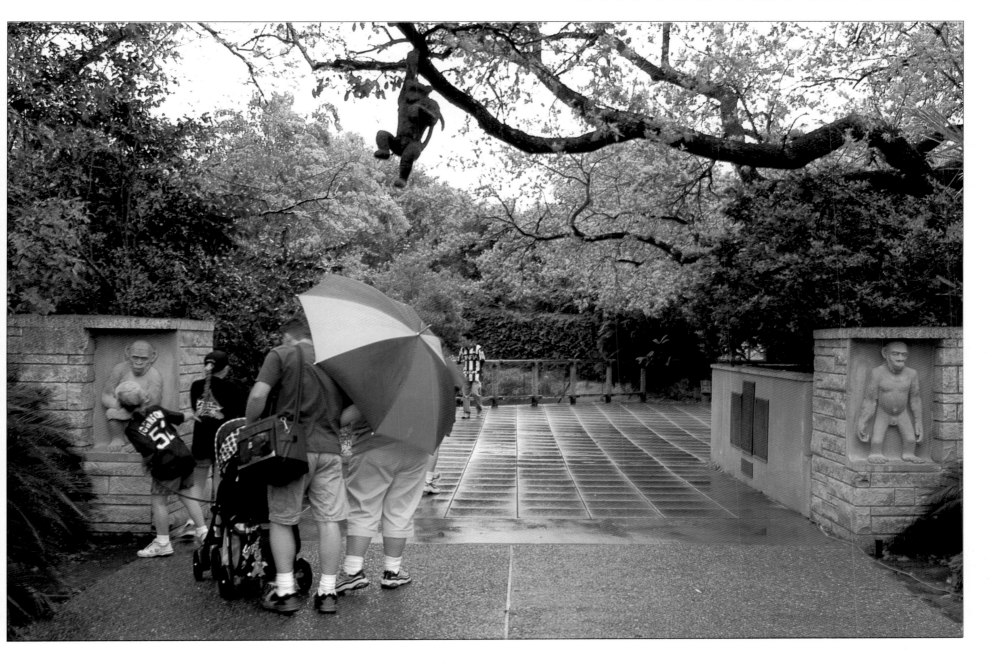

Today Earl would be proud. The Houston Zoo is the most visited zoo in the Southwest, bringing in 1.5 million visitors annually. It's home to over 5,000 animals and several elaborately engineered—and spectacularly displayed—habitats. The Wortham World of Primates offers up-close views of threatened and endangered primates, including mandrills, lemurs, agile gibbons, siamangs, patas monkeys, and Sumatran and Bornean orangutans.

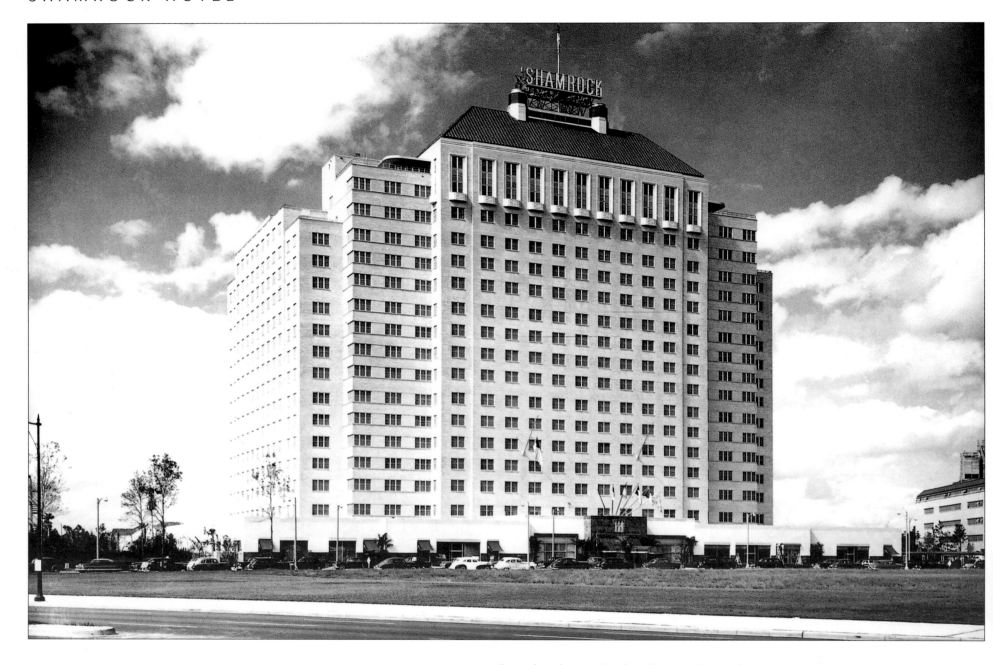

Completed in 1949, the Shamrock Hotel at Main and Holcombe embodied the early imagery of Texas oil extravagance. Built by independent oilman Glenn McCarthy, the 1,100-room hotel had a pool large enough for water-skiing exhibitions and featured sixty-three shades of green. Its opening was national news, bringing almost 200 movie stars and journalists. It also helped inspire Edna Ferber's novel, *Giant*.

Despite its social value, the Shamrock became a financial cow. McCarthy was forced to cede the hotel in the 1950s. It eventually became a Hilton. But in the 1980s recession, even Hilton couldn't make it work. Thousands protested its demolition on St. Patrick's Day, 1986. Today Texas Medical Center owns the land. It's home to a small park, which has a 650-foot pool, computer-controlled water columns, and eighty bald cypress trees.

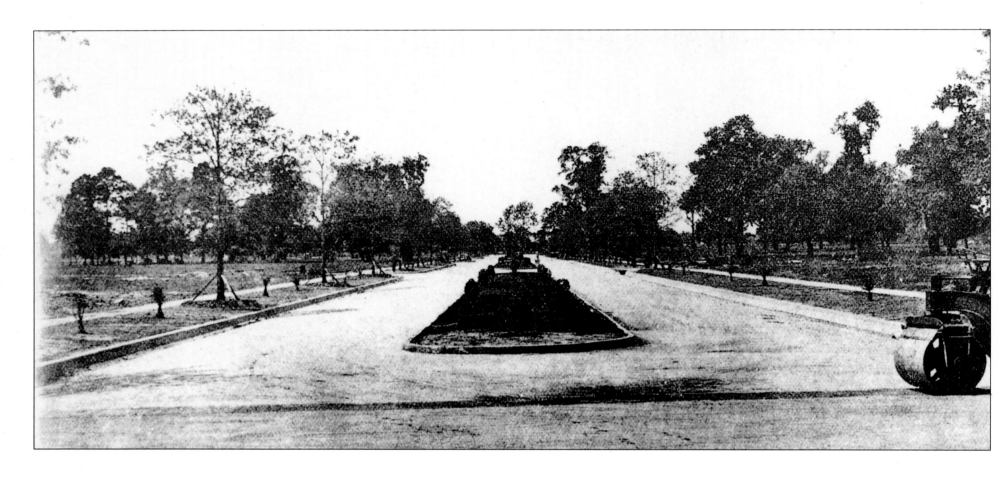

Foundations were being laid for more than just a street here at Montrose and Ross (now West Alabama) in the early 1900s. When J. W. Link first chartered Montrose Place, he insisted on social inclusion and fine, open roads and curbing. He built his own home, the Link Mansion, on Montrose Boulevard. While its well-groomed esplanades saw little traffic, the Montrose Line connected this then-suburban area to the rest of town.

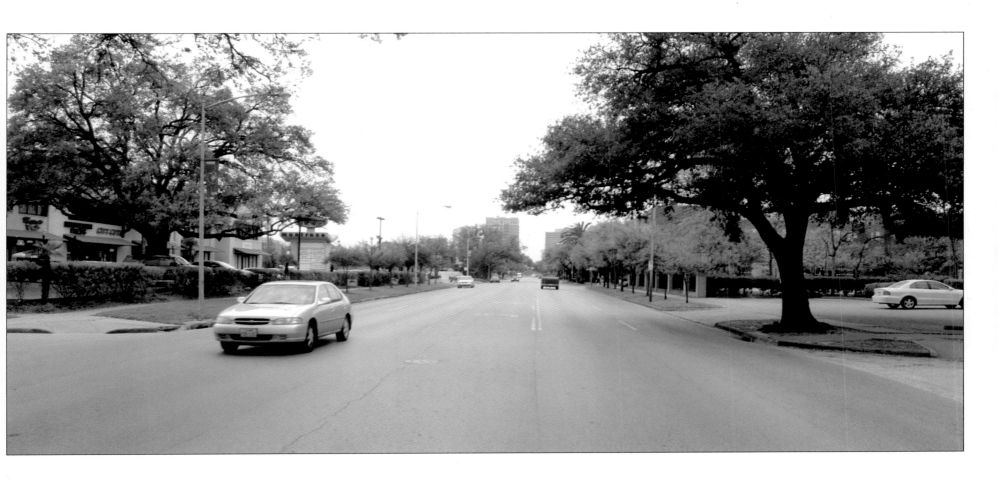

This bustling intersection is now an hour's drive from the suburbs. And Link got his wish of social inclusion. Today's Montrose is a cultural casserole, offering tattooing and body piercing, antiques, open-air cafés, poetry readings, world cuisine, and modern art, all amid a backdrop of eclectic mansions, town houses, and bungalows. The Link Mansion down the road is today known as the Link-Lee Mansion, part of the University of St. Thomas.

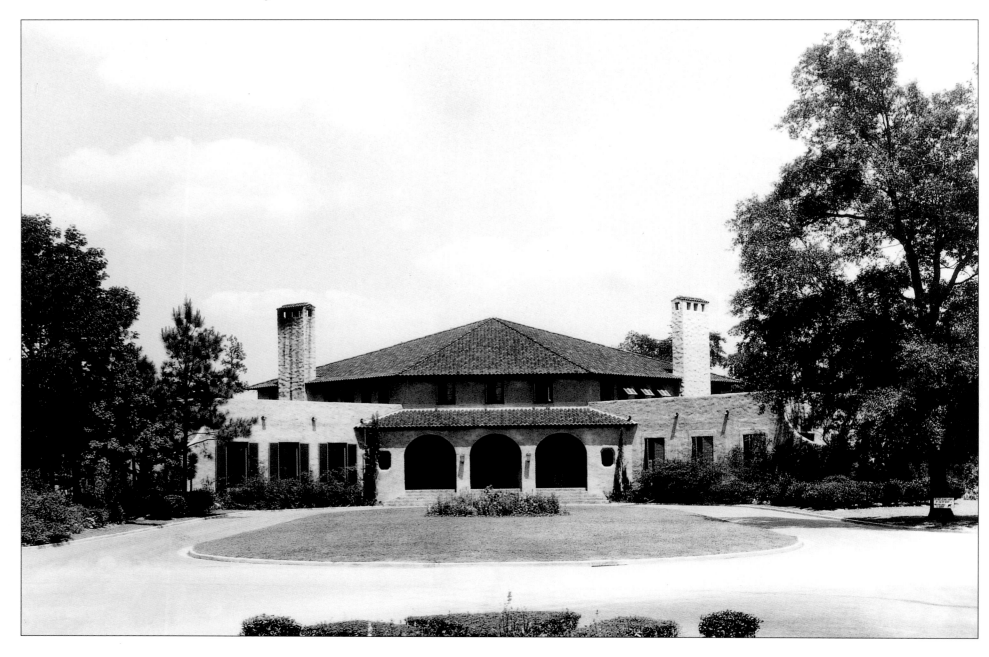

Westheimer was paved with oyster shells when River Oaks Country Club Estates was born. Its founders purchased 180 acres west of Montrose in 1920—far out in the country at the time. The Hoggs invested heavily into the project. It had a slow start, but by the 1930s it started turning heads (and a profit). Architect John Staub constructed the original Spanish Revival clubhouse that served its first adventurous members.

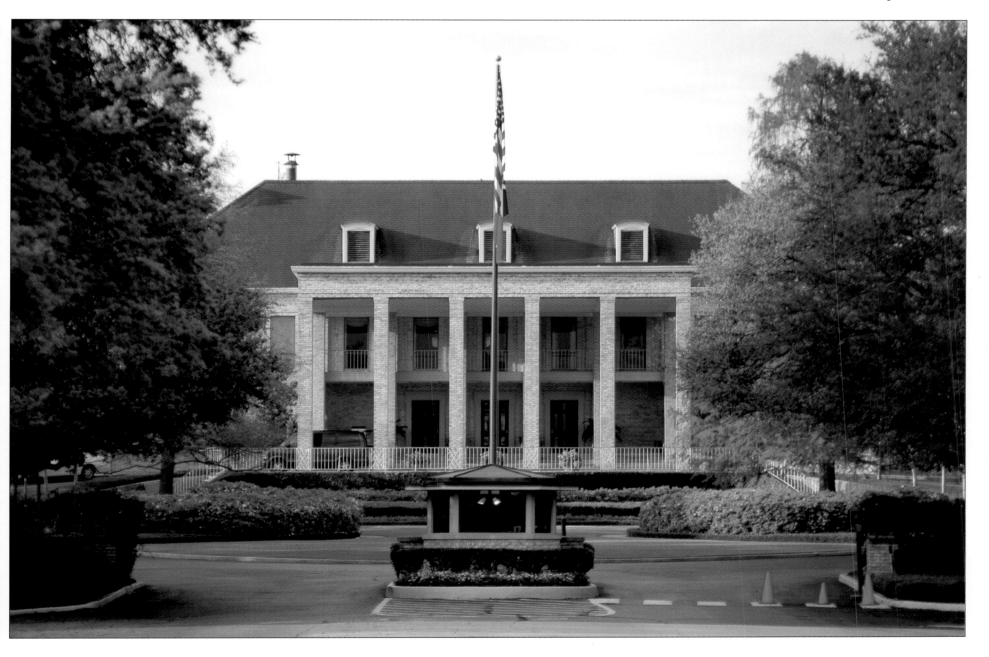

Today River Oaks is the geographical center of Houston. While established as a municipality, it's now a part of Houston proper—the most proper part, in fact. River Oaks is the most expensive and sought-after real estate in town. The old clubhouse was razed in the late 1960s to make room for a more modern structure. Its members include Houston's most powerful citizens, including George H. W. Bush.

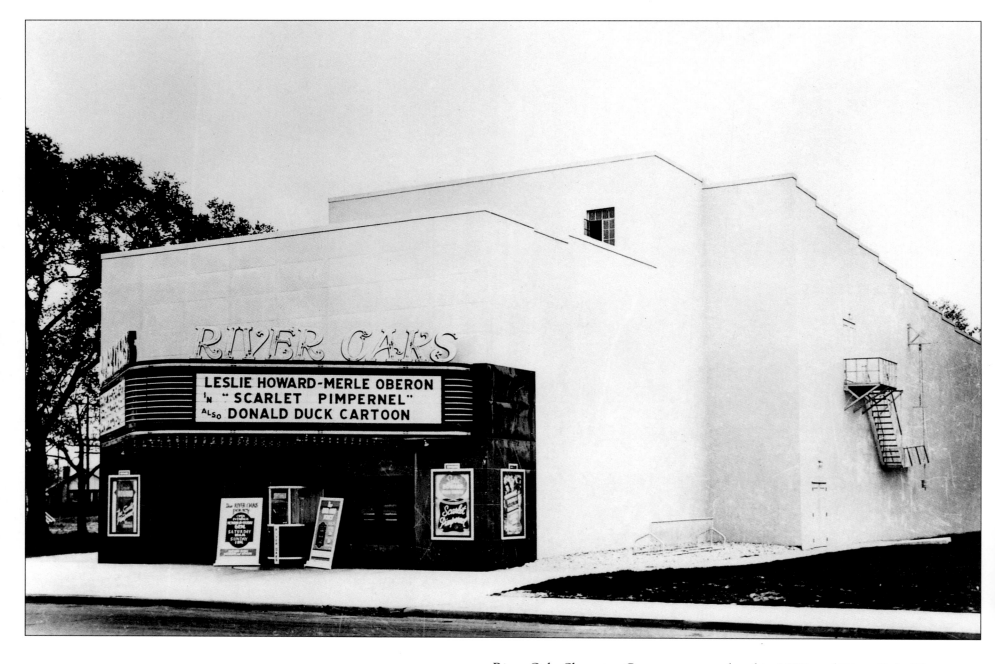

River Oaks Shopping Center was completed in 1937, and River Oaks Theatre opened its doors two years later. By the late 1930s, the upscale image of River Oaks was already legendary, and its retailers catered accordingly. The theater's neighborhood charm calls forth a time before the birth of generic franchise cinemas, when Houstonians still sought the refreshment of movie house air conditioning. On opening night it featured Ginger Rogers's *Bachelor Mother*.

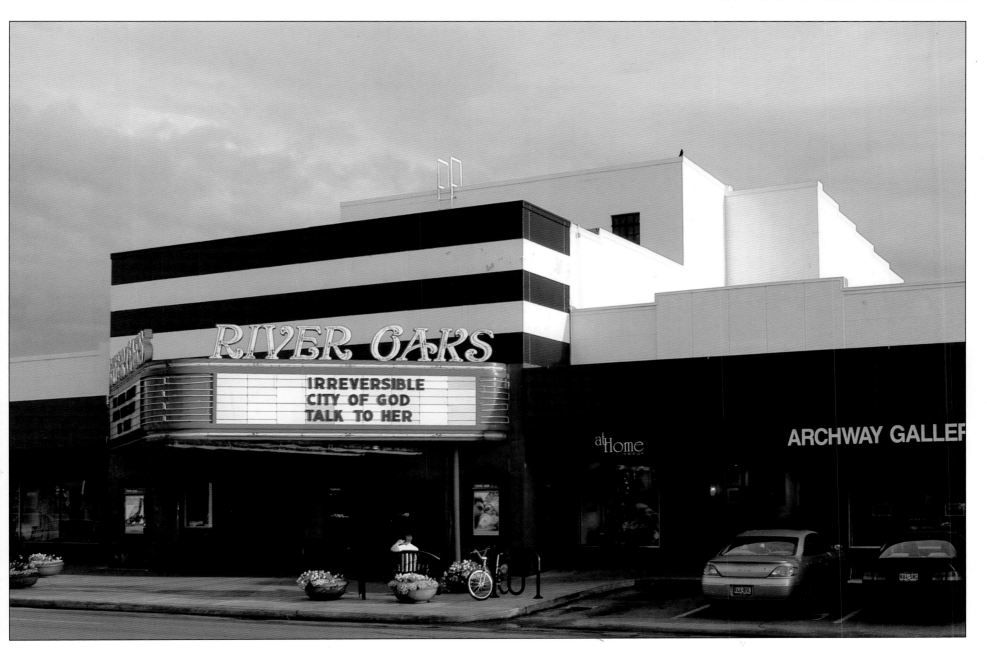

Houstonians still flock to the River Oaks Theatre to be refreshed, but not by its air conditioning. Now the Landmark River Oaks, it is one of the few Houston theaters that forsakes mainstream films for the masses in favor of providing a venue for independent, foreign language, unique, and just plain interesting films. Its diverse offerings and proximity to good food make it a favorite among Houston filmgoers.

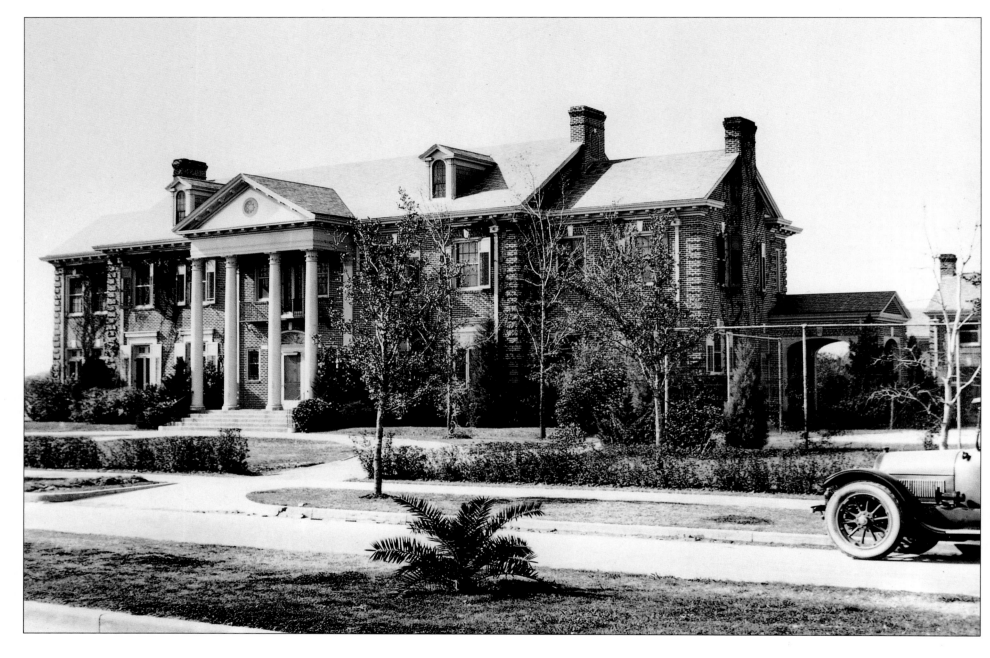

In 1923, this beautiful home at 5220 Montrose belonged to Neil T. Masterson, an entrepreneur who feverishly developed and promoted farming interests in the Rio Grande Valley. It was designed by William Ward Watkin, an accomplished architect who not only taught architectural engineering at the Rice Institute but also designed Rice Institute itself. When the Mastersons lived here, Montrose developers did not allow businesses to build in the area.

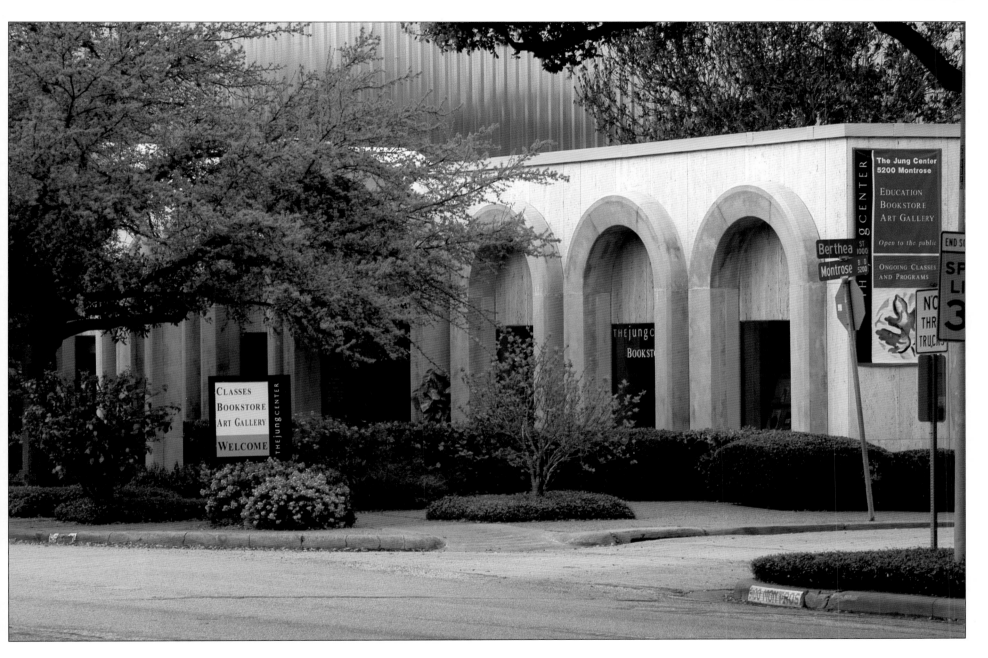

Montrose is still bursting with tasteful homes, though this one no longer stands. In its place is the Jung Educational Center of Houston, a unique institution offering courses and conferences to help Houstonians develop social and spiritual excellence. Swiss psychiatrist Carl Jung's theories provide the basis for its curriculum. Recognized psychological, spiritual, and esoteric leaders provide everything from in-depth dream analysis to tai chi and Islamic art and architecture.

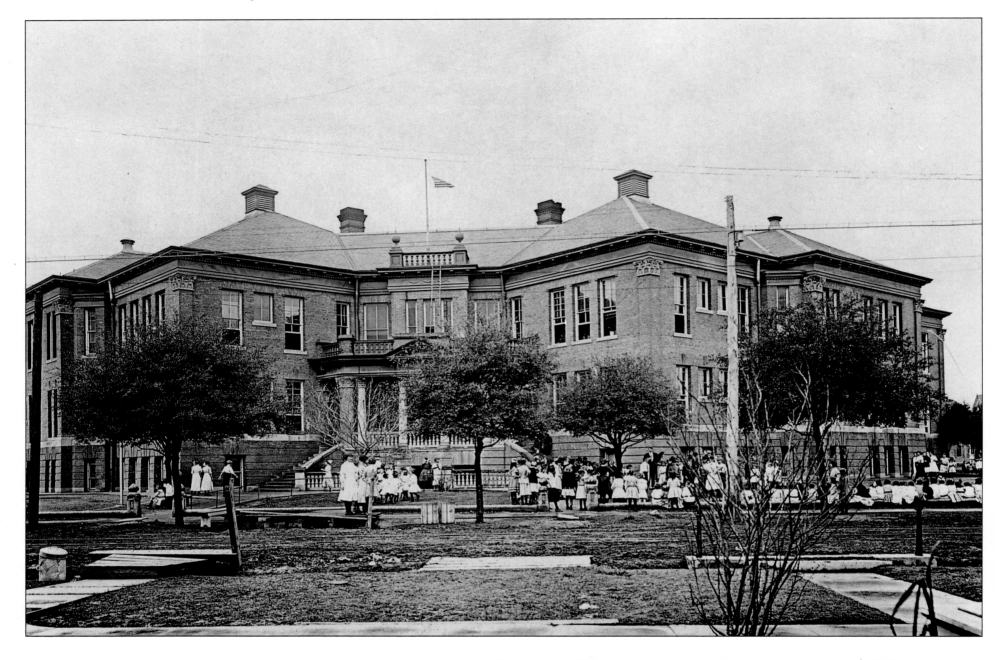

The suburb of Woodland Heights was born near downtown in 1907. At the time, Houstonians still considered public education a frivolous handout. School-bound children attended private schools, either locally or abroad. But the city's leaders saw the criticality of public schools. By 1909, Travis Elementary School, previously Beauchamp Springs School, was completed as one of its flagships.

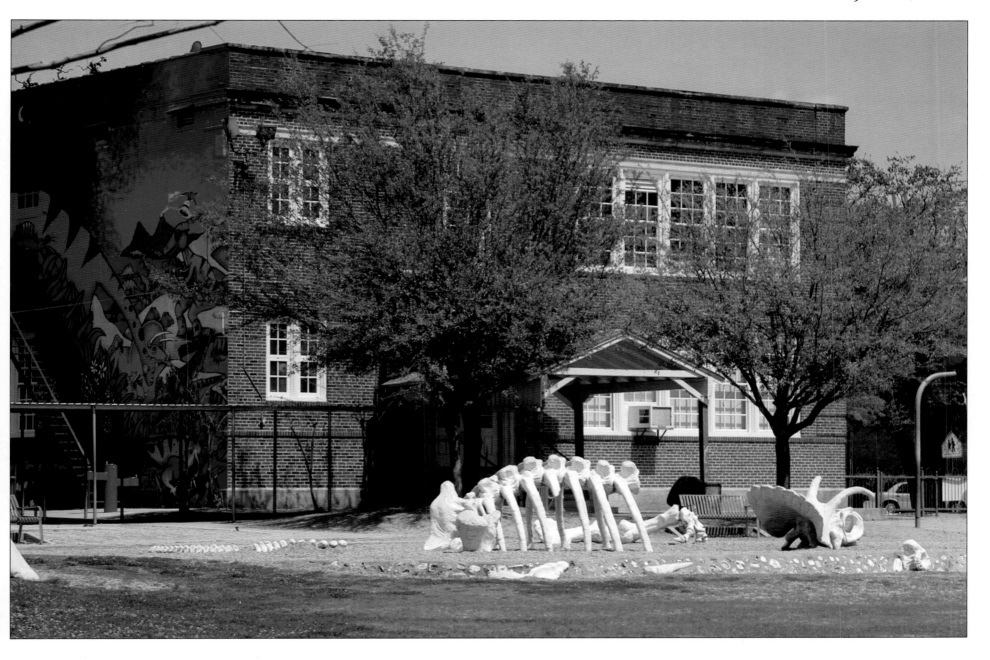

Travis Elementary is still one of Houston's most notable public schools. But the original three-story structure became a bit of a dinosaur over the years. In 1926, the site made room for a handsome, two-story brick building—perfect for expanding Houston's young minds. An open-air amphitheater-style classroom, outdoor educational garden, and its popular playground make it a favorite with teachers, students, and parents.

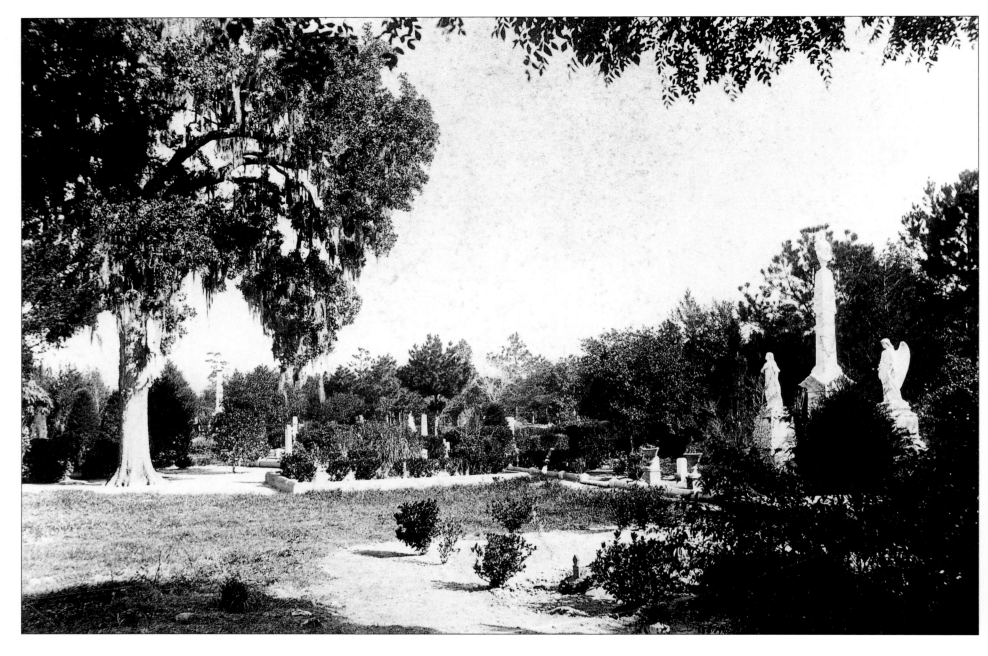

Houston's first professionally designed cemetery, Glenwood was completed in 1871 at 2525 Washington Avenue. A renowned landscape architect was brought from England to sculpt the property's lush hills into what would become the most famous and historically significant cemetery in Houston. Virtually all of the city's prominent citizens, bearing the familiar surnames of Cullinan, Hermann, Hobby, Johnston, Jones, McCarthy, Sterling, and Rice, were laid to rest in Glenwood.

Today Glenwood is a place of peace, reflection, and learning even for those without loved ones residing there. A turn-of-the-century Victorian cottage serves as its office, guiding visitors, coordinating services, and managing the many groundskeepers. Reportedly, the most frequently visited grave is that of billionaire businessman, aviator, and movie producer Howard Hughes. Hughes, born in Houston, died on an airplane returning to the Bayou City.

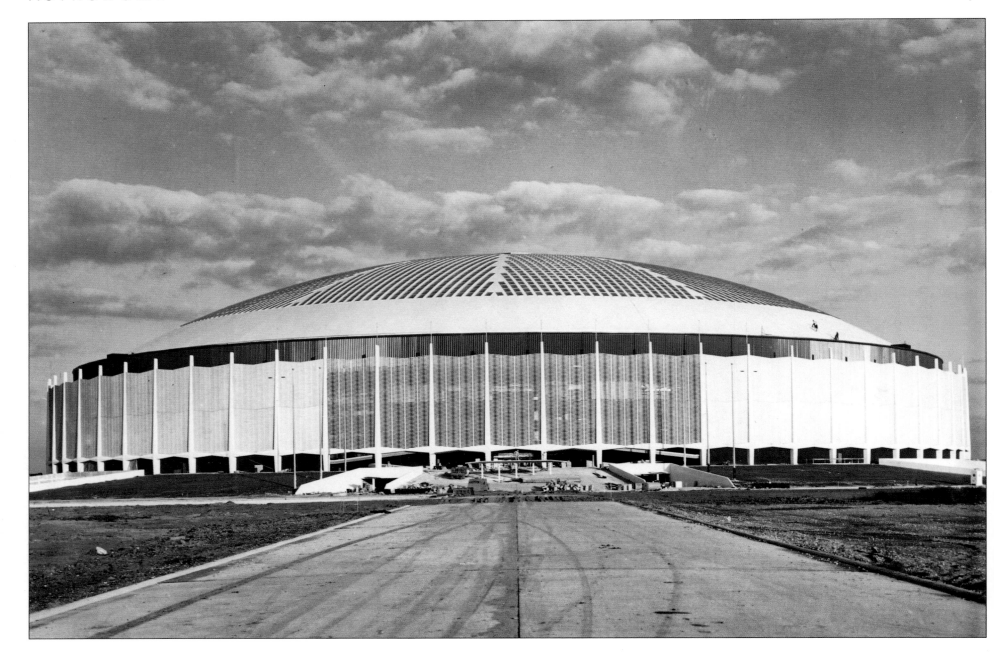

Its parking lot wasn't yet paved when this picture of the nearly completed Astrodome was taken in 1965. Widely publicized as the "Eighth Wonder of the World," it cost over $40 million. Big enough to house an eighteen-story building, it would be the model that cities across America used to build indoor stadiums. Its first event was an exhibition baseball game between the Houston Astros and New York Yankees on April 9, 1965.

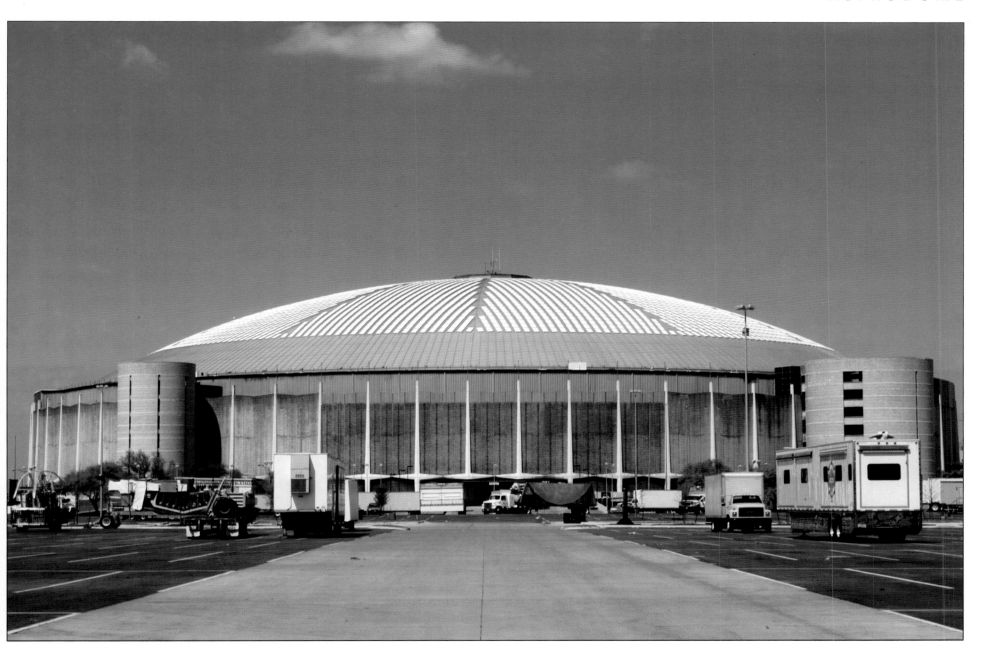

For decades, millions came to the Astrodome to see everything from baseball to bullfighting and polo. Also famous for concerts, football, and the Houston Livestock Show and Rodeo, the dome met its match when Reliant Stadium, home of the Houston Texans football team, opened in 2002. The larger, $450 million stadium has left the Astrodome with second-billing events and an uncertain future. The Astros now play at Minute Maid Park.

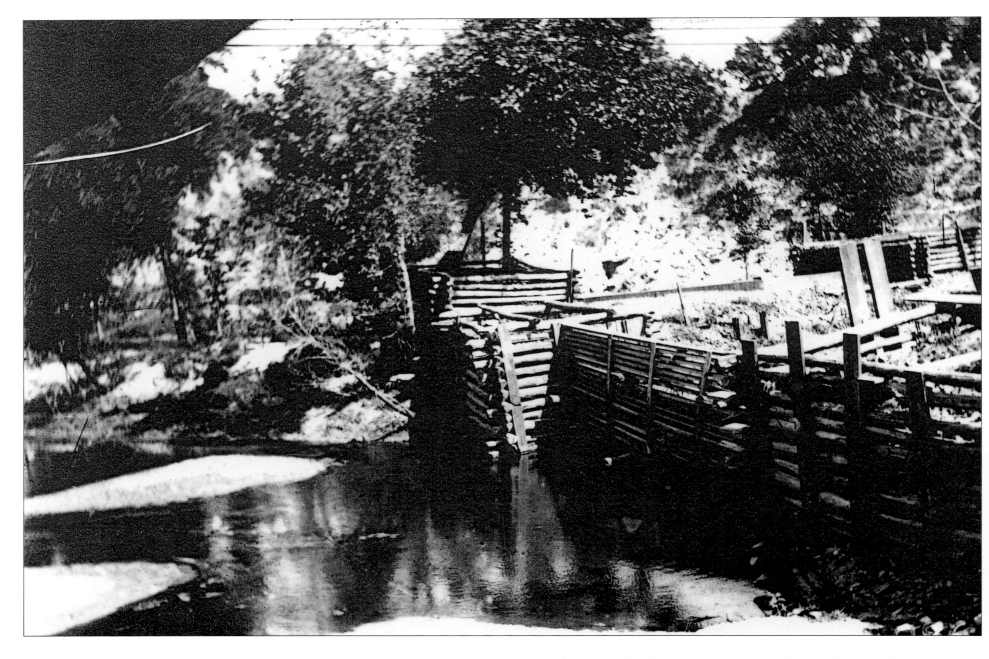

Before there was Shepherd Drive, there was Shepherd's Dam. Shown here around 1907 crossing Buffalo Bayou, it was near a sawmill and gristmill. There is debate as to whether banker B. A. Shepherd or one of his descendants is its namesake. While navigating a boat in this part of the bayou was dicey, some say Shepherd's Dam made the spot a darn fine place to swim.

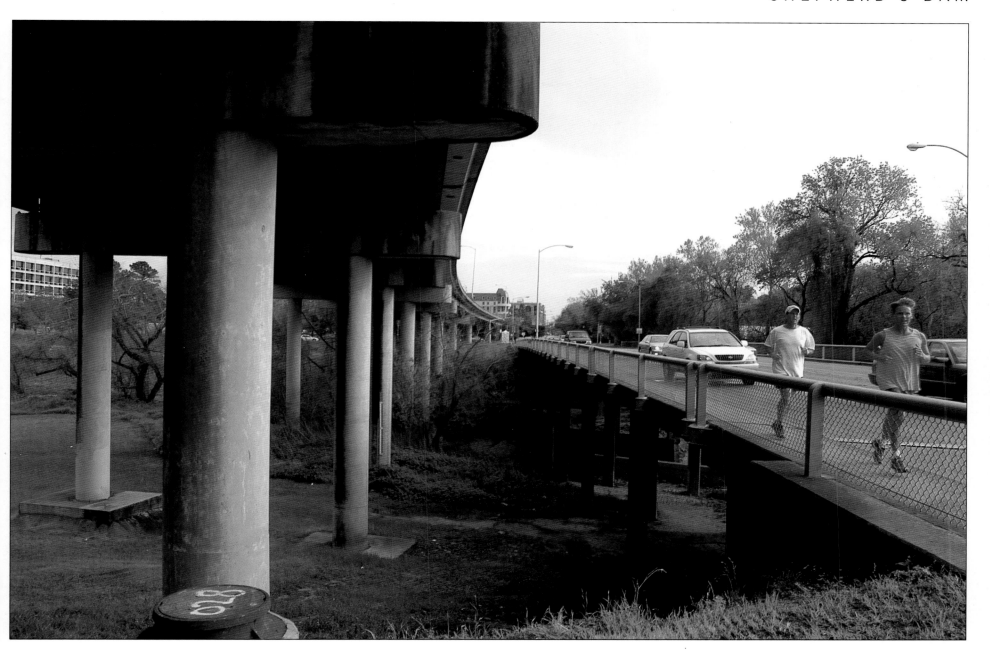

Today Shepherd Drive sees the daily commute of hundreds of thousands of Houstonians. Just north of the Shepherd Drive overpass at Buffalo Bayou are the stylish stores and restaurants of River Oaks Shopping Center. The bayou is still a popular urban recreation spot, though it sees more canoeing than swimming. Organized hiking and canoeing trips take place along Houston bayous every weekend, exploring the wildlife, flora, parks, and public art.

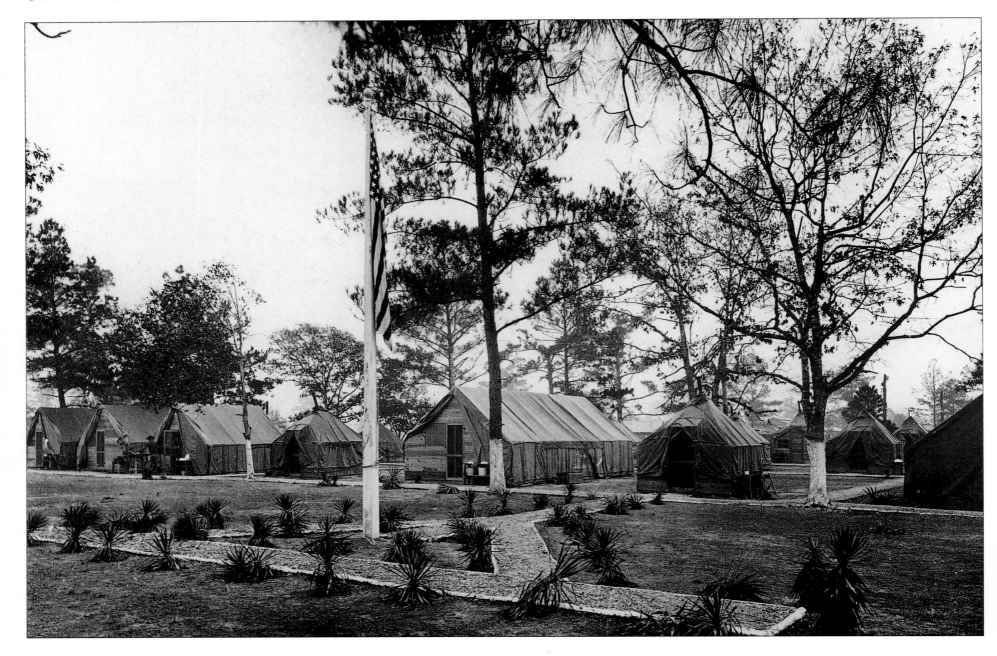

In 1917, construction began on an emergency training camp for U.S. soldiers in preparation for the anticipated fighting in World War I. The site was named Camp Logan and was built on 2,000 acres of land just west of the Houston city limits. In August of that year, an all-black troop from Illinois stationed at the camp rioted downtown, turning their rifles against the citizens they were supposed to protect.

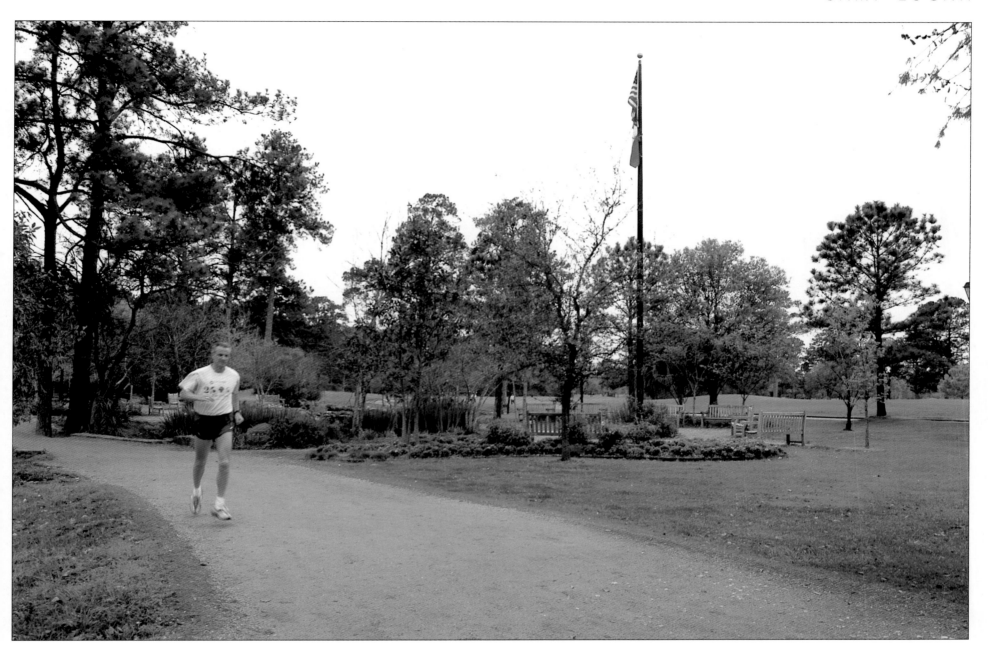

A lot has changed since Camp Logan and the riot of 1917. Today the site
is Memorial Park, the city's largest and most popular park. The center of the
universe for Houston-area runners, its 1,000-plus acres include a golf course,
softball field, picnic area, snack bar, and tennis courts. On any given day
you can see Houstonians and visitors doing everything from practicing
kickboxing to kicking back with a good book.

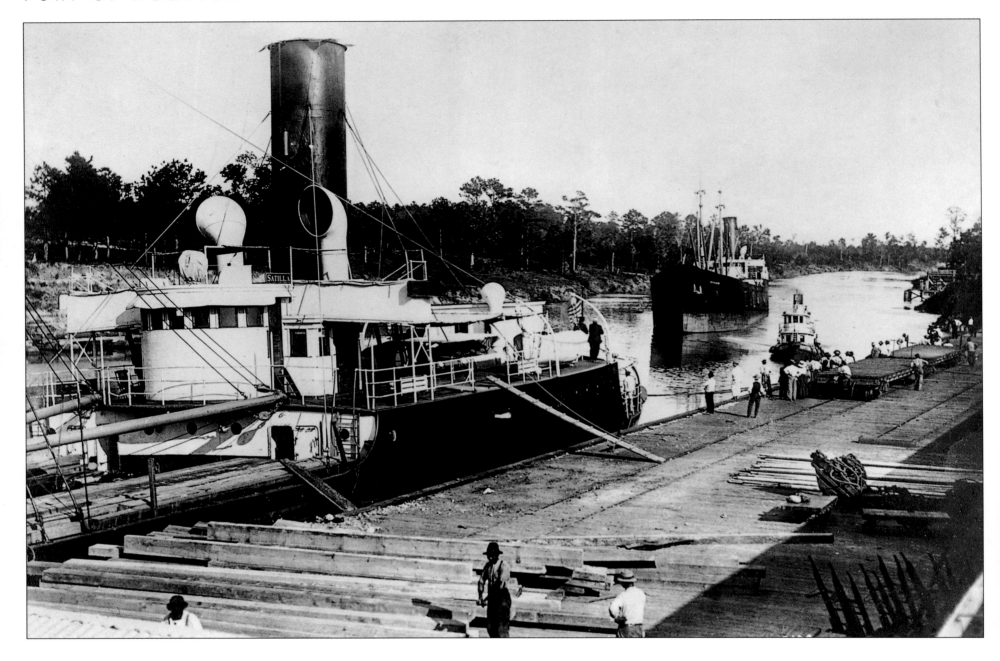

In 1870, the U.S. Congress officially declared Houston a port and began planning Buffalo Bayou's upgrade. Early merchants shipped cattle, cotton, and other commodities by steamer to Galveston, where they were transferred to more seaworthy vessels. The wharves roared with footsteps, factories, and freight movers. Gangplanks were still used to load cargo in 1915 when *Satilla* became the first deepwater ship to land at Houston's recently upgraded docks.

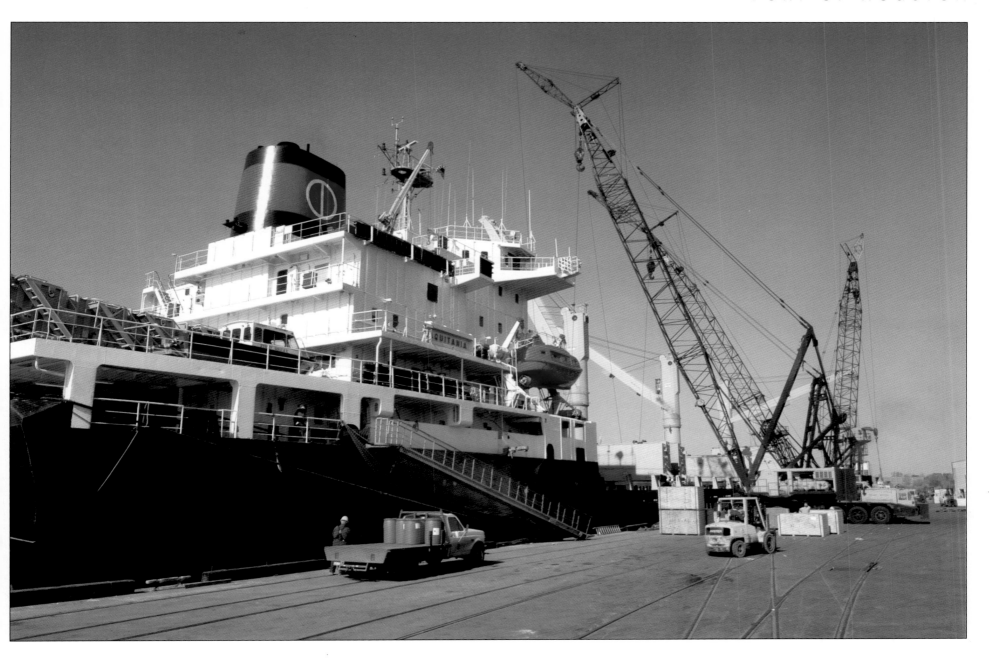

Today the Port of Houston is one of the world's leaders, ranking first in foreign waterborne commerce among America's ports. Now twenty-five miles long, almost 200 million tons of cargo crossed its decks in 2001— from petroleum products to machinery to automobiles. Its original wharves are now used only for mooring, and over one hundred public wharves are in use. Its terminals generate over $10 billion annually.

In 1874, an initiative was begun to turn Houston into a major port city. It started out as a project among Houston businessmen, but the government eventually bought the venture and invested over $1 million in it. Progress was gradual. In 1914, the twenty-five-foot-deep Houston Ship Channel was christened with white rose petals. Using a telegraph line from Washington, D.C., President Wilson fired a cannon at the event.

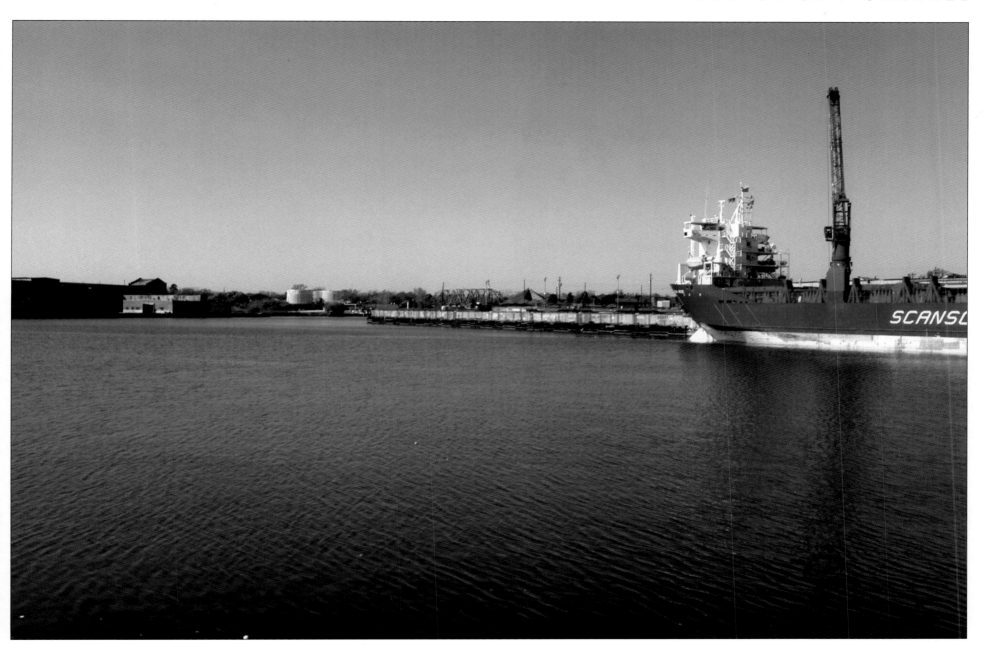

By the 1940s, oil refineries, factories, and shipping companies had grown along the ship channel like barnacles. In 1964, the Federal and local governments pooled their money and invested $92 million in its development. Today the Houston Ship Channel's fifty-two miles are the Madison Avenue of global industrial production. The businesses on its banks generate enough money to form a whole other city, creating hundreds of thousands of area jobs.

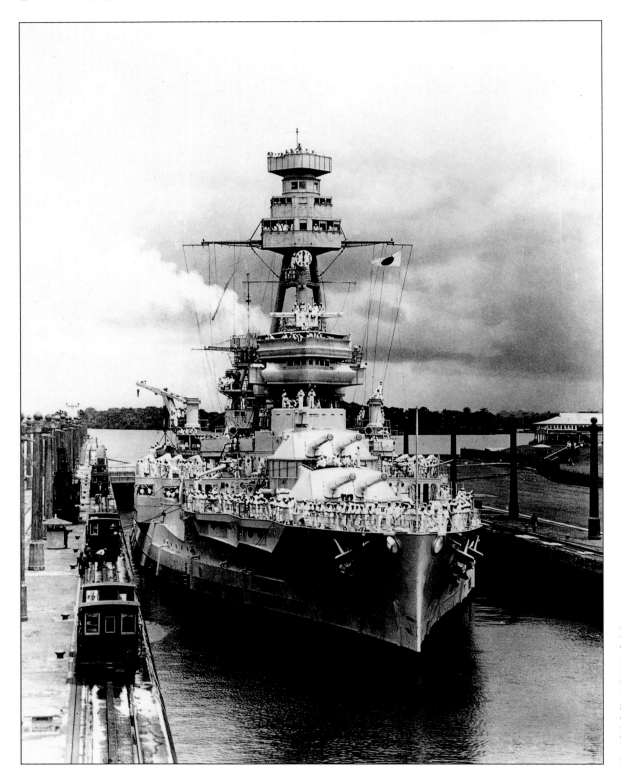

Modeled after the H.M.S. *Dreadnought*, the battleship *Texas* began its service in 1912 at Newport News, Virginia. It joined the Sixth Battle Squadron of the British Grand Fleet during World War I, and during World War II, after a major retrofit, *Texas* used its long-range guns to attack Nazi strongholds at Normandy. It was the first U.S. battleship to mount antiaircraft guns, use commercial radar, and launch an aircraft.

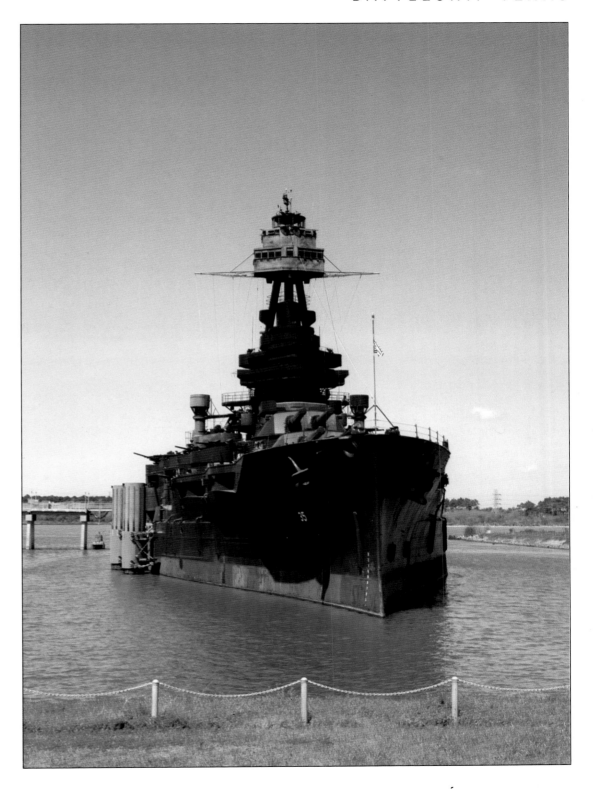

After decades of exemplary service, the U.S.S. *Texas* was decommissioned in 1948. Today tourists, not sailors, scurry through this iron giant. After decades in absentia, an extensive restoration of this classic American gunship began in the late 1980s. Managed by the Texas Parks and Wildlife Department, *Texas* opened to the public as a memorial museum in the 1990s and is moored near the San Jacinto Monument and Museum.

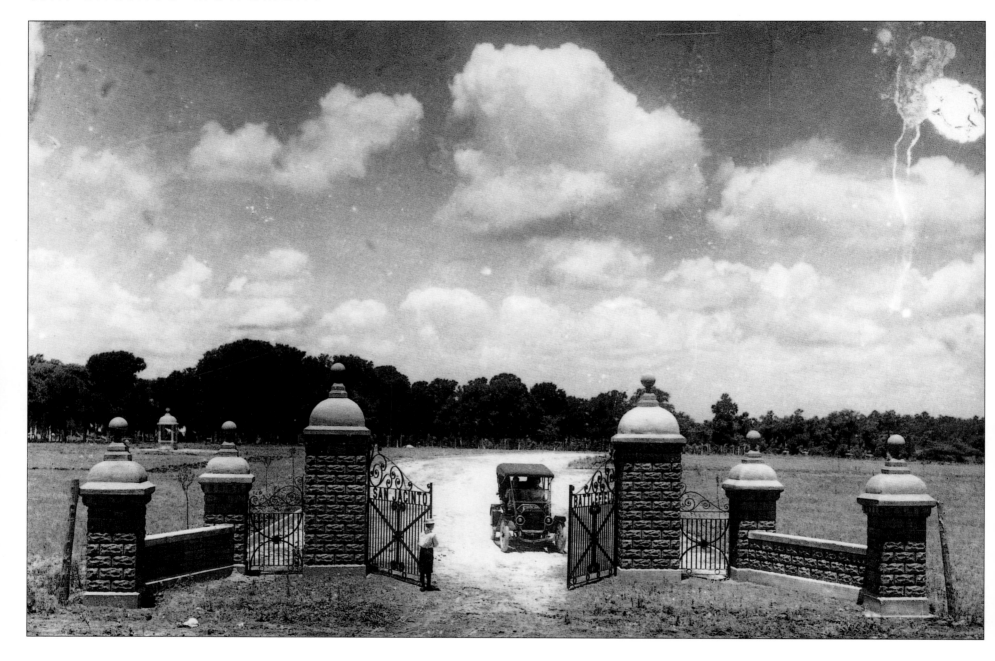

The Battle of San Jacinto was fought on April 21, 1836. Its outcome shifted the region's power structure, creating the Republic of Texas and eventually stretching the United States to the shores of the Pacific. The San Jacinto Battleground, twenty miles from downtown Houston, has been a sacred place for Texans ever since. A popular pastime for early Houstonians was to catch a boat down Buffalo Bayou to the battlefield.

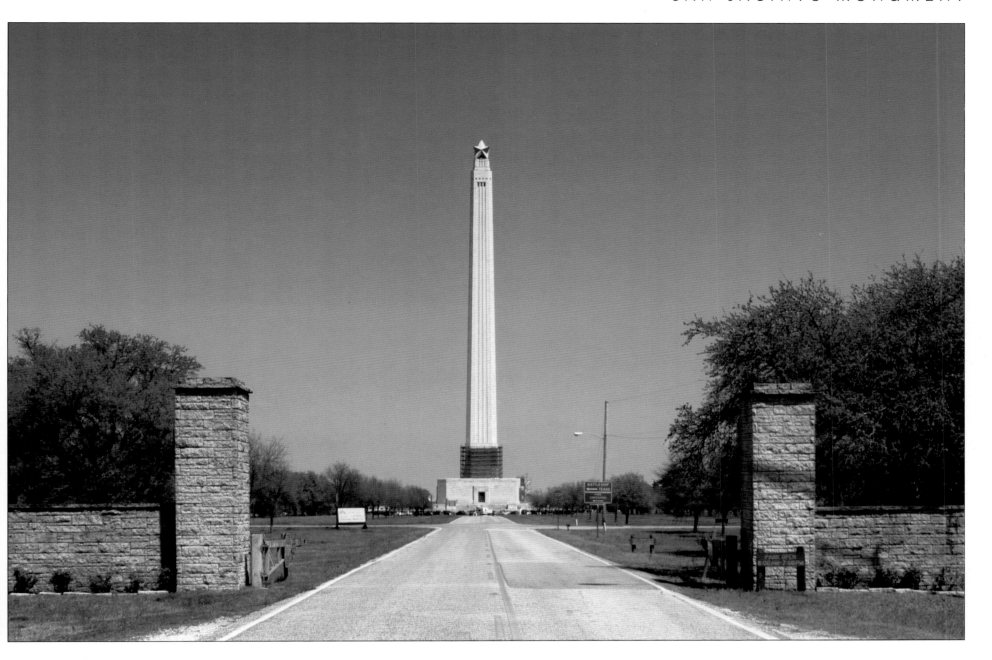

On the centennial anniversary of the battle, construction began on the San Jacinto Monument and Museum to commemorate Texas's heroes and heritage. Twelve feet taller than the Washington Monument, the monument houses a theater, museum, library, gift shop, and observation deck. The surrounding park, conference facilities, a nearby golf course, and its proximity to the renowned San Jacinto Inn restaurant make it an attractive place to spend a day.

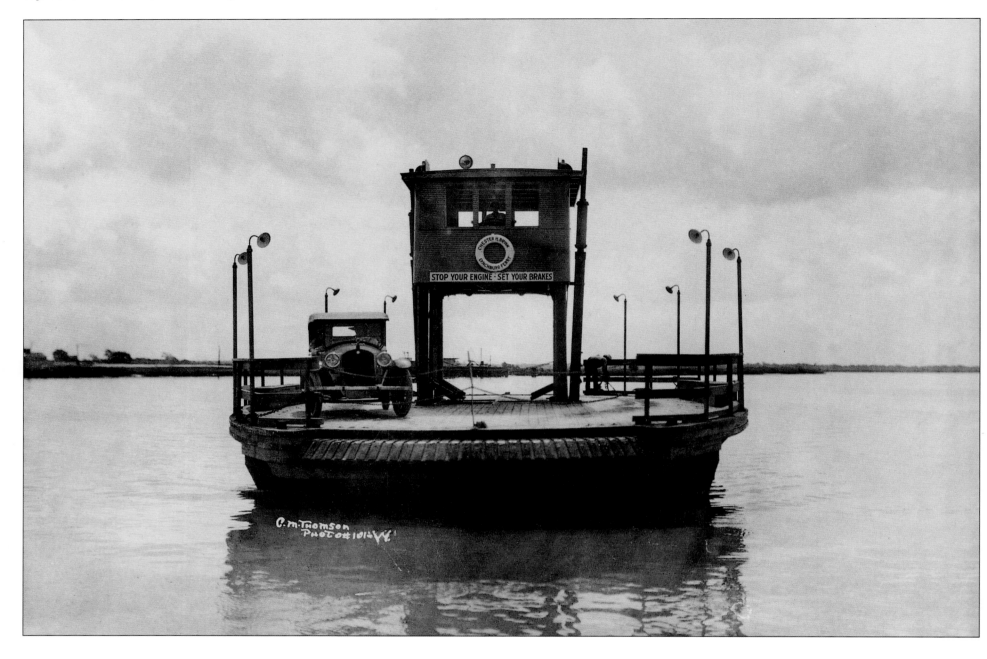

Nathanial Lynch, one of Stephen F. Austin's original 300 colonists, first constructed a pull-rope flatboat, known as *Lynch's Ferry*, on this spot in 1822. He saw opportunity when Texans began fleeing from the Mexican army. His ferry served a popular road to Mexico (and away from advancing Mexican troops). In very Houstonian fashion, he quickly hiked his rates exponentially, much to the annoyance of citizens trying to secure a safe passage.

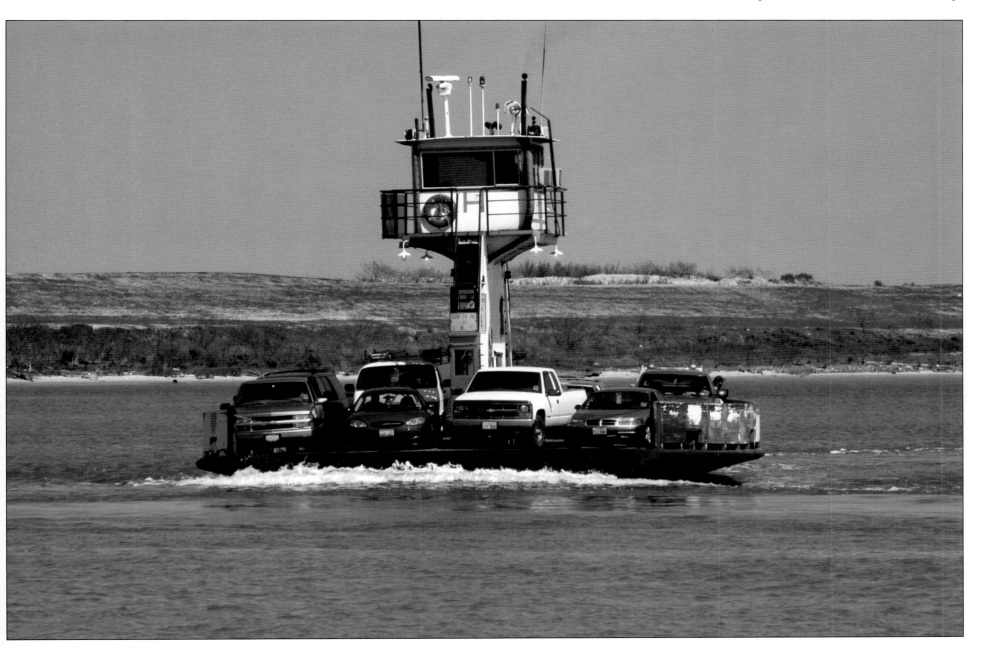

Nathaniel Lynch died shortly after the Texas Revolution. The ferry operation changed hands a few times afterward, but in 1890 Harris County started providing the ferry service free of charge. Now known as the Lynchburg Ferry, it runs two boats twenty-four hours a day. Each boat can carry up to a dozen vehicles twenty-five miles across the Houston Ship Channel.

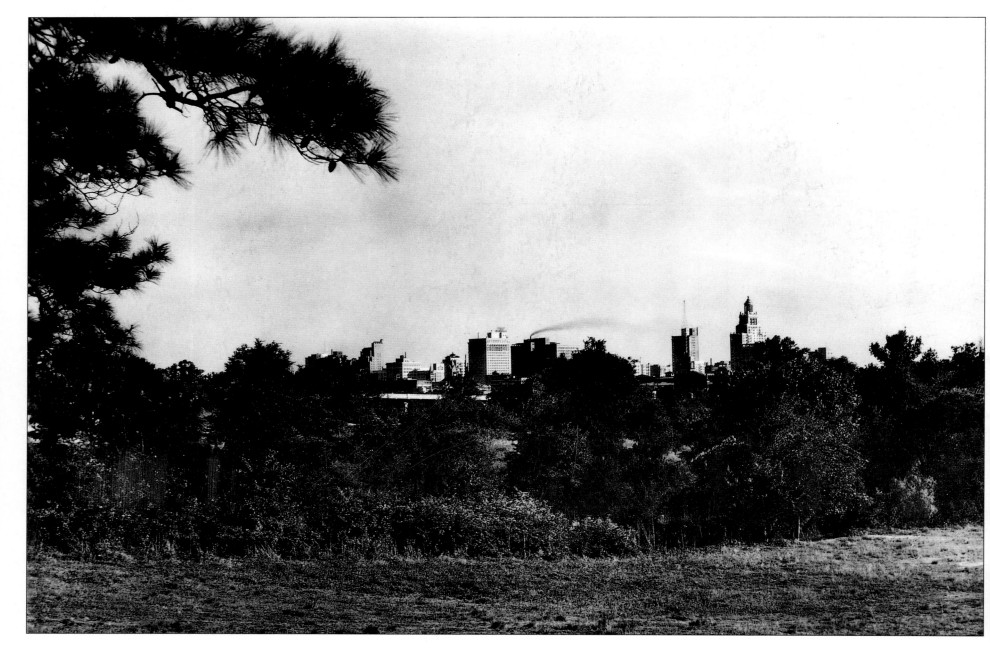

It was hard to imagine a bigger city than this, Texas's biggest, back in the early 1900s. By 1930, the population had increased more than 100 percent. The Gulf and Esperson Buildings dominated the downtown sky. The port already ranked third in foreign exports despite its improved but nascent infrastructure. By 1938, $25 million worth of building permits were issued and concrete, cars, and crowds were appearing in every direction.

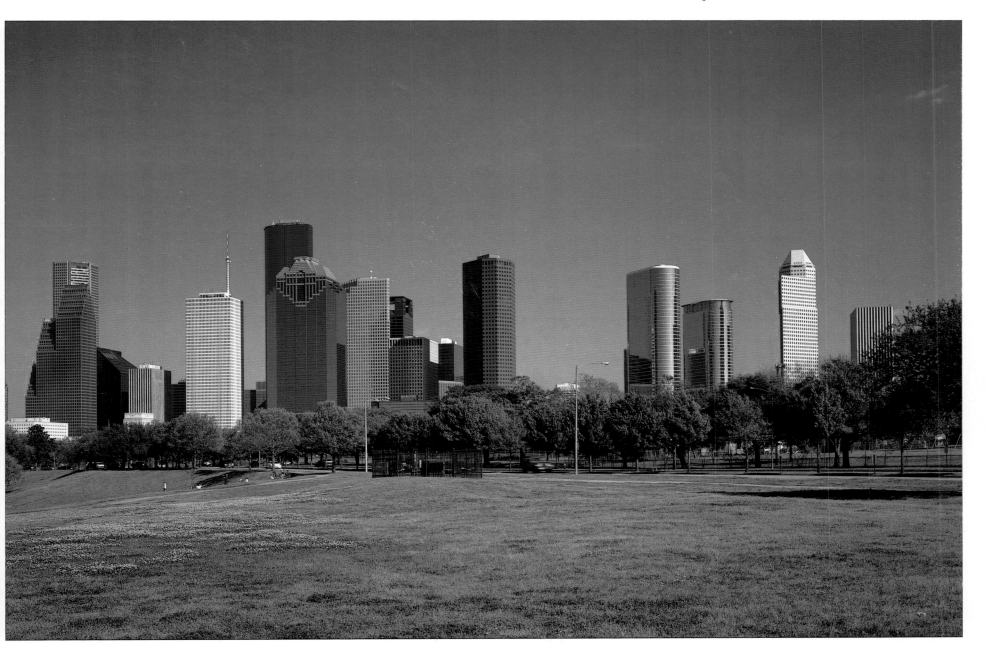

Today Houston's skyline catches one by surprise—its size and beauty holding
the eyes longer than intended. According to the Greater Houston Partnership,
downtown Houston now encompasses 1,178 acres and projects recently
completed or under construction are valued at almost $3 billion. The GHP also
states that New York, Washington, D.C., Pittsburgh, Minneapolis, Boston, San
Francisco, and Miami could all be placed inside of Houston's 620 square miles.

INDEX